THE CRITICAL HISTORIANS OF ART

The Critical Historians of Art

MICHAEL PODRO

YALE UNIVERSITY PRESS
NEW HAVEN AND LONDON

FOR CHARLOTTE, SARAH AND NATASHA

Designed by Stephanie Hallin.

Filmset in Monophoto Garamond
and printed in Great Britain by
BAS Printers Limited, Over Wallop, Hampshire.

Library of Congress Cataloging in Publication Data

Podro, Michael.
The critical historians of art.

Bibliography: p.
Includes index.
1. Art—Historiography. 2. Art criticism.
I. Title
N380.P53 701'.1'80943 82-4934
ISBN 0-300-02862-8 AACR2
ISBN 0-300-03223-4 (pbk.)

PREFACE

TWO INTERESTS prompted the writing of this book: firstly, the attraction of a literature which made a serious attempt to say things about the visual arts that would register the energy and complexity of the arts themselves; secondly, the sense that this literature continued to exert an influence largely through shadowy reminiscence, the texts themselves having slipped from view.

This material was the subject of lectures and seminars given at the University of Essex between 1970 and 1980. I should like to thank all those in the Department of Art who, during that period, argued over its problems. I am particularly indebted to Robert Bernasconi, Valerie Fraser, Michael Holly, Margaret Iversen, Jules Lubbock, Annie Richardson, Anna Tietze and Peter Vergo, and to Maureen Reid for keeping up with, and making adjustments to, continual revisions of the typescript. The comments of John Nash and Alex Potts on the main arguments of the book have been, for me, particularly helpful.

To E. H. Gombrich I owe the debt of anyone working in the field, and more, for many years of conversation. I owe a similar debt to Richard Wollheim, whose *Art and its objects* gave focus to many of the issues involved here. Throughout the period of writing, I have discussed the work with Michael Baxandall and Thomas Puttfarken, and they read and criticised drafts with immense generosity of time and thought. Without the library of Warburg Institute, writing the book would, for me, have been inconceivable, and I am very grateful to its librarians for their constant help. Finally, I should like to thank John Nicoll for his encouragement over a long period and Stephanie Hallin for her care in preparing the book for the press.

CONTENTS

CONTENTS

LIST OF ILLUSTRATIONS

When I first undertook to write these lives, I did not propose to make a mere list of the artists with an inventory, so to speak, of their works . . . I have endeavoured not only to relate what artists have done, but I have tried to distinguish the good from the better and the best from the medium work, to note somewhat carefully the methods, manners, processes, behaviour and the mind of the painters and sculptors, investigating into the causes and roots of things, and of the improvement and decline of the arts . . .

G. Vasari, *Lives of the Artists*, 1550.

The history of ancient art which I have undertaken to write is not a mere chronicle of epochs and of the changes which occurred within them. I use the term history in the more extended signification which it has in the Greek language; and it is my intention to attempt to make the subject systematically intelligible. In the first part—the treatise on the art of ancient nations—I have sought to execute this design in regard to the art of each nation individually, but specially with reference to that of the Greeks. The second part contains the history of art in a more limited sense, that is to say, as far as external circumstances are concerned, but only with reference to the Greeks and Romans. In both parts, however, the principal objective is the essential nature of art . . .

J. J. Winckelmann, *The History of Art in Antiquity*, 1764.

What can be achieved through philological methods is shown by archaeology . . . From philosophy I shall draw a stream of new ideas and inject them into history.

H. Wölfflin, letter, 1886.

It is the curse and the blessing of the systematic study of art that it demands that the objects of its study must be grasped with necessity and not merely historically.

E. Panofsky, 'Der Begriff des Kunstwollens', 1920.

INTRODUCTION

THE PRESENT book examines a central tradition within the literature of the visual arts. The foundation of that tradition lay in German philosophical aesthetics of the late eighteenth and early nineteenth century and it stretches from roughly 1827 to 1927, from the writing of Hegel and Rumohr to that of Riegl, Wölfflin, Warburg and Panofsky.

This literature has a strong internal coherence. Its writers not only re-examined the same issues, but challenged, expanded and elaborated on one another's work. And the tradition can be marked off from other contemporaneous art historical writing by its objective: it aimed to explore particular works in the light of our conception of art—of those principles which governed art as a whole. This kind of aim is signalled in various ways in the passages cited at the beginning of this book.

But what is meant by exploring particular works in the light of our conception of art? The most straightforward answer is perhaps this: we adapt a group of expectations and assumptions, formed in considering one group of works, to considering another group. For instance, we carry our experience of looking at a painting by Titian to looking at one by Rembrandt (Plates 1 and 2), or—to take a much more problematic example—we may try to use our experience of Greek sculpture—at whatever level of articulacy or self-awareness—to looking at figures from early Egyptian dynasties, and then see what can be sustained and what must be modified (Plates 6 and 7). What is assumed to be constant and what variable over different historical and cultural spans alters from writer to writer. But one essential part of the concept of art, of the way it constitutes a repository of our past experience, is how it develops flexibility in making such movements.

The project of extending our notion of art into the examination of fresh works, or revising our understanding of works in the light of each other can be distinguished from other kinds of historical inquiry. For instance in the case of Rembrandt's painting of a woman in bed we may ask about the biographical and circumstantial facts which gave rise to the painting, whether it is Hendrikje

Stoffels or Saskia? what earlier works he drew upon for the format? and who bought such an apparently intimate painting? But even if we could answer these questions we should still be left with a problem of a different kind. If the painting is—as it seems—so intimate and domestic, then how does it take on its interest beyond the original personal context? It is this latter question which may lead us to call into question our notion of art, to see how its application elsewhere could help us to clarify Rembrandt's achievement here.

We may ask both kinds of question, too, about Titian's *Woman at her Toilet*. Was this a depiction of Vanity or Venus? was the subject a courtesan? was the format of the painting derived from the 'heroic portrait'? and was it conceived by Titian as a painterly analogue to a Petrarchan sonnet? These are historical questions. But we are also prompted to ask how the artistry enhances or transforms the eroticism of the painting, and—as in the case of the painting by Rembrandt—this assumes we can draw upon some general notion of art.

It might be thought that there is no firm division to be made between these two kinds of question. If we look at our historical questions, those which attempt to establish—in the widest sense—the *genre* of the painting, it is clear that they already presuppose our notion of art. It is our notion of art which itself suggests what it is relevant for us to look for; it is our notion of art which dictates that we should try to see a painting as drawing on traditions of usage. It is also because we have a certain notion of art that we try to see the work in the light of the conditions and intentions with which it was made.

And the argument that we cannot divide the questions of historical fact from the questions about the role of the notion of art might invoke another kind of evidence: that the conception of art was itself one of the historical facts. For instance, the very level of artistic distinction of both Titian and Rembrandt—the level of achievement which each brought to his painting was surely integral to his relationship with his model. At the very least, whatever the details of their social relationships outside the paintings, a personal relationship would seem to constitute a theme within the paintings, a theme of the kind familiar and explicit in literature:

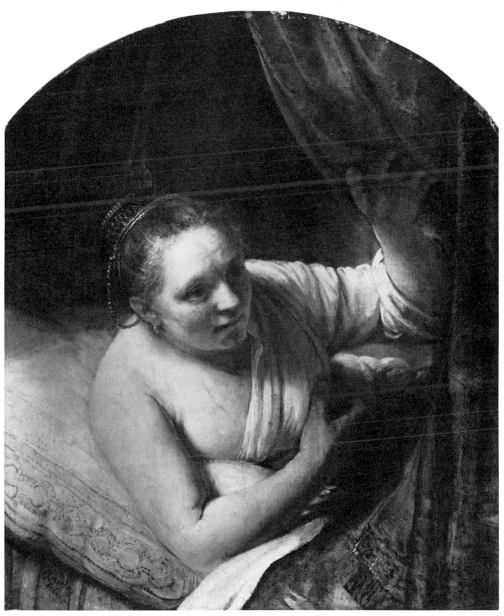

1. Rembrandt, *Hendrikje Stoffels* (?), *c.* 1647, Edinburgh: National Gallery of Scotland.

Nor shall death brag thou wandr'st in his shade,
When in eternal lines to time thou grow'st,
So long as men can breath or eyes can see,
So long lives this and this gives life to thee.
(Sonnet XVIII)

The sense of art and the mastery of art was, surely, as much part of Titian's and Rembrandt's self-awareness as it was of Shakespeare's. Their notion of art was one of the historical facts.

But while this is surely true, we could only understand the sense of art and artistic mastery relevant to Titian and Rembrandt if we ourselves had a conception of art, just as only someone with a sense of law or of logic could perceive the procedures in an alien society as those of its law or its logic. More generally, both the reciprocity between the search for historical facts and the deployment of the concept of art, as well as the way in which our notions of art may themselves become constituent features within the tradition of art, should not obscure the difference between the two kinds of question: one kind of question requires us to provide answers on diverse matters of fact, on sources, patronage, purposes, techniques, contemporaneous responses and ideals—the kind of question we can broadly describe as archaeological. The other kind of question requires us to see how the products of art sustain purposes and interests which are both *irreducible* to the conditions of their emergence as well as *inextricable* from them. Addressing the latter kind of question I shall call, for convenience, 'critical history' and that is the subject of the present book.

It may be that it is not possible to conduct the two inquiries independently of each other, but at any one time, any one writer's main concern can lie in one direction rather than the other. And as I shall here be concentrating on the critical as opposed to the archaeological direction of inquiry, I shall be adopting a narrower perspective than—in some cases—the writers themselves. Nevertheless, they were mostly clear that there were two directions of inquiry—the archaeological and the critical. Their difficulty was in defining precisely how to make the distinction, and that will be a recurrent issue in the following chapters.

One reason why there was difficulty about the distinction between two kinds of inquiry stems from what has been observed about the nature of art itself—its being both context-bound and

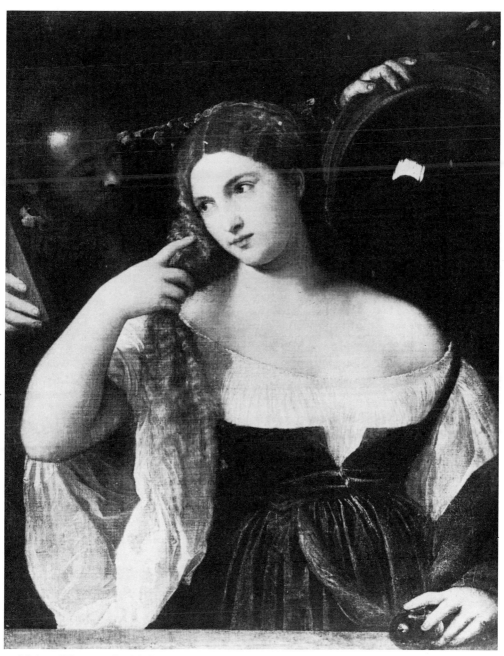

2. Titian, *Woman at her Toilet*, *c.* 1515, Paris: Louvre.

yet irreducible to its contextual conditions. A brief remark about that two-sidedness may therefore be in place here. Either the context-bound quality or the irreducibility of art may be elevated at the expense of the other. If a writer diminishes the sense of context in his concern for the irreducibility or autonomy of art, he moves toward formalism. If he diminishes the sense of irreducibility in order to keep a firm hand on extra-artistic facts, he runs the risk of treating art as if it were the trace or symptom of those other facts. The critical historians were constantly treading a tightrope between the two.

It is in this situation that the historian's concern with the irreducibility or autonomy of art could become identified with a purely formalist history, while contextual factors were seen as extrinsic to critical history. But reflection on the two paintings by Rembrandt and Titian should make it clear why this would be a mistake; for we were concerned with the way social elements within the subject of the paintings were transformed by art. An answer which did not engage with the fact that these were paintings of women which presuppose some sense of personal relations would be inadequate. The two-sidedness of the nature of art is itself a central topic of critical history. When that history collapses into formalism that is a failure and not intrinsic to the enterprise.

The way in which a single work may present us with divergent problems, the solutions to which are quite different in kind, can be traced in the complementary aims within art historical writing in general: on the one hand the purpose of building up and giving order to the documented archaeological knowledge of past art, and on the other re-casting our conception of art to give us purchase on the variety of its styles and purposes. Each presupposes a background of the other. It is striking that a historian like Franz Kugler, a central figure in nineteenth-century scholarship who was pre-eminently concerned with questions of archaeology and authorship, shared the metaphysical view of art with the philosophically minded writers.* The difference was that he was not concerned with testing, revising or relating that general conception in his detailed work. Another major historian, with a comprehensive familiarity with the theoretical literature,

*See below Chap. I, note 19.

Julius von Schlosser, largely withdrew from such discussion, recording as a matter of history the viewpoints of others. He did so from a conviction that between the creative achievement of the individual artist and the complexity of historical facts there was an unbridgeable gap—that art itself transcended the material language of artefacts which alone could be treated as an object of study.†

What follows is limited to critical history and—more specifically—to critical history written in German. (Language here provides the relevant cultural category.) This German tradition is not altogether isolated; it is not without relation to the writing of Ruskin, Pater and Fry in England, or to Viollet-le-Duc, Taine and later Focillon and Francastel in France, or to that of Croce, Leonello Venturi and others in Italy, but it seems better to try and get one part of the story clear first, and the German tradition traced here is relatively independent.

The term 'critical history' offers itself as an appropriate description for this body of writing for several reasons. First because it suggests a parallel with literary criticism. A central interest of these historians is that they provide the kind of attention to works of visual art—to paintings, prints or buildings—which corresponds in certain ways to the 'practical criticism' of literature.

There is then a second and more local reason for using the term 'critical': it suggests the connection between this art–historical writing and the philosophy of Kant. For these writers the Kantian opposition between human freedom and the constraints imposed by the material world is, in various ways, central. The year 1827 seems an appropriate starting point. By then the more strictly philosophic writing on aesthetics on which they were to draw—the aesthetics of Kant, Schiller, Herbart and Hegel—was complete; and in that year the aesthetics which Hegel carried across into the schematic history of art was confronted by the hostile position of the historian and theorist Karl Freidrich von Rumohr. This confrontation provided a focus and point of departure for subsequent argument. To mark the end of the period discussed by the date 1927 is slightly more than a convenient rhyme. It was the year in which Erwin Panofsky published 'Die

†See below Chap. X, p. 212.

Perspektive als "symbolische Form"',* perhaps the most famous
of the series of theoretical and critical papers whose themes went
back to Hegel. The main patterns of Panofsky's subsequent
writing remain close to those of the early papers.

After the 1920s the concerns and procedures which were central
to these critical historians became outmoded. Developments in
philosophy, in the study of perceptual psychology and psycho-
analysis precipitated a radical shift of assumptions and concepts.
But the arguments and modes of interpretation offered by the
critical historians over the previous hundred years remained
fundamental to those writing both within and outside the German
traditions.

The following chapters give an analysis of arguments, of a
debate, and not a narrative of the lives and institutions of the
participants. It may thus be helpful to introduce the main speakers
roughly in order of appearance, and with some indication of the
positions they adopt.

Two central concerns gave direction to the writing of critical
history: first, to show the way in which art exhibited a freedom of
mind, like that experienced in discursive thought or in composed,
self-possessed behaviour; and second, to show how the art of alien
or past cultures could become part of the mental life of the present.

If one treats Hegel as the first of the critical historians, it is with
two reservations: writing about the visual arts was not central to
Hegel's general enterprise, and it would be quite misleading to
suggest that everything important in subsequent critical history
can be traced back either to his influence or to adverse reactions to
it. He was not quite so important to critical history, or it to him, as
placing him first may suggest. Nevertheless, he did confront both
of its major problems when he set art within his comprehensive
vision of the development of Spirit. Furthermore, the way in
which Hegel's *Aesthetics* was challenged contemporaneously by
Rumohr signalled a fundamental difference between two con-
ceptions of art, and the tension between them lay at the centre of
argument for the following century and beyond. The difference
was between a conception of art as part of contemplative and as
part of active life—as tied primarily to thought or primarily to

*Titles of books or papers are given in German where there are no
English translations, otherwise in English. References to original texts
and translations are given in the notes and bibliography.

social relations. The opposition was prefigured—as we shall see—in the aesthetics of Kant and Schiller.

The history of the critical historians after Hegel falls into three fairly clear stages. In the generation immediately following him, Karl Schnaase (1798–1875) was, of the writers to be considered here, closest in thought to Hegel. In his *Niederländische Briefe* of 1834 he adapted Hegel's broad teleological scheme of history to the independent development of the visual arts, which he saw as complementary to the development of religion.

In the same generation Gottfried Semper (1803–79), an architect and architectural theorist, whose main writing appeared between 1851 and 1863, was virtually unaffected by Hegel. Semper provided the basis of a systematic treatment of art history strikingly different from that of Schnaase. Where Schnaase, following Hegel, had been concerned with *attitudes* which were formulated in works of art, Semper concentrated on *motifs*. He explored the way visual artists, in particular architects, took structural features like the plaited twigs of primitive building or the woven threads of textiles, and exploited their potential for pattern making, and how they transferred such motifs to different materials, in this way generating architectural metaphors. The contrast between Schnaase and Semper was not only between an account of artistic style in terms of attitudes and in terms of motifs, but between a view of art as having an ideal toward which it developed through history and a view of art as developing by the piecemeal adaptation and re-application of those motifs.

Semper's motif theory became combined with Herbartian psychology in the writing of a younger contemporary, Adolf Göller. In Herbart's psychology, simultaneous perceptions or 'ideas' in the mind fuse with each other by virtue of common features and conflict with each other insofar as they are different; furthermore the mind's current perceptions or 'ideas' become associated with similar past 'ideas'—patterns of past experience are revived and the mind tries to reconcile present experience to those patterns revived from the past; in this way it produces a new fusion of past and present. Architectural motifs became thought of as a species of Herbartian 'idea', with past motifs deliberately recalled and fused in new configurations, and this gave to the history of architecture and design a principle of development and order.

Both Schnaase and Semper were unlike two other major figures in their generation of critical historians, Jacob Burckhardt (1818–97) and Anton Springer (1825–91), both of whom were hostile to the philosophy of history as an impediment to direct historical inquiry. Their respective roles within the tradition were, however, very different. Burckhardt's study of the social life of the Italian Renaissance was only implicitly linked to his study of its art. His study of Italian Renaissance architecture, *Die Kunst der Renaissance in Italien* (1867), and his *Cicerone* (1855), as well as his schematically arranged surveys of the genres of altar painting and the portrait (in *Beiträge zur Kunstgeschichte von Italien* published posthumously in 1898) do not present any general argument in the light of which particular works are seen. His short comments on particular works possess a remarkable capacity to give focus to a work, particularly in these late papers on Renaissance art and his posthumously published *Recollections of Rubens*. One aspect of his varied influence was to prompt others to clarify the notions he used and extend the insight of his particular comments.

Anton Springer (1825–91), the most wide-ranging of art historians, integrated his intensive study of art and of social life much more fully than Burckhardt. His work extended from studies of antiquity to the nineteenth century. He seems more aware of the philosophical problems of art history than any other nineteenth-century writer; he had written his doctoral dissertation in 1848 on contradictions in Hegel's philosophy of history; subsequently his acute conceptual alertness informs his writing, rather than becoming its theme.

When we come to the second generation of critical historians after Hegel, those born just after the middle of the nineteenth century and beginning to publish around 1890, we find it dominated by three men, Alois Riegl (1858–1905), Heinrich Wölfflin (1864–1945) and Aby Warburg (1866–1929). And the division between them broadly corresponds to that of the previous generation.

Let us start with Wölfflin. He was the heir of Semper and Göller in the following way. His first work, *Renaissance and Baroque* (1888) aimed to explain changes in style as changes in *attitude*, and to do this he invoked empathy theory: that is, the theory that we invest inanimate objects with inward states by analogising between their physical shape and our own bodily poise. When he came to apply it

in critical detail, what he did was talk not narrowly about empathic effects but rather about the metaphorical force of architectural motifs. He then turned to the development of architectural history as the progressive integration and elaboration of motifs from the past (*Die antiken Triumphbogen*, 1893). In *Classic Art* (1899) Wölfflin attempted an account both of the development of visual tradition and the change of social attitude to explain the shift between quattrocento and High Renaissance art, but left the two unintegrated. He then turned exclusively to an analysis of visual tradition which he sought to treat in isolation.

Wölfflin's theory of visual motifs had become vastly enriched by absorbing another Herbartian theory of ordering, that of Adolf Hildebrand's *Das Problem der Form* of 1893. Hildebrand's theory was essentially an analysis of classical relief, which examined the ways in which cues indicating the three-dimensional character of the subject matter were integrated into a system of planes parallel to the relief surface. This was the first time someone had given a systematic account of the reciprocal adaptation of subject matter and the material of visual representation. Wölfflin developed Hildebrand's notion of relief into a much wider theory in his *Principles of Art History* in 1915. In that book he expanded the notion of the reciprocal adaptation of subject matter and the material, treating it as itself having a pattern of development like the progressive integration of architectural motifs.

Riegl's development is in some ways closely parallel to that of Wölfflin. He first adopted a form of Semper's motif theory in his *Stilfragen* of 1893 but concerned himself with the transformation of one motif, the acanthus, which he saw as developing from the shape of the lotus motif by virtue of an internal dynamic seeking richer and more integrated form. This seems to have been, for him, a model of the internal logic and purposiveness of the development of art as a whole. In his subsequent mature works, *Spätrömische Kunstindustrie* (1901) and *Holländisches Gruppenporträt* (1902), his position came very close to Schnaase and absorbed further details from Hegel. Although he used a teleological scheme in both works, he treated the visual arts as constantly reconceiving their own goal, making its sense of order progressively more subjective and implicit; in this way the teleology no longer offers a final vantage point from which to look back at the past. For Riegl as for Wölfflin the problem of accommodating

the art of the past within the mental life of the present was a matter of seeing how a fundamental feature of the mind, the pursuit of order, is realised in different kinds of art.

The third major figure in this second generation was Aby Warburg (1866–1929). In his concern with exact social detail he was like Springer and Burckhardt. His major work, a series of papers on the social and religious function of symbols in late fifteenth-century art, makes no sharp break between the significance of symbols inside major works of art and in commonplace prints or coats of arms. The underlying theme of his work is the fight which he sees the artist as waging against superstition and repressive social convention.

The third and final stage of the tradition of critical history is here represented by one figure, Panofsky. He turned back to re-examine the question of how the present could have an authoritative viewpoint toward the past which he did not regard as established by Wölfflin's empirical generalisation or Riegl's psychological theory, and he followed Hegel's project of tracing in the visual arts an analogue of discursive rationality. Three problems in particular, which were treated diffusely or simply unthought about by Hegel, were here given a very clear focus: first, the relation between the ideal of a systematic viewpoint and the detail of historical inquiry; second, the relation between the concepts of the general theory and the infrastructure of particular works; and third the relation between images and concepts.

PART ONE

I

THE PROJECT

i. *The Retrieval of the Past*

When we would treat of an excellent work of art, we are almost obliged, as it were, to speak of art in general, for the whole of art is contained in it, and everyone may, as far as his abilities allow, by means of such a monument, develop whatever relates to art in general.[1]*

GOETHE's remark may be given narrower and more extensive meanings. It may be taken to assume some underlying norm for art in a restrictive academic way, or to be intimating that our perceptiveness with regard to a particular work involves our reflection upon art in general and its role within the mind's education. There is no reason to believe that Goethe was here concerned to distinguish the two. But it is a distinction which becomes crucial for the critical historians, for it involves the problem of how we regard the diversity of the art of the past, and how we regard it as retrievable, as more than an object of archaeological study.

'If', wrote Karl Schnaase in 1834, 'artistic form depends upon religion, how can we Christians . . . accept antique heathen forms?'[2] Schnaase was not concerned that we could not imagine the past, but could not participate in its art—make it a serious part of our own lives—if we did not share the beliefs and purposes which that art originally served.

The problem emerged in the generation before Hegel, in its clearest form in Herder's essay on Winckelmann of 1777. Herder challenged the idea that Egyptian art should be judged by Greek standards. The Egyptians did not produce their art for the Greeks and they did not produce it for us. It served, said Herder, their own funerary cults which gave meaning to each gesture. Herder made great play with the puzzlement which we may imagine an Egyptian to have had when faced by a Greek warrior who never released his weapon or an Aphrodite who never finished getting out of her bath.[3]

*The German of translations quoted in the text is given in the notes.

What Herder pointed to was the way in which the products of one society were conditioned by the purposes and ideas of that society, and that its purposes may not be ours: 'it would be manifest stupidity to consider yourself to be the quintessence of all times and all peoples'. Herder did not deny that men in different times and places shared a common humanity, but 'only the Creator can conceive the immense variety within one nation or all nations without losing sight of the essential unity'.[4]

This variety of human societies and the corresponding variety of their arts did not, for Herder, imply that someone from one culture could not understand the art of another, and understand it as art. He wrote of Indian art, that it was the memorial of a philosophic system which belonged to the culture of the Ganges, but however unlike the European art with which his readers were familiar, he believed that it was nevertheless of interest as art and not only as evidence of that philosophy. And in the essay on Winckelmann he said that the sculptor would recognise the skill and vitality of carving in a strange work, about which the antiquary could tell him nothing.[5] For Herder the notion of art was in some way a constant, but no one art could be a standard for all art. And this was the starting point for subsequent critical writers.

Among them was Karl Friedrich von Rumohr, about whom we shall say more later. In 1827—fifty years after Herder's essay on Winckelmann—he wrote that the figurative arts obey general rules, but if you take one example to provide the rule, other possibilities are improperly excluded.[6] He was here perhaps recalling Kant's dictum that earlier art is exemplary without providing a rule for later artists.[7] But this presented a problem: the more firmly you attached a work of art to the concerns and purposes of the society in which it was produced, the firmer the separation from the purposes and concerns of those elsewhere. And this is the problem which was expressed by Schnaase.

At first sight it might seem that provided the interest of a work was not reducible to the functions which it served or to the symbolism it exhibited—provided we could appreciate the artistry with which symbols or rituals were elaborated or celebrated—we outsiders could have access to the work. But appreciation of the artistry of a work, enjoyment of the way it transformed its ritual or symbolic material, does not enable us to overcome the problem of

cultural difference expressed by Schnaase; for this is the problem of how we can make a work of art, which is in part constituted by beliefs which we do not share, part of our own mental life without some inward treachery or mental schism. It is inadequate to reply that we can respond to the artistry, for the artistry would be trivial if we separated it from the subject or function which it elaborated.

Let us take an example. Someone who is not a Christian is shown a painting by Rubens (Plate 3) and is told that it is an altarpiece—so a focus of prayer and meditation—which depicts the crucified figure of Christ which is being pierced by the spear of a passing horseman to see whether he is dead. Would pointing to Rubens's artistry, to the way we are disorientated by the ordering of the figures as if we were caught up amid them, or the way we are led to feel the casual cruelty of the rider's spear thrust, give the painting the force it had within the framework of Christian belief?

The real problem is how the interest of the painting—its subject and the ritual of which it is a part—can be seen in a way which would neither assume that the outsider held beliefs he did not hold, nor treat the subject and ritual as a mere occasion for the artist's virtuosity—and so trivialise it.

What is required, someone might answer today, for the alien spectator to have a serious involvement with the art of a culture which he did not share, is a preparedness to learn—a preparedness to exercise a sensitivity which his own immediate culture did not demand or make possible, so that he felt his own beliefs and imagination under pressure. Other people's beliefs do not have to be genuine alternatives for us, that is, they do not have to be part of a way of life or belief system that we may really adopt, for us to be exercised and involved by them or by the art embedded in them.[8]

But this is not to meet the problem raised by Schnaase in the early nineteenth century any better than saying that one can at least recognise the *artistry* of alien works. For learning about another culture and sensitising yourself to its art already presupposes that you have a cultural institution of such learning, rather as the Aztec priests, as part of their religious culture, had a negotiating mechanism for dealing with conquerors whose religious systems were different.[9] They assumed that at least there would be someone corresponding to a priest or spokesman and if they submitted with respect to some religious practices they would be

allowed to keep others. It is a crucial factor in the work of the critical historians—but under internal rather than external pressure —that they had to forge just such a mechanism, to devise ways in which they could extend their sense of art beyond its inherited classic or Gothic norms—norms which had become a second nature through education, convention and religious involvement.

What was needed was a way of adapting their understanding of one kind of art to the understanding of another, as in seventeenth-century France de Piles demonstrated that the concept of unity, which was attached by academic theorists to the work of Raphael and Poussin, had its equivalence in the art of Rubens and Rembrandt.[10] But what was involved was more than piecemeal adaptation, it was a way of conceiving art which would allow identity to be traced through wide variations of cultural institution.

Here we should perhaps anticipate how this new way of thinking about art developed. There were three stages: the first was the view, like that of Winckelmann, which accommodated alien art only as a deviant or as a precursor of the writer's own norm. This was enriched by allowing different criteria and so different norms, as when Hegel makes Greek art a supreme exemplification of art yet allows later art a greater status as an expression of the mind's freedom, or where Germans identify Gothic art as their cultural heritage while still assuming the paradigmatic role of Greek art. There was then a third stage in which a general conception of art was constructed, of which particular arts were seen as modes or manifestations. In this last stage, rather than seeing earlier works as partial expressions of an ideal to which the writers themselves subscribed, continuity with the sensibility of the present was maintained by the concept of a universal artistic purpose shared by past and present. That purpose was seen in the way art exhibited the mind's freedom.

ii. *Composition and Composure*

The notion that works of art, like thought, exhibited the freedom of the mind was not itself novel. In earlier theories, both in antiquity and the Renaissance, two senses of freedom had been associated with art. For convenience we might label them the constructive sense and the ethical.

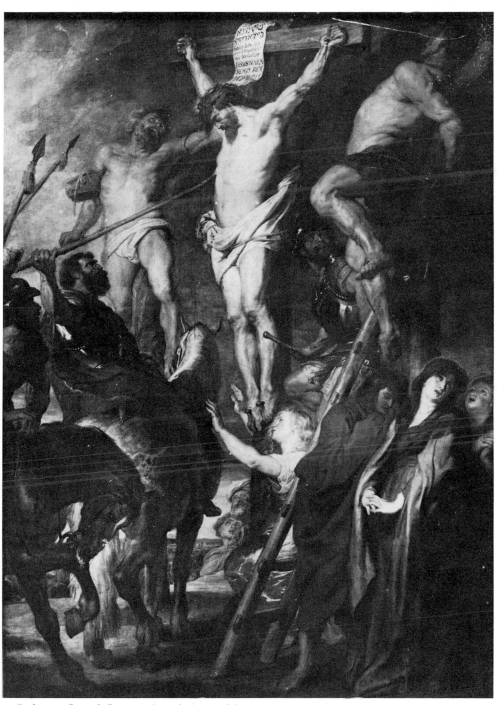

3. Rubens, *Coup de Lance*, 1620, Antwerp Museum.

The constructive sense of freedom may be understood as the artist's selectiveness with respect to the subject he represents, or as his articulation of the subject's latent structure, and would include his fluency and the way he prevented the interest of any one part disrupting that of the whole. It would include Alberti's account of the artist's control of his subject matter, the subordination of figures to the story they enact (as opposed to indulging in an accumulation of unordered interests and devices) as well as their co-ordination in a coherent spatial effect.[11] Similarly it would include Aristotle's prescription for the consequentiality of the action in tragedy, as opposed to a mere collection of episodes.[12] This theme of the artist's control over his material continues into the aesthetics of the eighteenth century, and Schiller was only adding a new emphasis to traditional views when he said that the artist must not be imposed on by his material, that the more imperious the subject matter the greater the artist's need to subsume it within an order of his own making.[13] Correspondingly there was the demand that the spectator should not scratch away to extract the detail which the artist has woven into the fabric of his work. This then is our first notion of freedom, the freedom exhibited by the artist in command of his material, composing and controlling pre-existent elements and absorbing them into his own formulation.

The second of our two senses of freedom is ethical. To be clear about this we can at first disregard art altogether. It is the sense of autonomy or inward composure in the situations which confront us. What, in classical theories, would be achieved by the exercise of self-control; appreciating one's own limitations in relation to the gods, or to society, or in comparison with other men, and then acting accordingly. It would include the objectives of Plato's and Kant's and Freud's regulation of the parts of the mind to each other, Stoic submission and Epicurean detachment.[14] Freedom, in the sense of inward composure, had been associated with art in several ways since antiquity.

But the two notions of freedom—as composing and composure—came into a new kind of combination in the late eighteenth century, in Kant's aesthetics. They became joined so that the constructive procedure of the artist, the first sense of freedom, was conceived as bringing about the second, an inner composure. And in this way the role of art was seen as overcoming our ordinary relations to the world.[15]

It was not the purpose of Kant himself to produce so crucial a position for art. He prepared the way for it by the sharp division he made between human life as free insofar as man exercised Reason in moral thought, and unfree insofar as it was part of the system of nature governed by the laws of cause and effect, laws which constrained inward feelings and material states. This division between man as part of the realm of Reason and as part of the realm of Nature left feeling cut off from our moral sensitivity, our true 'rational' self cut off from sensuous life. It is this sense of our situation to which the critical writers responded, seeing art as overcoming the division. The following quotations are representative.

Hegel, early in his *Aesthetics*, wrote:

The universal and absolute need from which art springs has its origin in the fact that man is a *thinking* consciousness, that is, he draws out of himself and puts *before himself* what he is and whatever else is . . . Man does this in order, as a free subject, to strip the external world of its inflexible foreignness and to enjoy in the shape of things only an external realisation of himself.[16]

Hegel's view of replacing a world he merely confronts with one which he has constructed is echoed, if in a lower key, by Gottfried Semper thirty years after Hegel's death:

Man is surrounded by a world full of things which are amazing and powers, of whose laws he has intimations but can never unravel— intimations which reach him only in occasional fragmentary harmonies; while his sensibility is kept in unresolved tension, he conjures up for himself, in play, the perfection which he misses; he builds in miniature a world in which the cosmic laws appear before him . . . self-contained and in this respect perfect; in this play he satisfies his cosmic instinct.[17]

In a remarkably similar way Riegl, forty years later, was to write:

All life is an endless altercation of the individual 'I' with the surrounding world, the subject with the object. Man, in a state of culture, finds a purely passive role toward the world of objects by which he is completely conditioned impossible, and he sets out to regulate his relation to it, to make that relation one of independence and autonomy; he does this when, by means of art (in the widest sense of the word), he seeks another world which is his own free creation, to put beside the world which was none of his making.[18]

But it is not only in such programmatic statements that the contrast of art and our ordinary unredeemed relation to the world is to be found. It is also present in such moves as isolating an autonomous visual root of artistic style, which is treated as independent of the conditions imposed by the surrounding culture, or seeing the role of art as overcoming fear and superstition, as Burckhardt and Warburg were to do.[19]

The conception of art as a way in which we achieve a new freedom in relation to the external world carries many echoes from earlier writing—most clearly echoes of neo-Platonic writing on beauty. But the distinctive force given by the critical historians to the relation of art and freedom, their sense that through the composing of the artist an inward composure was reached, constitutes a crucial break with the thought of earlier writers on art. This can perhaps be brought out by contrasting their views with those of Winckelmann, the most important of their eighteenth-century predecessors.

Winckelmann's conception of the way art was associated with freedom might at first seem close to that of the critical historians, but there is an important difference. For Winckelmann, freedom is associated with art in three ways: there is the freedom of society which encourages the development of art, as well as the freedom involved in the artist's fluency and the composure of the represented figures. The first two make possible the central content, the calm grandeur of the figures of antique art. The political freedom is a condition of the development of a serene sensibility, which is, in turn, needed for developing artistic fluency. But art itself is not, for Winckelmann, the release from the constraints of politics, or from a gloomy temperament, or from awkwardness in drawing. Overcoming these is a condition of artistic performance.[20]

In the next two sections of this chapter, we shall examine in outline the two theories of art which were to be implicit in the thought and conflicts of the critical historians. The first is that of Kant, and the second that of Schiller—who adapted and made radical revisions to Kant's position. The critical writing which forms the main topic of this book could almost be defined by the way these two theories—together with Herder's sense of cultural variation—were taken up in writing the history of art.

iii. *Kant*

It was Kant's development of the Cartesian dualism between mind and matter that had precipitated the call for art to re-unify human personality, or at least to console the mind in its confrontation with the material world. But Kant himself had also turned to the problem of the mind's freedom in the realm of sensuous material. He had not only given definition to the problem but worked out a model of its solution. It might seem, at first sight, that Kant could have no room for freedom of any kind within the material world, for in his account the material world was governed by laws of cause and effect and this would seem to exclude the possibility of acting freely. But Kant conceived freedom of action to be possible because he also held that the structure of the material world, its articulation into objects with properties which were joined together in causal connection, was something the mind itself had imposed on a world it could know in no other way; and that outside the limits of the natural phenomenal world, on which the mind had imposed that causal system, there was a 'self' which the phenomenal world could not include[21] (in the way the camera lens does not appear on the television screen or the way the seeing eye does not appear as an object in its own sight). The left-over self was free and could act out of pure rational reflection, unimpelled by mere natural urgencies, and it could itself initiate impulses which would figure upon the screen of the phenomenal, causally ordered world. It was this pure rational consideration which Kant regarded as employed in our moral self-government: by making moral thought govern our intention we could act freely.

But where, within this scheme, could Kant find space for an *aesthetic* judgement which exercised the mind's freedom?[22] Kant saw the possibility of this in the way we might take satisfaction in the relation between, on the one side, an array of sensory material which confronted the mind and, on the other, the mind's own ordering procedures. That fittingness between the sensory material and the mind's ordering procedure was something which the mind itself sought and took delight in finding. Now it may be objected that in Kant's view of the functioning of the mind, the material received by sensibility was always combined by the understanding, because that was a condition of ordered experience in general and so there was no further seeking for us to do.

Fittingness between the sensory material and the ordering mind was inevitable. But Kant held that the sensory material was not given structure only by the rules of understanding (which allotted properties to objects and combined them in causal sequence); there were also other structures: we could look across what was presented in experience for other kinds of order, for instance, relations of analogy or continuity through difference. In some cases analogy and continuity would be perceived among features already organised by the understanding; in others, as with musical sounds or mere arabesque patterns, the understanding may not have resolved them into objects but could still search for continuities.

Kant's notion of an aesthetic judgement might well be thought to be in conflict with his general position in another way. For why should concern with analogy, or continuity through difference, not merely be part of our natural response to the world, an appetite like others? Kant's answer was this: the satisfaction we take in the perception of order, that is, the satisfaction in aesthetic judgement, is not satisfaction in the material presented to us. We perceive this difference, according to Kant, if we notice that an aesthetic judgement is held to be valid for anyone; it is not held to be dependent upon something which varied from one individual to another, whereas it would be thus variable if it were a judgement of sensuous satisfaction in the material itself. What gratifies one man's appetite may well be repugnant to another's. We believe that in judging something to be beautiful we are expressing more than a personal preference; we are expressing a sense of rightness which we believe valid for all men because it is based on the nature of the mind itself.

Kant sustains the distinction between the satisfaction of appetite—part of our causally conditioned relation to the world— and the aesthetic judgement's free relation to the world, not only by pointing to the universality of the latter (which would be rather inconclusive) but by the way he relates aesthetic judgement to material objects: for Kant the satisfaction expressed by pure aesthetic judgement is satisfaction in a spontaneous activity of the mind concerned with itself, it is not concerned with the material outside the mind, except insofar as the material provides the occasion for the mind's exercise. When we said of something that it was beautiful, this was not something we said about the object as

an object.[23] The concept of the beautiful, he said, did not extend to
the object, by which he seems to have meant that the object is of
interest only because the mental activity it affords is of interest.
The aesthetic judgement is not—it seems—saying something *about*
the object but doing something *with* it. The mere verbal utterance
'This is beautiful' signals what you are doing and that it is going
well.[24] In this way Kant envisages an activity of mind playing
upon the sensory world yet neither constructing it as an object of
knowledge nor changing it in response to natural urgencies.

Kant himself did not regard the pure judgement of taste as
exclusive to, or as exhausting the interest of art. It was only one of
the mind's functions which art involved; it would be joined by
others like our moral concerns. Unfortunately there was no
intimation in Kant's text of how the play of the mind in pure
aesthetic judgement could be integrated with our interest in, for
instance, the subject matter of a work of art.

One further feature of Kant's aesthetics must be mentioned in
this section, because of its impact on subsequent discussions of art.
It is his conception of the sublime, which involved an exercise of
the ordering mind, when confronted by an array too complex to be
grasped. In Kant's view that experience of the disproportion
between our power of ordering and an ungraspable complexity
may serve us as an analogue for another situation, that in which we
attempt to comprehend something beyond the scope of our
understanding—when we find ourselves attempting to grasp such
ideas as God, Freedom and Immortality which as objects of
knowledge lie outside its scope. Like the pure aesthetic
judgement, this sense of the sublime plays upon an epistemolog-
ical interface of the mind and its objects. In each the mind is
similarly self-absorbed.[25]

iv. *Schiller*

What could be included within the order of art, and how that
order could be related to other concerns, was a problem
recognised even by Kant himself. He allowed that the pure
aesthetic judgement, or judgement of taste, did not comprehend
the whole interest of art; and he acknowledged that the exercise of
the mind in the judgement of taste would soon become boring if it
were not attached to moral concerns.[26] But if we regard art as
identified with an exercise of the mind's freedom we need a richer

sense of freedom than Kant provides to overcome his limiting formalism.

It was this which Schiller set out to give in the *Letters on the Aesthetic Education of Man*. He attacked the Kantian dualism insofar as it identified our freedom so narrowly with the exercise of reason and treated any other relation to the material world as one of subjection. The dualism was re-articulated by Schiller in a series of interconnecting senses, and he tried to show how these should be overcome. The first duality was the simple opposition of thought on the one hand and feeling and perception on the other. He regarded the separation of these as a wound which humanity had inflicted on itself. In Greek culture, so runs his mythical history, a unity had obtained between feeling and thought, but by specialising in different pursuits—including philosophy—men had lost their earlier comprehensive unity.[27]. This ideal of the integrated self and its dismemberment may be demythologised, at least with respect to philosophical thought, in the following way.

Let us assume a state of human affairs in which we do not make a clear distinction between, on the one hand, our thought, and, on the other, our ordinary articulated world and our transactions within it. Let us assume, that is, a flexible responsiveness and projective intelligence towards the world and other people in which thought and feeling have not been divided. What would lead us to isolate *thought* and set it against the world in which we lived? And why should we identify that activity of thought with our essential selves?

First, why should we isolate thought from that fabric of encountering, responding, anticipating? One answer is that our language requires consistency of meaning, and so, insofar as we see our responding and anticipating as exemplified pre-eminently in the use of our language, we direct our attention upon the conservation of meaning from utterance to utterance, and upon compatibility and incompatibility of statements. Just insofar as we are concerned with the consistency of content between utterances we treat them as propositions, as ideal entities. In doing this we transfer our attention from the purposes with which we make our utterances to their strictly propositional content. Here we set thought in language with its regularities against the flux. This seems in line with Schiller, at the beginning of the *Aesthetic Education*:

In order to lay hold of the fleeting phenomenon, he [the philosopher] must first bind it in fetters of rule, tear its fair body to pieces by reducing it to concepts, and preserve its living spirit in a sorry skeleton of words. Is it any wonder that natural feeling cannot find itself again in such an image . . .[28]

And in *Naive and Sentimental Poetry*, he wrote:

The understanding of the schools, always fearful of error, crucifies its words and its concepts upon the cross of grammar and logic, and is severe and stiff to avoid uncertainty at all costs . . .[29]

Insofar as we see our thought as the way in which we control or keep check upon our world, we not only need the consistency of thought but economy and orderliness, and so we look for general principles. We then regard that consistency and those principles as our active self, bringing the flux of things under control.

But consistency becomes a constraint if it leaves sensitivity unexercised or evidence unexplored. Insofar as we identify the freedom of the self with our reason, 'we need,' Schiller says in Letter XIII, 'to preserve the sense of life against the *encroachments of freedom*'. We could lose our freedom not only by being inundated with sensations or carried away by feeling, but also by vesting our judgement in some general rule. With our finite minds our rules may always be too narrow.

What Schiller is arguing for is a redefinition of what constitutes the judging self. The self cannot be handed over to any rule or system of belief which we already have, or which we might have, any more than it can be regarded as the mere locus of urgencies and sensations. 'The mind,' he says later in Letter XIX, 'is neither matter nor form, neither sense nor reason.' That is the first sense of overcoming the opposition of sense and reason, disengaging the self from identification with either.

The *second* way of overcoming the dichotomy of sense and reason is by ceasing to place the mind's spontaneous activity exclusively in the domain of reason. It is when the mind is at play, he says in Letter XXIII, when it is engaged *aesthetically* with the world, 'that the autonomy of reason is opened up within the domain of sense'. What Schiller means by this is first of all that there is a constructive activity of the mind (pre-eminently exemplified in works of art) through which we weave together elements from the world, by analogy, by suggestion, by relations

which are not those of literal connection. The activity of the mind is no longer Kant's ordering unconcerned with—abstracted from—the character of things ordered. The objects and sensuous stuff of the world are now actively felt for, celebrated and elaborated upon.

The *third* way in which the duality of reason and sensation is understood is as the opposition of actuality and potentiality, our actual condition and an ideal we set ourselves. In a work of art, in Schiller's view, we overcome the responses which the material or subject matter most readily precipitate; the construction of the artist enables us to reflect on and evaluate the material, even to evaluate it in reciprocally curtailing ways. By virtue of the play of the imagination the actual is set in the context of the ideal, by which Schiller means that the actual is seen from the most comprehensive viewpoint. Thus when Schiller talks about the character of different arts (Letter XXII), he observes that each kind of art and each kind of subject matter will tend to involve one aspect of us rather than another, as music will tend to arouse our feelings and sculpture to engage the mind with exactness of definition. The central point is not the character he gives to any particular art but the way he sees the work of the artist as overcoming the limitedness of any art or any subject matter and guiding us towards a more comprehensive attention.

But the ideal of comprehensiveness is not a matter of judgement cut free from behaviour. Throughout, Schiller's concern with aesthetic education is conceived as informing, even governing, our social behaviour. The point is reinforced in the last letter, where Schiller talks of the elaboration of play. On the one hand there may be an elaboration of artefacts beyond the demands of function, and on the other the articulation of our exuberance and feeling by giving it order:

Unco-ordinated leaps of joy turn into dance, the unformed movements of the body into graceful and harmonious gesture; confused and indistinct cries of feeling become articulate, begin to obey the laws of rhythm, and to take on the contours of song.[30]

So elaboration may order and control our exuberance, or celebrate the objects of need, and the two procedures may converge. In particular, both are involved in courtship. For Schiller the

restraining of impulse is a condition of our imaginativeness and correspondingly imaginativeness induces restraint.[31]

Schiller's conception of aesthetic education, and so of art, attaches itself to social behaviour rather than theoretical reflection, and it is this difference of emphasis which, crucially, distinguished Kant's aesthetics from Schiller's and is a recurrent issue throughout the following century.

The aesthetics of Kant and Schiller were not written primarily with the writing of history in mind. Admittedly in the case of Schiller's writing, both in the *Letters on Aesthetic Education*, and subsequently in *Naive and Sentimental Poetry*, there is a sense of historical change. In the *Letters*, aesthetic play is seen as sensitising the mind in a way required for the development of a society which is neither anarchic nor repressive, and in *Naive and Sentimental Poetry* Schiller contrasts the spontaneous art of early nations like the Greeks with later poetry which is marked by modes of irony, or the sense of an ideal world which has been lost. Schiller had seen the naive and sentimental modes of poetry as equally valuable but belonging to different cultural conditions, but the sequence is as much a typology as a history; even the naive can still appear in his own time—as in the work of Goethe.

The central question raised for us by the theories of Kant and Schiller is how they could provide a comprehensive principle for the understanding of culturally diverse arts, in particular *visual* arts.

Within the assumptions of this essay, visual art would, by definition, have to call upon the mind's capacity to analogise—to take some initial material, subject matter or conventional form and modify it by giving metaphoric force to some features, while masking or marking others. An artefact must involve our sense of the initial material or subject being transformed by the artist's treatment in order to fall under our concept of art. If some tribal masks or Renaissance astrological illustrations hardly get into the category of art, this seems quite acceptable. Objects may be drawn upon by artists without themselves being art. But there is a second assumption about art within the present context: it is that the artist's transformation of his material must be something in which we take satisfaction, that—in some sense—it brings about a contentment of mind. Here too, it may be argued, this might well rule out many prized artefacts. But it seems an ineliminable

component of our conception of art that it should involve a sense of well-being. Even Nietzsche—who challenged the escapism of the mind's artifice more directly than any other writer—subscribed to this sense of the redemption of 'pain' through artistic appearance.[32]

II

HEGEL

i. *A Prelude to the* Aesthetics

THE TEXT of Hegel's *Aesthetics* was put together from his own lecture notes and those of some of the listeners. The series was given for the last time in 1828, three years before his death. Throughout his career, the arts had constituted a recurrent focus for his thought, and throughout his *Aesthetics* the main currents of his general philosophy—from his logic to his philosophy of history—make themselves felt. But the *Aesthetics* is distinct in its focus and irreducible to his general philosophy of history.[1]

The figure of Hegel is surrounded by an intimidating aura. His extraordinary conceptual inventiveness involved risk of utter confusion—into which it frequently collapsed. But it also lighted upon parts of mental and social life which had previously been only half acknowledged—including parts connected with art. With Hegel one needs to remain fairly flexible in one's attitude, sometimes following his theory as if it were a fairy story—the mind and its adventures in the world of raw matter—but then the images resolve themselves into sharply focused thought. In this chapter I shall try to make clear the shift from suggestive mythology to critical insight, and extract both of these from his more serious inconsistencies.

Hegel's *Aesthetics* presents two central theories which are contradictory. One addresses the question of how works of art bring about the release of the mind from constraint, while the other is directed at the question of how the art of the past or of another culture can be re-absorbed in the mind of the present. The two theories thus correspond to our two principal questions. The division between them can be traced throughout Hegel's 'Philosophy of Spirit' which claims both to have an absolute authoritative viewpoint and to recognise and accept the distinctive character of past art and thought *without* regarding them as superseded by the present.

In an early work, Hegel wrote:

Just as the works of Apelles or Sophocles would not have appeared to
Raphael and Shakespeare—had they known them—as mere preliminary
studies, but as a kindred force of the Spirit, so Reason cannot regard its
former shapes as merely preludes to itself . . .[2]

Taking as our starting point this passage, we might put a problem
implicit in Hegel's aesthetics like this: Raphael may be able to
recognise his affinities with Apelles, Shakespeare with Sophocles,
and so Hegel might recognise Plato not only as precursor but as
having his own unsuperseded vision. But how can Hegel as a
philosopher have a comparable affinity with Raphael or Shakes-
peare? Philosophy is not writing plays or painting pictures, so the
kind of affinity which makes one artist available and a challenge to
another does not seem to carry across to the relation between
philosopher and the art to which he addresses himself. Artists
adapt, re-interpret and resist the influence of other artists, but how
could a philosopher have such intimate relations with paintings or
plays? How can paintings challenge his thought, make him think
differently? The question is not: how can painting be the object of
discursive thought? but how can painting be *thought-like*, or how
can thought conduct itself in painting?

This question (how can painting, for example, be thought-
like?) underlies Hegel's sense of how the present is to incorporate
the art of the past. For Hegel it was not so much a problem of how
a Christian can assimilate Egyptian or classical art, but of how a
philosopher can assimilate any art into the new culture of
philosophy (into which, for him, Christianity had developed).
How art is thought-like is thus central to the two problems of
Hegel's aesthetics: the problem of the role of the art of the past in
the mental life of the present, and the problem of showing the way
in which art constitutes an exercise of the mind's freedom, its role
in the life of Spirit: 'What [Spirit] wants, says Hegel, is sensuous
presence, but liberated from the scaffolding of purely material
nature.'[3] The aim of art is 'to strip the world of its inflexible
foreignness'—to make the external world into something the
mind can recognise as its own product, but not only as its own
product but its own image; so that man can 'enjoy in the shape of
things an external realisation of himself'.[4]

What gives the world its inflexible foreignness is its lying
outside the mind. For Hegel, as for Kant, human freedom lay in
the exercise of Reason, but for Hegel it was an essential part of that

freedom for the mind to break out of its isolation, the isolation of pure thought confronting the alien world of matter. It is in the nature of the mind that it should be utterly discontent—indeed oppressed—unless it can reach out into the world, unless it can unite thought with the material world. In this way our thinking would be not merely *about* the world, but re-constitute it—so that material nature is 'born and born again of the mind'.[5] Hegel's vision takes up suggestions from Kant: that in the perception of harmonious order we felt the world adapted to our minds, while in the complex orders too great for the mind to grasp—such complexity as was suitable to subjects like divinities and hell—our mind's frustrated activity gave us an analogue of our situation in relation to those things which lay, unknowable, beyond the material world, like God and Freedom. But Hegel conceived of us as having more than an intimation of these supersensible entities; he conceived of art and philosophy as successfully penetrating the world of sense and able, as it were, to come out the other side and look back at it with the comprehension of God.*

Hegel assumed that at each stage of history the mind found itself differently related to the material world, and that at each stage the artist or poet articulated that relation. Works of art:

call forth in the Spirit a sound and echo of the depths of consciousness. In this way the sensuous aspect of art is spiritualised, since in art the spirit appears made sensuous.[8]

What calls forth a sound and echo of the depths of consciousness are objects fashioned by men.

*Admittedly, both Schiller and Hegel (following Fichte)[6] had a conception of the mind grasping the world comprehensively and definitively, that is, absorbing the actual in the Absolute and permeating the material diversity of things with thought. Schiller held that this was an ideal end which we could not attain, and that if we pursued it single-mindedly we should lead ourselves back into a one-sided and insensitive imposition of thought upon the world, caught up in 'the impatient spirit of enthusiasm, which applies the measure of the absolute to the sorry products of time . . .'[7] Hegel was caught up in the impatient spirit. Hegel's *Aesthetics* is a blend of the theology of the incarnation, Kant's sublime and the philosophical ideal of comprehending the world as an ordered system, and to these we must attach a psychological image of the world reaching for its consummation in being known.

ii. *The Historical Stages of Art*

Let us now turn to specific ways in which Hegel regards objects as
sending forth echoes of the spirit. In early symbolic art, when the
mind or spirit has unclear intimations of its own nature, when it
cannot fathom how divinity and the material world can be
integrated, it produces objects like pyramids. They are seen as
proclaiming the presence of an inner entity to which the external
structure is manifestly extrinsic:

the pyramids put before our eyes the simple prototype of symbolical art
itself; they are the prodigious crystals which conceal in themselves an
inner meaning . . . the shape *for* an inner meaning remains just an external
form and veil.[9]

At the other end of the history of art lies the opposite type of
architecture, the Gothic cathedral. Here mind has overcome
matter, and this finds its visual image in the dominance of the
interior with its connotations of inwardness, and so of Spirit,
over the exterior of the building (Plates 4 and 5). This
contrast of pyramid and Gothic cathedral is usefully taken
together with Hegel's account of sculpture. Corresponding to the
pyramid are such images as the human figure (Plate 6), 'so
represented that it has the inner element of subjectivity outside
itself, and so cannot unfold itself into free beauty . . . the inner life
of the human form is still dumb', mind is exterior to it.[10]

 In classic art the Spirit or the Idea reaches a point at which it can
find adequate embodiment, the exterior form can be eloquent with
life (Plate 7). At the core of Hegel's view here is the way in which
the human form was seen as the natural expression of the mind in
the world of sense:

physiology should have made it one of its chief propositions that life
in its development had necessarily to proceed to the human form as the
one and only sensuous appearance appropriate to Spirit.[11]

One can perhaps bring out Hegel's point by saying that classical
sculpture could use the poised and mobile human figure as the
expression of matter permeated by Spirit but pre-classical art could
not; this was not to imply that there were no poised mobile human
figures available, but that they would not have presented
themselves as significant in that early period—they would not
have presented themselves as the image of man's sense of his own

4. Amiens Cathedral, Ambulatory interior.

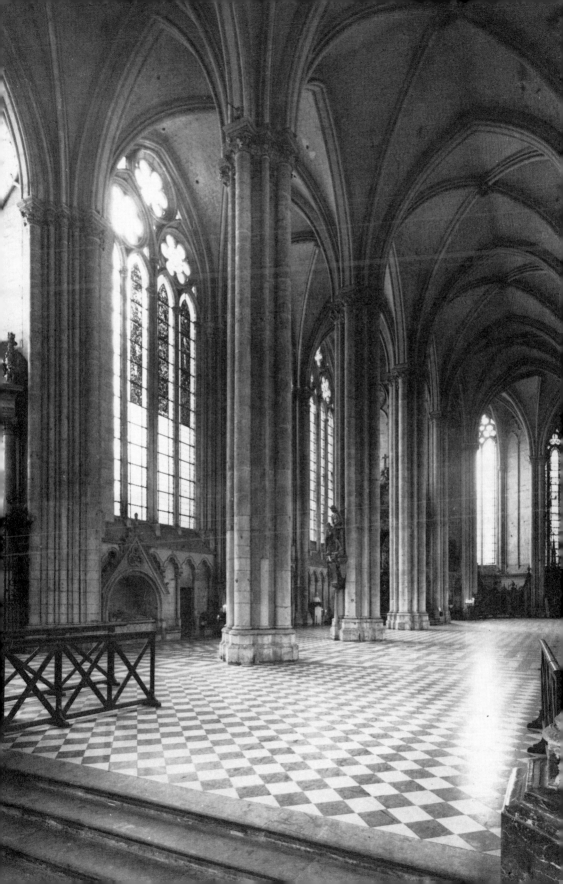

situation, they could not have brought a response of recognition from the depth of consciousness, and therefore could not have served to represent man to himself.[12]

But what was involved in classical art was not simply the pre-established correspondence between spirit and human form—for then no art would have been needed; it was the re-use of human form in art which brought to realisation this permeation of matter by spirit. The human figure re-used in art serves as an *image* just as the pyramid had done. In the case of the pyramid the disconnection between the external shape and the interior was seen as a metaphor for the extrinsic relation of matter to meaning and Spirit. In the case of the classical Greek figure, its mobile human form was seen as representing the *integration* of body and Spirit.

What is particularly important for Hegel here is that the relation between the material object and the perceiver's mind is something of which the perceiver is self-conscious; the perceiver feels an object's suitability for his mind, or its alienness, and this is an essential part of its meaning for him. The mobile human figure is responded to as eloquent and expressive of the perceiver's mind at one stage of the development of Spirit, but at an earlier stage, when the material world was not felt to be permeated by Spirit, it was immobility and ineloquence which was expressive.

The way in which a work of art is—in this sense—reflexively seen is most striking in Hegel's account of painting. Hegel sees the two-dimensionality of painting as manifesting painting's in-completeness in relation to what it represents, that is, in relation to three-dimensional reality:

This reduction of the three dimensions to a plane surface is implicit in the principle of withdrawing into inwardness, this can be interpreted in a spatial form as inwardness, only by virtue of the way it does not allow externality to remain complete but curtails it . . . In painting . . . the content is the spiritual inner life which can be made manifest in the external world only as withdrawal from the external world into itself.[13]

That is, we appreciate the inwardness only insofar as we see the painting as having divested itself of three dimensionality. And this sense of having deliberately curtailed its physical character is seen as an apt metaphor for Christ divesting himself of his power, particularly apt for scenes of the Passion: '. . . the mockery, the crowns of thorns, the Ecce Homo, the carrying of the Cross . . . For

5. Amiens Cathedral, Ambulatory exterior.

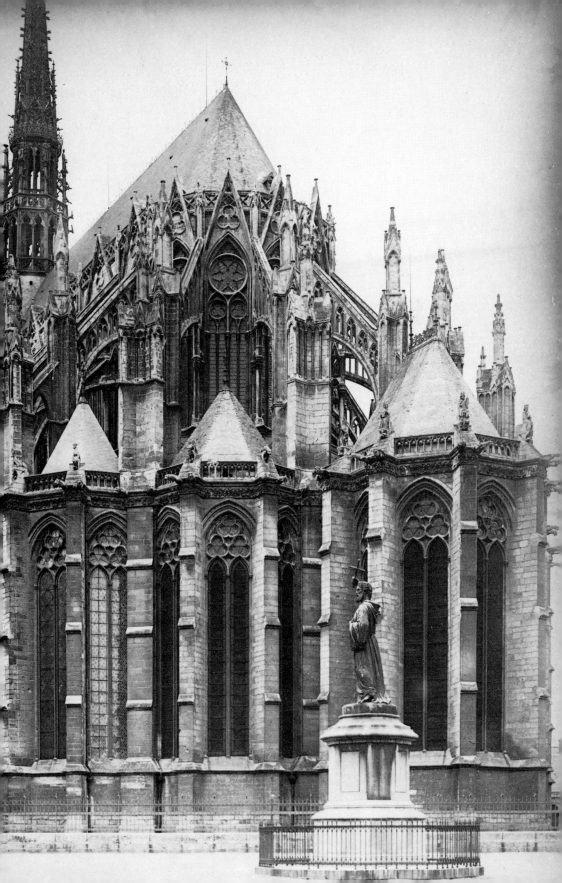

here the subject is provided precisely by God in the opposition of his triumph . . .'[14] But it is not simply that the two-dimensional character of painting can be given meaning as a metaphor of self limitation. The combination of the subject matter which concerns the inner self (Spirit withdrawing from the world) and the limitation of the medium of painting, leads *us*, the spectators, to take on a particular relation to the painting:

By displaying what is subjective, the work, in its whole mode of presentation, reveals its purpose as existing *for* the subject, for the spectator and not on its own account. The spectator is, as it were, in it from the beginning, is counted in with it, and the work exists only for this fixed point, i.e. for the individual apprehending it.[15]

Here Hegel has seized on the way in which painting treats its subject as something seen from a specific viewpoint, and being seen from a specific viewpoint, becomes a theme within the painting. We do not simply look at the subject—which it so happens must be seen from a specific viewpoint—but the fact that it is being seen from a given viewpoint is part of the content. The perception of painting is exemplary of the wider category of 'perceivings', of inward mental life as opposed to external objects.

This treatment of painting as a projection seen from a given viewpoint and so implying the presence of the spectator is elaborated by later writers, particularly by Riegl and Panofsky. Riegl distinguished between those compositions in which the depiction is bound together by its internal dramatic relations, and those in which the presence of someone outside the painting, the spectator, is assumed in order to give the work coherence. Riegl here also drew on Burckhardt's distinction between narrative altarpieces and those in which the figures of the Virgin, Child and saints were there as figures to appeal to—*Gnadenbilder*. But it was Hegel, rather than Burckhardt, who made the implied presence of the spectator part of the content and organisation of the painting.[16]

In this chapter so far we have considered how, in Hegel's *Aesthetics*, objects of sense perception are accommodated by the mind, 'stripped of their foreignness' and endowed with meaning. The meaning is in each case reflexive, in the sense that the way the mind feels itself engaged by the object is part of the object's artistic significance. For example, the way in which the mind, which

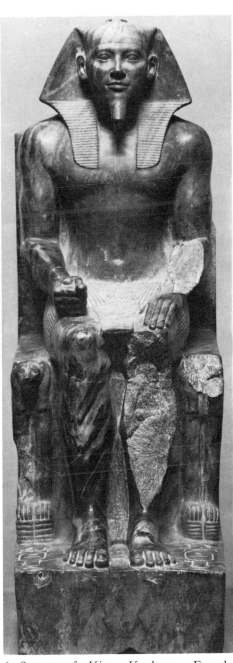

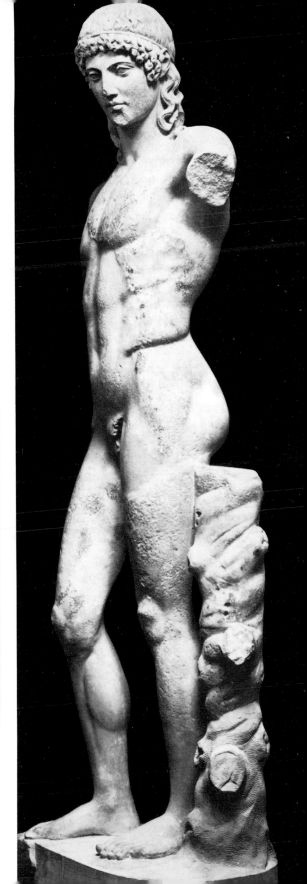

6. Statue of King Kephron, Fourth Dynasty, Cairo Museum.

7. Apollo, fifth century B.C., Rome: Museo Nazionale.

naturally pursues meaning, found the outer form of the pyramid resistant to it and possessing significance by virtue of that resistance—a meaningful meaninglessness; or the way in which the mind found the use of the human form in classical sculpture as an eloquent expression of its own life; or the way in which a scene in a painting was experienced so as to make us aware of the relativeness of our viewpoint. These various forms of reflexiveness are ways in which matter is re-used by mind or Spirit to give it meaning for Spirit. In these ways art is not, in Hegel's phrase, mere cladding for thought.

iii. *The Recovery of Past Art for the Philosophy of the Present*

Let us now turn to Hegel's second major objective in his *Aesthetics*, the recovery of past art from the vantage point, and for the use of the present. Now we might have thought that Hegel had already achieved that recovery by adapting his notions of thought and self-consciousness to different stages of art. After all, any comment had to be from the standpoint of the present, and so, we might have thought, no further feat of retrieval of the past was required.

The reason he thought that there was something else to be done (or, more exactly, the reason he had been doing something else simultaneously in a highly ambiguous text) was that he assumed that the art of the past fitted into a comprehensive system of all the possible forms of thought or Reason. That is, he not only saw the types of past art as fusions of Idea and shape but he also—and at the same time— saw all art in its various forms as manifesting parts of the final Idea, the world in its fulfilment as thought. This means that the Idea comes into the theory twice: first as part of the original relation of Idea and shape, which produces the works of art like pyramids and classical figures, and second when all those matchings of Idea and shape are seen as part of the final manifestation of the Idea, the world turned into a system of thought and carrying the stages of its own development (including its art) vestigially within it.

Hegel's second viewpoint is that of a system which was so perfect that it lacked contingency; a system in which the objects were completely absorbed by thought, where there was no gap between thinking and the thing thought about. So we may

perhaps describe the aims of Spirit in Hegel's *Aesthetics* as one which tries to break out of the abstractness of thought into the sensuous materiality of art, and the other which tries to draw art back from materiality into pure thought.

When we have seen the role of art within the completed system of Spirit, it turns out that all the time the Divine Idea or God or the Concept, underlying and embracing everything, has actually been imposing the content:

> For the Concept does not allow external existence in the sphere of beauty to follow its own laws independently; on the contrary it settles out of itself its phenomenal articulation and shape, and this, as the correspondence of the Concept with itself in its outward existence, is precisely what constitutes the essence of beauty.[17]

We no longer see art as overcoming the material world's foreignness to Spirit, but now as part of Spirit.

It does not seem an adequate response to this paradox to say that for Hegel all art, religion and philosophy were contained in Absolute Spirit, and each had its distinctive role. For it is quite unclear what having a distinctive role could have meant for Hegel, once Spirit had reached the level of philosophy, for the past products of Spirit were not allowed to be external to that final philosophical view. The ambiguity between the view of the Absolute as containing and superseding past art is one which our present concerns do not require us to pursue.

iv. *Rumohr's Response to Hegel*

Karl Friedrich von Rumohr is most often thought of as the founder of modern archival research in art history, the author of a book on cookery and as an adviser on the collection of Italian painting for the Berlin Museum as well as the guiding spirit in the creation of a gallery ordered by subject and school rather than for decorative effect. He was also a serious theoretician.[18] His *Italienische Forschungen*, the first volumes of which were published in 1827, began with a full length treatise on the aesthetics of the visual arts. In passing he was critical of positions which are identifiably Hegel's, and his opposition derived not only from some detailed consideration of weaknesses in Hegel's thought but from a radically different view of art. The contrast of Rumohr and Hegel is sometimes thought of as that between the empirical inquiry into

history and a merely speculative system. But the opposition is more interesting.

Rumohr attacked those whom he saw as still under the influence of Winckelmann for, among other things, treating works of visual art as expressing moral ideas. In an early essay he had attacked the division between the artist, responsible for content, and the craftsman responsible for execution, which had been accepted by Lessing. For Rumohr the work of visual art must be seen as the artist defining his subject matter; the grasp of the object in perception, and the presentation of it in the artist's medium, going hand in hand.[19]

One implication of this is to reject the view that a work of visual art has as its content a non-visual idea, that it is the mere vehicle or amplification of something known in language. The opposition to a view of art as the expression of thoughts or ideas is elaborated in a way clearly aimed at Hegel:

... indeed people are fond of intimations of a higher wisdom and this, veiled in the generality of the little word 'idea', of which the meaning, tottering between the sensuous and the mental, provides opportunity for all kinds of wild assertion, in which all manner of indeterminacy and vagueness is accommodated.[20]

Hegel was concerned to distinguish his view of the role of the Idea in art from that attacked by Rumohr: 'from such a reproof, what we mean by the word Idea is in every respect free for the Idea is completely concrete in itself, a totality of characteristics, and beautiful only as immediately united with the objectivity adequate to itself'.* He insists that in his view the Idea in art is not one which imposes a single academic model nor one which is conveyed by and is separable from its sensuous form.[21]

*Hegel goes to some lengths to confuse the issue. This comes out when, just after his insistence that his own use of the term Idea is not open to Rumohr's objections, he turns to attack a theoretical section of Rumohr's *Italienische Forschungen*.[22] The passage he takes is one in which Rumohr had distinguished three species of beauty: first, that of immediately pleasurable sensations, second the sense of proportions and spatial relations, and third that which works upon feelings through knowledge and intimations of moral character. This, says Hegel, is simply to reduce beauty to effects on our feeling, and Kant has shown that this is unacceptable in aesthetics. (What Kant had in fact pointed out, in the

Rumohr's criticism of Hegel's notion of the Idea in art might at first sight appear to be directed only against what here we have treated as Hegel's second thesis. But even Hegel's more moderate position, that the work of art in its material character enriches the Idea in bringing it to sensuous formulation, would have been unacceptable to Rumohr, for whom the work of art was not merely an embodiment or equivalence or elaboration of an idea, but was itself part of the activity of social and religious life— something ignored by Hegel. Rumohr wrote:

The artistic expression of moral relations . . . can be serious and spring from inward urgency, but it can just as well derive from a gifted outward display of wit; it can as well penetrate the depth of all there is, or play upon the surface of things, pick out the incidental and mock the frailties of men.[23]

Here visual art is seen as responsive to and participating in communal life:

For art . . . is moved by the same laws, the same standards underlie its evaluations, as in every other free activity of the mind. Thus the same considerations must direct our judgement on the merit or demerit of works of art . . . as on the value or valuelessness of other human products. In art, as in life generally, energy, intensity, scope, goodness and gentleness, acuity and clarity about its own purpose make a proper claim on our approval.[24]

And this sense of art as part of communal life is revealed very clearly in his characterisation of Giotto, whose great fresco cycles had not yet been rediscovered and of whose painting Rumohr knew only one panel. On the basis of early anecdotes about

Critique of Judgement §3, was that there were distinct kinds of satisfaction which the expression 'feeling of pleasure' could cover, and we should not on account of that expression think all pleasures the same and constituted by a certain kind of feeling and this Rumohr had clearly not done.)

Rumohr, in the passage Hegel cited, was following Aristotle and arguing that the beauty of art did not correspond to the beauty which the objects represented had in ordinary experience outside art. Artistic taste and natural taste had to be distinguished. We needed to see how each kind of beauty could enter art, and how the work may impart its beauty to indifferent or ugly material by force of style. It is precisely this factor of the artist's taste and style which Hegel ignores in answering Rumohr, and which is the whole point of Rumohr's chapter.

Giotto, he is represented as canny and worldly, and Rumohr associates this personality with the way in which, as a painter, he breaks through older constraints to produce striking and novel dramatic effects. It seems to Rumohr natural that it should be a quick-witted and worldly personality that initiates new procedures and handles the forms more loosely, in contrast to the more reserved and tightly controlled form expressive of piety found in the work of Cimabue and Duccio.[25]

The sense of art as part of social life is underlined in his remarks on his own procedures as an historian: 'Not uncommonly historical relations are illuminated infinitely better by the citing of sources than the most consummate elaboration.'[26] There are two ways in which the distance from Hegel may be remarked on here. The first is the decision to work from the exemplary particular, and the second is in choosing what it is that should be exemplified, and what needs to be exemplified, in Rumohr's view, are such factors as commercial practice in public commissions, the relation of artists to their patrons and contemporaries, and the artists' technical procedures.

When we contrast Rumohr with Hegel there may be a temptation to elide these two factors, that is, to elide Rumohr's working by example and his concern with the social transactions involved in art. But this would be too simple. And we can perhaps make this clear in the following way. We could imagine (and we shall later find) a development of Hegel's conception of art which is highly refined and specific; we could be shown delicate ways in which visual forms interplay with abstract concepts, both as metaphors and instances of those concepts. But however finely and exactly this may be shown through examples, it would still fail to meet the other factor in Rumohr's opposition to Hegel, for it would still locate art as an extension of, or part of, reflective thought rather than social behaviour. The difference between their two conceptions of art, has been anticipated by differences between Kant and Schiller, and the criticism of Hegel was taken up again twenty years later by Anton Springer. It is, however, necessary to turn first to more immediate developments and adaptations of Hegel's thought.

III

SCHNAASE'S PROTOTYPE OF CRITICAL HISTORY

KARL SCHNAASE had attended Hegel's lectures in the early 1820s in Berlin as a student. Unable to afford the life of a private scholar, he became a lawyer. But throughout his life he wrote on the visual arts, his most extensive work being the eight volume *Geschichte der bildenden Künste*, of which five volumes are devoted to the art of the Middle Ages. It is a work richly documented and is quite unlike his first book, *Niederländische Briefe* published in 1834. But it is this early book which is the concern of this chapter, because it provided a model of historical writing which was both ingenious and highly influential. It is the principal transposition of Hegel's thought into the general discussion of the development of art.[1]

Schnaase is remembered for his championship of the Gothic and his romantic attitude toward the Middle Ages, but in this he was representative of a great deal of German writing from the beginning of the century. What is distinctive is his capacity to conceptualise such attitudes in a critical theory and critical procedure.

In his *Niederländische Briefe* Schnaase responded to two difficulties in Hegel's *Aesthetics*; the assumption that past works of art were definitively understood from the point of view of the present, and that art was representative of its culture rather than contributing to it. The way in which he did this dominated one critical tradition for the next hundred years.

i. *The Synoptic View*

In Schnaase's conception of the modern historian's relation to the art he studies, there are three principal lines of thought—the first is the search for a total picture of the past:

Each period contains the totality of human essence, and so each is mirrored in the others, so inevitably the whole realm of art is evoked more or less [by each particular period] . . .[2]

The conception of all periods of art as reciprocally mirrored means

for Schnaase that they are reciprocally *illuminating*, not just that they have a common denominator. To realise this reciprocal illumination, furthermore, the historian must aim at a comprehensive conspectus:

. . . One only understands art in its historical character, if one has a sense not only of its brightest moments, but of the stages connecting those heights . . . the real value of this is a more comprehensive view of the whole, which otherwise would be disrupted by missing components.[3]

The need is to see the whole, the high peaks and the troughs. But Schnaase's notion that the arts of different periods were reciprocally illuminating was not limited to the art of Christendom. His sense of the recovery of the past through the reciprocal illumination of different periods is perhaps best brought out in the following passage:

Our fathers, half a century ago, passed cold and unmoved over the works of the pre-Raphaelite period, the older Italian and Netherlandish artists, as they did the Gothic cathedral. For us, as a repercussion of the rediscovered antique, they have become fully intelligible again, and are as deeply or even more deeply understood than the art of antiquity itself This historical process, and particularly the experience of most recent times, gives us a very sure disclosure about the nature of beauty.

 The understanding of the antique prepares our sensibility for the Middle Ages: but the art of the Middle Ages at its peak leads back to a glowing reverence for ancient art. Each calls up the other, and returns again to itself, thus constructing, as it were, a circular pattern. The puzzlement when confronted by an unlimited number of types of art then disappears, and we see an inner unity in the beautiful, without it being confined to one specific manifestation.[4]

Schnaase has replaced Hegel's conception of a single systematic viewpoint with a conception of the mutual illumination of past arts, a mutual illumination which the present is particularly capable of realising: first because it is in a position to survey more of that past art, and second because it has enriched its own view by comparisons between itself and the work of the past. As we distinguish ourselves and our art from the classical world more clearly, we understand it better, and it in turn can throw more light, for us, on other past art.

 This is unlike Hegel's conception of re-interpreting the past in that it does not assume we have some notion through which the

relations of past arts are *fixed*. On a liberal interpretation of Schnaase's position, it leaves open continued re-understanding and re-interpretation through the fresh comparisons. Some set of general notions may function to alert us to such connections but they do not saturate or circumscribe our relations to past art. Our interpretative vision could be changed for us. Different kinds of experience might bring different aspects of a past art into focus. Schnaase clearly regarded such re-interpretations as developing toward an ideal of completeness which was never reached.

While this view avoids the rigidity of Hegel's systematic viewpoint, it shares with that of Hegel the characteristic of making the retrospective view of the historian a view which is fuller and richer than that which the contemporaries of past artists could have had.

ii. *The Continuous Transformation of Art*

However, there is a more contentious aspect to Schnaase's view of the value of our retrospective viewpoint: the historian's ability to observe not only the analogies between the art of different periods but to observe the transformation of art; the capacity to see individual works or groups of works as part of this transformation, enabled the historian to treat each work as carrying intimations of what came before and after:

I begin to feel in each section of the past its present together with its future. In this way clear and exact historical consideration leads to higher aesthetic realisation . . . which feels in the beauty of each individual period its connection with the others . . .[5]

Schnaase's view of the transformation of art through history might be interpreted as a prescription for seeing works in the context of the tradition upon which they draw, and to which they contributed; in effect, it might simply be saying that we understand a work of past art better insofar as we are familiar with its sources or motifs. But clearly Schnaase was saying something more radical than this.

His transformational view of art makes the links between a sequence of works part of their meaning, part of their substantial interest. The way in which a work is linked to its successors is by reference to the way it deviates from an earlier work in the direction of a subsequent work. Schnaase, in an influential

elaboration upon a Hegelian example, describes, in the development of mediaeval architecture, a conflict between two opposed architectural conceptions: the conception of a building as an object, as constructed for the sake of its exterior, and as constructed to create an interior space. The temple architecture of antiquity was designed so as to be seen primarily from outside, in contrast to the church which was designed as an interior space in which the community gathers. In the development of Christian church building, architectural membrification is adjusted to bring out the sense of space rather than to create a sense of solidity, and the concern for the interior gradually dominates the form, so that the exterior is permeated by the forms of the interior:

. . . ancient architecture was less capable of creating a beautiful interior, because it placed greatest importance on the self-contained, firm forms, defined by circles and straight lines. It was not only the religious and domestic morals of the ancient world which made the interiors of their buildings unimportant, but also its formal sense.[6]

This opposition of emphasis between exterior and interior is treated eloquently by Schnaase as a pattern of conflict and resolution, perhaps the first piece of art history written in quite this way. The central passage warrants extended quotation:

I remarked above, that the beauty of the interior makes demands which are opposed to those made by the exterior, and that because the harmony of both parts is an unobtainable objective, distinct styles emerge from the conflict, in which now one, now the other is dominant. We can see that this is not an accidental deficiency of the architects, but that it is a necessary opposition, in which the historical development of this art is set in motion.

Greek architecture had forms only for the exterior design: for the interior it lacked such forms so completely that in great temples, where the interior space must be more significant, it was left unroofed, like an open court. At a later period, in its Roman adaptation, this was altered; the forms became slimmer, softer, more differentiated, and were drawn gradually into the interior.[7]

The more the interior was developed, the less force the exterior possessed; the self-contained masses of the exterior became gradually more fused, and finally: 'The exterior is completely permeated by the sense of the interior.' And Schnaase talks of the increasing delicacy and homogeneity in the architectural members, and describes the final stages of the development:

The last residue of conflict was dissolved, the whole consisted of individual, clearly discernible members but so similarly formed that nothing disturbed the unity and perfect execution of the perspectival system.[8]

Here he has Antwerp Cathedral specifically in mind, and possibly one of the many paintings of it (Plate 8). Schnaase, having taken the theme, already present in Hegel, of the contrast between the ancient temple and Christian church, has traced—albeit rather broadly—the process of transformation. No such dialectic of form occurs in Hegel's own writing on art.

Schnaase's conception of art progressing through stages of integration is suggestive but confused. It seems to conflate three rather different models of development. The first, and smallest in historical scope, would be the development of a particular building or building type, or single painting, the integration of specific motifs within a single final design of a particular work. This process of integration of a single work is then transferred to the development of a particular genre. Then its importance is extended further, so that the scheme of development is thought to be representative of the transformation of a whole art over a long period.

It is not difficult to see, in a series of versions of a painting, or plans of a building, the artist gradually integrating the component elements—the earlier stages leaving him problems which he later resolves. It is not very difficult, but it begins to require some reservations when we take a series of different buildings or different paintings and trace the integration of elements through them. Here, even when the same artist or architect is involved, we may not be quite so sure that he is regarding his earlier work as unsatisfactory, and that the apparently enhanced integration of his later work does not involve a shift of focus, taking some things for granted which had been focal, and following up intimations felt while producing the earlier work. The assumption that the development from earlier work can be treated as superseding that earlier work becomes even more doubtful when we trace the development of a genre, to which it is hardly plausible to attribute a single sustained purpose. Credibility breaks down completely when a single objective is attributed to the whole development of an art through history.

There is a crucial distinction between the sense of artistic continuity as the resolution of an earlier problem, and the sense of artistic continuity as the exploitation or redeployment of earlier forms. In both cases we see new works as drawing upon the understanding of earlier works but what is being done is different. The confusion between the two is apparent in Schnaase in the following way: he posits a problem right back in the building of Greek temples: 'Where the interior space must be more significant, it was left unroofed like an open court.'[9] Yet at the same time he acknowledges that such building corresponds to a quite different ideal: 'It was not only the religious and domestic morals of the ancient world which made the interior of their buildings unimportant, but also their formal sense.'[10] What Schnaase has done is to compare the later 'solution' with the earlier stage which is then seen as failing to achieve this solution. This overrides the distinctive purposes and interest of the earlier and intermediate stages, and leaves out of account a fact already acknowledged by Schnaase: that the way in which earlier forms are drawn upon will depend in substantial measure on the attitudes and interests which they are called on to serve, e.g. the Christian community as opposed to ancient cults.

A more modest form of teleology could regard the way in which various stable elements like columns, capitals and entablatures are gradually brought to a classic solution in the development of a genre (like the development of the sonnet, sonata form, High Renaissance figure composition or the Gothic cathedral). But having traced the development of the genre it would not regard the interest of individual works to be exhausted by their role in this history. The history of the genre would not claim to be *the* critical account of the works within it. But it is not clear that in 1834 Schnaase had any firm idea of the difference between seeing the series of individual works as part of a single enterprise, and seeing the genre reach a classic stage. That ambiguity was, as we shall see, transmitted to later writers. But, in historical fairness to Schnaase, he can, in his massive history of mediaeval art, be seen as holding the more moderate form of teleology.

When discussing the Byzantine development of vaulting, he speaks of it as 'an incomparable means of realising the essential task of Christian architecture, the construction of interior, to make

it spacious and ordered: an expression of multiplicity in unity'. And then, in a remarkable descriptive passage Schnaase points to the shift in the way domed architecture was used (see Plates 9 and 10).

From the introduction of the dome flowed a consequent transformation in all architectural details. The straight entablature becomes more and more rare, it merges with the capital and then disappears altogether. When the capital has become the carrier of the arch, it has to give up the delicate line of the Corinthian calyx with its light foliage, and in place of it put the stable, correct, but dry cubic form, thrusting upward from below, mediating the circular shaft of the column and the rectangular section at the springing of the arch.[11]

Here Schnaase has provided a model of analysis in which the reciprocal adaptation of components occurs in the light of a general sense of function and a sense of the pursuits of order, of integration. What is of real theoretical interest is that when he comes down to detailed historical examination, the *telos* has become sufficiently general or broad for us *not* to regard each building as of interest for its role in the sequence: we are not hurried forward to the integration of vaulting ribs and piers in later Christian architecture, nor is the straight entablature of the earlier buildings assumed to present a problem from the start.

The view which stands in apparent opposition to the teleological conception of art is one which treats each work as a modification of its sources, without implying any defect in the sources. (This second view is itself open to many variations which I shall examine later.) The earlier works are then seen as offering models and suggestions for further elaboration. But these two viewpoints are not as completely distinct as they may seem, for even the latter, what we may label as the 'source and variation' view, must have some notion of the purpose of change. Furthermore, the less problematic 'source and variation' view may give plausibility to the strictly teleological 'problem and solution' view because two superficially similar notions become interchanged, on the one hand a general objective shared by artists, the objective of a fully integrated work, and on the other the identification of one work (or type of work) with the ideal of integration. The conflation of this general rationale of development with the development of particular motifs is a problem to which later theories will require us to return.

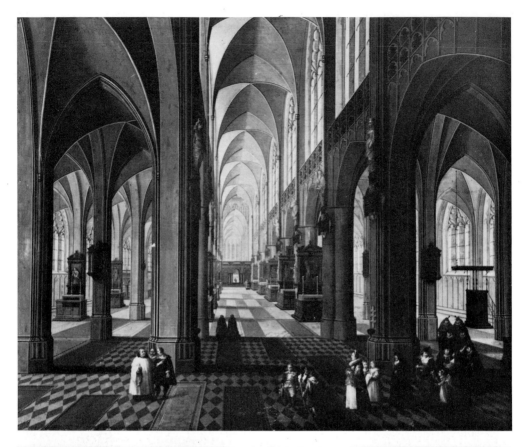

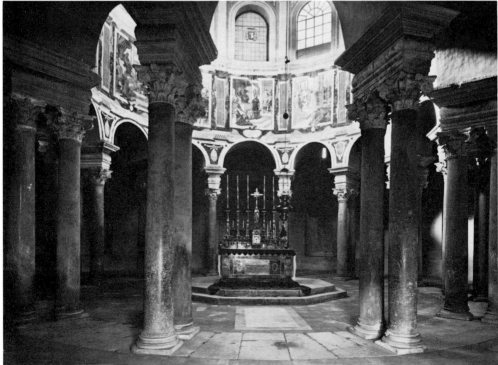

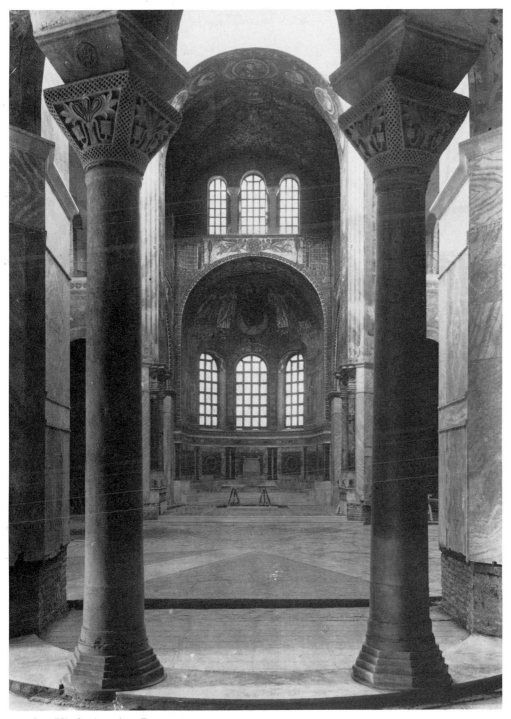

10. San Vitale, interior, Ravenna.

8. (facing page, above) Pieter Neeffs, *Antwerp Cathedral*, c. 1640, Jerusalem: Israel Museum.

9. (facing page, below) Santa Costanza, interior, Rome.

iii. *The Disregard of Function*

The capacity to follow that transformation through the art of the past was one of the ways in which, according to Schnaase, the historian was able to have a fuller understanding than the contemporaries of the art concerned. The thesis becomes enforced by what Schnaase regarded as another privilege of hindsight. This is the view that the contemporary may be so concerned with the function of a work—and Schnaase regards this as particularly the case with architecture—that he misses the aesthetic character, the real artistic import. Clearly this would make the contemporary viewer's disengagement from the original purposes of a building or an altarpiece a positive advantage in understanding it. Later this position was to be explicitly exaggerated, for instance in Riegl's *Historische Grammatik*, where the fulfilling of purpose (*Gebrauchzweck*) or the evoking of ideas or thoughts (*Vorstellungszweck*) is distinguished from genuinely artistic intention.[12]

Schnaase's explicit prising free of the work of art from its functional and symbolic purpose can be seen to enforce a strong reading of his transformation thesis; the strong reading of the thesis is that we understand a work as modifying its antecedents and as carrying intimations of its successors. This way of interpreting works becomes more plausible once their visual form is released from contextual functions and contingent meanings. For then the works can be seen exclusively in the context of each other, and so as progressive modification of each other: the rationale of each can be identified with its role in the developmental sequence.

iv. *Art as Culturally Autonomous: A Response to Hegel*

This isolation of art, and the conception of its autonomous principle of development, is enforced by the way Schnaase responds to that other problem left by Hegel—reducing art to being merely representative of its culture rather than contributing to it.

Schnaase insists that the transformation of art is not simply dependent upon changes in religion—'art is as much determining of each particular state of affairs as defined by it'.[13] He argues against the view, for instance, that the painting of interiors in Holland can be explained simply by the Reformation's banning of

pictures in churches; there were other kinds of painting possible, like heroic public themes. The growth of a new art comes out of something in art itself: 'There must be a ground which lies within art itself, in the nature of development which brings forth the change.'[14] Schnaase regards the autonomy of art as entailing that it has its own independent trajectory of development and yet, at the same time, the development of art is assumed to have a common purpose with the development of religion. That is, Schnaase assumes a pre-existent harmony between the aim of art and religion but with the reservation that the equivalent stage of each may not be contemporaneous, and that both of these modes of mental development are contributory to the man's spiritual development, and that we cannot safely infer a man's piety from his painting.

In his general attitude Schnaase holds onto a Hegelian vision of the trajectory of history: 'History figures forth a progressive series, in each stage of which nature and spirit reach ever purer harmony.' Then Schnaase immediately modifies this: 'Art and Religion stand at the spiritual summit of humanity, but they are in the position of body and mind in man himself. They are complementary, but they stand in opposition to each other; if one becomes too dominant the other suffers, and it is only when they are united at the highest level that the highest form of life is achieved.'[15] But while being complementary, developments in art and religion are separate: 'Thus they alternate in history; one goes ahead and pauses . . . sometimes one is dominant, sometimes the other . . .'[16]

If we contrast Schnaase's position with that of Hegel, what becomes salient is his insistence on the constitutive role of art within a culture. Schnaase seems to have seen Hegel's confusion quite clearly and so has insisted on distinct epicentres of spiritual development. What is of importance for all subsequent theory, however, is that he buys the autonomy of art at the expense of regarding it as having a quite separate logic of development. *To be autonomous is to have a separate history.*

One source of Hegel's inability to cope with the way the visual arts were constitutive of a culture and not merely representative of it, was his conception of art as only properly understood when we see it as part of the single enterprise of Spirit. What Schnaase did was to re-duplicate that single enterprise and single line of

development in another single complementary enterprise and single line: that of art itself. The sense that the autonomy of art required a separate developmental history, in its turn, gave emphasis to the way works were thought to link together in an historical series.

v. *The Convergence of Critical Examples*

There is a further element of the tradition from Hegel which is not so much theoretical as material. The specific contents of art are of the kind developed in Hegel's typology. The opposition between interior life and exterior object quality which had been applied to the human form and to architecture was elaborated by Schnaase. He observes in ancient painting a lack of the interconnectedness of figures:

... The forms remain isolated, scarcely attending to each other, shown mostly in profile or frontally. Groups, when they are concerned with a mere external action, are often arranged with extreme elegance and delicacy . . . But we never find a group in the spiritual sense which makes manifest to us through position, bearing and form their relation to each other, the reciprocity of speech and feeling, the inner bonds of intimate relationship through which the individual isolation is overcome, and shows the whole as forming the spiritual character of a family, a community between members and a unity with their environment.[17]

There are two strands in Schnaase's analysis here: the first is one which observes what was felt to be a fundamental difference between the dramatic character of ancient painting (and presumably relief sculpture) and the painting of the Renaissance, particularly of northern Renaissance painting from van Eyck to Rembrandt. But attached to this distinction between inter-connectedness in Christian art and separateness in antique art is the presumption that this betokens, or is a correlate of, a moral condition—the sense of Christian community as against the mere individualism and the mode of human relations in the ancient world.

 This sense of separateness as opposed to cohesion was also developed in Schnaase's conception of architecture. He sees in the parallel rows of interior columns of a basilican church an effect of, or intimation of, perspective. And he elaborates the idea with respect to Gothic churches: 'These columns are very slim, and

there they appear to stand close together ... to make the perspective effect more telling.'[18] This sense of perspective is made to include a sense of shifting views as we move toward the choir of the church.[19] Perspectival effects are associated by Schnaase with unity and that unity with community:

The parts possess, instead of a direct value in themselves, an indirect or dependent value; now they do not have their effect, as in earlier times, outwardly and in the sense of broad articulated planes, but inwardly, through their interconnection in the spiritual unity of perspective lines. The basic principles of the Christian form of life are therefore given in art; the individual arts tend towards painting, in which even individual things are no longer solid and set one beside another, but serve a higher unity.[20]

Schnaase has made three moves: first, he has distinguished between separate, disjoined objects and things seen in a higher unity; second, he has associated that unity with the unity of perspective; and third, he has associated it with inward spiritual life. (Furthermore, he has co-ordinated architecture and painting although not, in his own theory, contemporaneous architecture and painting.[21])

The sense of the 'interior' in architecture, as a metaphor for mental inwardness derived from Hegel, but draws into the image cluster two elements which Hegel had not connected: the psychological reciprocity of people in painting, which in turn is seen as a connotation of perspective (here thought of as views through the interior).[22]

These interconnecting images reinforce each other and become a central body of metaphor in terms of which art is subsequently explored. The simple starting point of meaning and its sensory vehicle, after being transferred to the body as expression of inward life, has become vastly extended: the inward life has come to correspond to the interior of the building, and its rows of columns to the image of the reciprocity of the Christian community. In the final sentence there is an echo of Goethe's remark that all the visual arts strive toward painting, which seems not so much to add to the content of Schnaase's thought as to signal his sense of reaching his conclusion.

IV

FROM SEMPER TO GÖLLER

GOTTFRIED SEMPER is conventionally seen as representing the opposition in the mid-nineteenth century to the tradition of Hegel and Schnaase. In 1834, when Semper was beginning his career as an architect, he joined in an archaeological controversy; he argued for a much more extensive degree of polychromy on the surface of classical architecture and sculpture than had at the time been recognised.[1] The other view widely attributed to him is that architecture is the product of material, technique and function; it is ironic because his stand on polychromy involved him in arguing that the real material and technique, in what he regarded as the greatest of all art, was more concealed than current aesthetic taste found acceptable. But then Semper never held the view that architecture was the product of material, function and technique.

Semper shared with Schnaase the sense that there was a serious problem about our present understanding of the art of the past. Just as Schnaase had asked how we were to make past art part of contemporary mental life, Semper in his first essay of 1834 surveyed the pastiches of past architecture in modern cities, and asked how it was possible to learn from the past and not merely ape it; how we could penetrate its constructive procedures:

our principal cities bloom like the gathering of a thousand flowers, the quintessence of all countries and all ages, so that we, in this charming deception, finally forget to which century we belong.[2]

But Schnaase and Semper had more in common than a concern about the relationship between the art of the past and the life of the present. Both sought systematic schemes of interpretation for the visual arts, Schnaase was inspired, in *Niederländische Briefe*, by Hegel, and Semper by the comparative anatomy of Cuvier; furthermore both were concerned with articulating the non-literal meanings of visual works—primarily architecture—and to give accounts of the continuity of artistic tradition. They understood these problems in very different ways, but their influences converged to give these three concerns—systematicity, non-literal meaning and development—their centrality in German art historical writing.

There are important connections between Semper and the discussions of design in England in the middle of the century. He came to England as a refugee in 1848 and was involved in discussions with Sir Henry Cole at the time of the Great Exhibition. His major literary activity started then, in 1851, and reached its climax with his major work, *Der Stil* (1860–3).

i. *Visual Meaning*

At the centre of Semper's thought is the question of how artefacts and architecture take on meaning or how they take on symbolic implication. And this problem had practical implications for the architect or designer because the alternative to understanding the authentic procedures for creating meaning was chaos, caprice or the deadness of mere imitation:

The theory of *Urmotiven* and the forms derived from them could figure as the first, art historical part of a theory of style . . . Without doubt there is a feeling of satisfaction when, in the case of a particular work, be it ever so far from its origin, the *Urmotiv* penetrates it as the underlying keynote of its composition: its value for clarity and freshness in artistic effects is in holding at bay caprice and meaninglessness and giving positive guidance to invention. The new is tied to the old without being a mere copy and is freed from subjection to the influence of empty fashion.[3]

Artefacts for Semper take on meaning in several ways, two of which are central. First of all, they take on meaning from the way they are made and the purposes they serve—they take on *meaning* from these, they are not merely the resultant of these factors. Let us follow a series of examples. Semper starts out by considering the elementary procedures which he gathers together under the heading of textiles: the seam, the knot, the band which ties things together, and the wreath:

The series, combining simple and hence still aesthetically indifferent strips together, is indeed the most elementary product of art, the first real intimation of a sense of beauty, of the aim to express unity through multiplicity . . .[4]

What is of particular significance here is that for Semper the sense of beauty involves having a distinct aim, the sense of ordering or combining, which is not reducible to other purposes. In fact, so far no other purpose has been mentioned.

But this sense of ordering is no mere matter of 'formal' or mathematical relations. Semper spends considerable time distinguishing between the way in which unity is produced by a seam, where tension is exerted from either side throughout its length, and the unity of a band which is pulled from either end and binds things together. The unity in each case involves a particular kind of making.[5]

The sense of artifice involved in these different procedures may seem to bear out the image of Semper as concerned with craft, material and function. But it is not with techniques as such that Semper was concerned but with the way in which a technique could become part of a design, the way objects may become 'self-illuminating symbols', that is the way they could draw attention to the procedure of their own construction.

Let us return to the wreath, for it provides an example not only of the way the unifying procedure of its making has its own interest, but of the second way in which meaning is generated, through metaphor:

The wreath is perhaps the earliest example of a serial continuity. As a coronet it continues to have in the art of all periods its old pre-eminence as a symbol of coronation and hence as giving definition to the top of something and in the opposite sense as giving definition to the bottom of something; with the latter connotation it has its leaves pointing downward.[6]

The wreath, for instance, on the neck of painted pottery with its leaves pointing alternately up and down, intimates that the liquid is poured in and out. The device of leaves pointing alternately up and down is also used at the base of an Ionic column to intimate the opposition of forces.

The transference of motifs from one material to another and one context to another in this way is a central element of Semper's thought. In the most elementary form of building he distinguishes the hearth, the roof, the floor and space dividing screens. This last function he conceived as initially performed by the use of textiles, either by a plaited fence of by hanging drapery; and he regards all subsequent wall forms as retaining intimations of that original mode of screening or dividing space:

As wicker-work was the original [form of enclosing space], so later, as the light matting is re-constituted in hard earth-tiles, bricks or ashlar, it

retains in practice or in conception, the whole of its old meaning, which is the real essence of the wall.

The woven fabric remains the wall, the visible division of space. The masonry behind, often very strong, is concerned with necessities quite other than the division of space, for securing the support of the roof, for greater permanence and the like . . . and even where the erection of firm masonry is required, it forms only the inner and hidden scaffolding, stowed behind the true and legitimate representation of the wall, the decorated fabric . . .[7]

Semper has been concerned to direct our attention back to the most elementary techniques and materials not because he was concerned with a restrictive historical purism or a literal concern with techniques or materials, but because he was concerned with the way in which traditional forms retain the trace of, and *represent*, earlier structural forms: the way in which the solid masonry may be marked by a symbolic representation or at least the suggestion of the original material. He illustrates the point by citing the outer wall of the Royal Tomb of Midas at Gordion, which he regarded as carrying a textile motif. And excavations from the tomb did reveal textiles containing the pattern to be found on the wall. I am concerned here not with Semper's accuracy, however, but just to elucidate his sense of architectural metaphor.

It is not only central to Semper's conception that techniques can yield metaphors, it is also central to his view that the literal character of material and technique are not themselves objects of our stylistic appreciation unless their potential has been brought out by their handling. The artist may succeed or fail in making a virtue of necessity, and he may even decide not to.[8] Thus, writes Semper, in classical and late Babylonian times:

Silk is not really exploited stylistically; at first it is merely recognised as a material which possesses characteristics present in other materials already in use, and although present in a more extreme way, it does not become appreciated for its own qualities . . . which could serve as the foundation for a new style, and so the basis of a new principle for the art of silk weaving.[9]

This sense of bringing out the latent character, or potential, is an idea which also occurs with respect to ornament, and in particular primitive bodily ornament. Pendant ornaments, such as earrings and noserings, emphasise the strict vertical and by contrast give a sense of grace to the undulations of the body felt in contrast to it,

for instance the fall of the pendant earrings against the curve of a woman's neck. The ornament also conditions bodily poise: pendant ornaments restrict movement; you cannot have your ear or nosering swinging about uncontrolled, and 'the brave red Indian will hold his shoulders more proudly when wearing his decorative head-dress'. Clothes, similarly, both bring out and correct the forms of the body: 'They clothe the naked form with an elucidating symbolism.'[10]

This notion of realisation, of bringing out aspects of the body or material or construction, of imparting value to them, is a recurrent feature of Semper's thought. The notion of realisation or evaluation can be traced in Semper's earliest ideas. In a lecture in 1834, quoted in a biographical essay by his son, Hans Semper, he said:

It is distinctive of the figurative arts to comprehend things not in concepts but in intuitions, and to present what is perceptually grasped in such a way that, without calling upon the activity of the understanding, it can be realised directly in perception by others.[11]

The passage connects Semper's use of *Auffassung*, the artist's perceptual grasp, with Rumohr's use of *Auffassung*, the essential transformation by the artist of his subject. He had just met Rumohr and they were to remain friends until the latter's death.

The way in which factors in a building or in drapery call attention to themselves, the self-illuminating symbol which is not quite a fiction but which dramatises its own presence (or even uses deception to make clear what is really present, as in architectural refinements), is the starting point for Semper's conception of architectural meaning. Where such realisation takes place we already have an element of suggestion; for instance, when the architect makes the ground floor of a building denser, with fewer openings, than the second storey, he will provide a sense of the lower storey being the support of the upper storey:

The stage by stage diminishing of the force implicit in the structural components, as you rise from the ground upward, seen everywhere in better architectural masonry, corresponds at the same time to a principle of beauty and dynamics.[12]

One could illustrate Semper's conception of the coincidence of beauty and physics, of 'inner structure' and 'artistic schema', from an almost infinite range of buildings in traditional European

architecture. One building which seems to offer a particularly
vivid set of examples is Vanbrugh's Seaton Delaval (Plates 11 and
12): for instance the heavy masonry of the basement with its
intimation of compression, and the way the columns of the main
front are divided by horizontal breaks. What Vanbrugh is doing
here is to give the real drums, out of which the columns are made,
a stylistic value. The drum divisions are just visible on the fluted
Ionic columns of the garden front but here they are are not made
a feature, are not given value, do not enter as a motif, do not yet
enter the style. Here we can understand unequivocally what
Semper means by a *self-illuminating symbol*: marking of the real
structure so as to hold it up for our attention; in terms used by
Semper elsewhere, the aesthetic and the structural scheme
coincide.

The architect can mark a real feature, suggest a fictive one, and
doing the latter may well involve masking some aspect of what is
really there, as in the concealed breaks of the fluted Ionic columns
or in a typical piece of mediaeval window masonry where the
supporting colonettes are merely sculptural elaboration cut into
the stone courses.

In sculpture Semper sees the process of masking what is really
present taken much further. Thus, Phidias effaces, as far as
possible, the sense of stone in which he made the pediment figures
of the Parthenon, freeing it of anything but its religious and
symbolic meaning.[13] In his 'Prolegomena' to *Der Stil*, he says
explicitly that in order to become an idea brought to realisation in
appearance '. . . it is not absolutely necessary that the material as
such be a factor in the artistic appearance':[14]

Every artistic production on the one side, and all enjoyment of art on the
other, presupposes a certain temper of carnival, to express it in modern
terms—the carnival half-light is the true atmosphere of art. The denial of
reality is necessary where the form, as a symbol charged with
significance, is to emerge as the self-contained human creation.[15]

Semper's sense of the carnival half-light, the play between the real
and what is suggested, would in eighteenth-century terms already
have been called, as Semper calls it, 'artistic appearance'; the
modern expression would perhaps be interpretative seeing,
looking for a feature or aspect of an object in such a way that
implies that flexibility of the perceiver's mind.

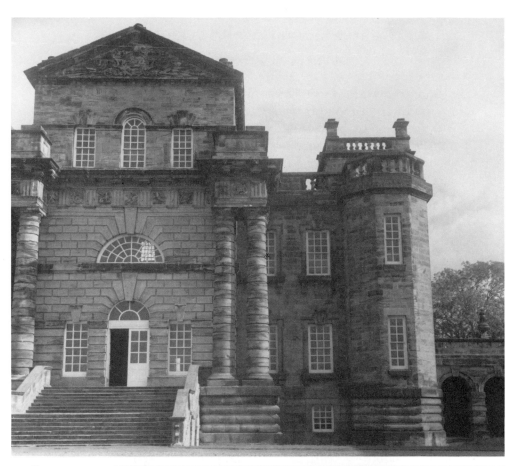

11. Seaton
Delaval House,
Northumberland,
Main Front,
detail.

12. Seaton
Delaval House,
Northumberland,
Garden Front,
detail.

ii. *Fiction and Function*

This sense of fiction and realisation is at the centre of all Semper's theory and yet almost all accounts of his position (with the honourable exception of Schmarsow's) obscure this. In part, this is the result of the response to Semper of Alois Riegl.[16] It was Riegl who set the pattern of later attitudes, and he had this influence in large measure because his confrontation with Semper could be read as the opposition to positivism. In *Stilfragen*, Riegl had said that Semper himself recognised a conception of design over and above material, technique and function, while Semper's followers did not. But in later manuscripts, published now under the title of *Künstlerische Grammatik*, Riegl set out a series of categories for the consideration of style, and having listed technique, material, function, gives two more: that of space and plane, and that of artistic intention; it is to the last two that Riegl gives exclusive attention, and insists 'practical purpose and artistic purpose are separate from the very start'. In Riegl's view even if people discovered symmetry when engaged in construction with practical purposes, this would not mean that symmetry did not also answer an inner need quite independent of those practical purposes. Riegl does not seem to conceive the possibility that those purposes could themselves become part of the import or content of something as art.

Subsequently Waetzoldt, in his chapter on Semper in *Deutsche Kunsthistoriker*, coarsens Riegl's criticism: 'intuition, imagination, formal fantasy, which lie behind all technical conditions and activities, are taken too lightly for their real weight and importance', wrote Waetzoldt. And he went on, 'it is a mistake (on Semper's part) to hold that the factors of function, material and technique are positively creative'.[17] In fact, as we have seen, Semper constantly insists on the freedom which must accompany technical necessity and sees function, technique and material as creative only insofar as the designer or craftsman reflects upon them, evaluates them or gives them metaphorical or analogical force. When Waetzoldt defines the position which he sees as opposed to that of Semper's, that what is primary in art is 'a particular form of feeling', the Semperian may well turn round and say that it is a particular feeling of form, where this may be the sensitivity to the curve of a woman's neck or the sense of order

which the artist can bring about amid the confusion of ordinary experience, and the layers of metaphor and transferred meaning which elaborate and enrich the artist's work.

Such criticism of Semper fails to make the distinction which underlies all his writing: the distinction between *causal conditions of production* (technique, material and function), and the meaning achieved by reflection upon—and amplification of—those conditions, the creative and interpretative freedom with which they were used. Semper's critics are caught in the belief that there is an absolute opposition or incompatibility between the material factors and condition of a work and the artistic imagination, between mental freedom and natural necessity. It is the failure to overcome the dichotomy which has made Semper's thought apparently unintelligible within the context of much German art historiography.

To make Semper a functionalist is no better, for it leaves that crucial division between imagination and material conditions unchallenged. Thus Quitzsch, in many respects an extremely sensitive analyst of Semper's thought, writes:

The opposition [of his position and that of Hegel] makes the main feature of Semper's theory of art quite clear . . . From the basis of his mechanical materialistic position it appears correct that there are certain relations between artistic and natural forms . . . but he does not see the active artistic side. This mechanistic conception reveals itself likewise in his doctrine of the basic [constructional] forms.[18]

According to Quitzsch, Semper fails to understand that it is through the way the human activity alters its material that the beautiful in art arises. Unless he is under the same spell as Riegl and Waetzoldt, it is hard to understand how he too comes to say this.

iii. *Historical Continuity*

Art has its particular language, residing in formal types and symbols which transform themselves in the most diverse ways with the movement of culture through history, so that in the way in which it makes itself intelligible, an immense variety prevails, as in the case of language. Just as in the most recent research into linguistics, the aim has been to uncover the common components of different human linguistic forms to

follow the transformation of words through the passage of centuries, taking them back to one or more starting points where they meet in a common *Urform* . . . a similar enterprise is justified in the case of the field of artistic inquiry.[19]

Semper does not hold that the re-use of a motif carries all its previous connotations with it, but rather that we need to see which connotations have been carried forward, in order to articulate for ourselves what we see: to observe, for instance, that 'all Egyptian graves down to the time of the Pharaohs show the traces of the *Urmotiv*, which underlies them, namely the wall covering of embroidered textile'.[20] The Greek clay dish carries the form of an Assyrian metal plate and that in turn goes back to a common basic Asiatic pottery form.[21] The motif of the censer suspended by chains is taken up in the covering of an oriel window and the canopy of a Gothic niche. He allows that meanings may be lost as the Greeks lost the mystic meaning of the plant ornament, when they developed a formal beauty out of it.[22] And changed circumstances restrict what will be taken over from a prototype: 'Good taste, like good sense, means taking what is relevant and can be integrated with what you are doing. Even the most striking features of your prototype must be left out if they will confuse your work.'[23]

There is some tension between Semper's insistence, on the one hand, that it is by going back to the *Urform* or *Urmotiv* that design can be understood, and on the other that old meanings are shed in new contexts. For if old connotations or meanings are shed and new connotations are taken on, how much of the old meaning is required for the work to be understood and how much must the artist carry forward not to be unintelligible or capricious? Semper clearly does not believe that there is, at any one time, a strict formula of correctness. His argument is rather that the intelligibility and intelligence of architecture and design require that the designer be sensitive to the forms on which he draws and to their appositeness or adaptability to the function his work is to serve. The architect's position is like that of the language user who can adapt vocabulary and syntax by virtue of his understanding of them. Thus Semper talks about the unconscious tradition which carries forward the connotation of various motifs.[24] He does not assume that all designers and architects have been archaeological scholars any more than past speakers have been philologists or

past poets anthropologists aware of the origin of their images. ('The Greek imagination could only have come into existence on the humus of long dead and decayed earlier conditions and strange imported motifs the original meaning of which was no longer known.'[25])

His concern with pressing backward to the *Urmotif* is a concern produced in the particular situation of the mid-nineteenth century. The easy availability of styles, the facility of techniques which can cut granite like cheese, and the separation of designers from craftsmen in industry, makes it necessary to reflect on the stylistic potential of particular materials and tasks (for instance, the way the elaboration of leather calls for a design in flat planes); this sensitivity to materials has been an integral part of the natural spontaneity and freedom that proceeds from a man's hand in working with a particular material.

The conception of an *Urform* of style or design is always, in Semper's thought, a matter of the interaction of a number of factors, and their relations are not absolute; the flexibility is apparent in his account of his basic typology. The four main categories of artefact by reference to which motifs are defined are first *textiles*, made primarily by weaving, stitching and knotting, but extended to mean all types of covering, for instance a metal covering of the wooden core of a statue or the incrustation of a surface with tiles which still have intimations, he thinks, of textile covering. Secondly there was *pottery*, artefacts made by moulding pliable material which dried hard; the central artefact was the clay container for liquid but this category, too, was extendable to different kinds of object and to materials like glass and metal; third *carpentry*, the rigid furnishing structures, which were typically of wood and which were mobile rather than permanently attached to the ground; and fourthly the *construction of walls* which were bound together by the reciprocal pressure of the stone, and, unlike the artefacts of carpentry, were permanently sited, attached to a particular piece of ground. These basic categories connect a material and a function, but Semper does not regard these connections as rigid. 'Most of the products of Art and Industry wear a mixed character and are related to more than one of the above given four families,' Semper wrote in English in a manuscript now in the Victoria and Albert Museum, and goes on to say that 'even the question of material is secondary'.[26]

The *Urmotif* is a product associated with a material, but can be adapted to a new function and to new materials. The sense of underlying working procedures and the classification of materials serves the purpose of overcoming the conventional divisions between types of artefact, and pointing to the underlying vocabulary of forms which they use. His systematic classification is devised to bring out the continuity and variation between them: 'allowing students to see things in their similarities and dissimilarities . . .' he says of his plan for a museum of artefacts.

Semper's view of artistic development stands in contrast to that of Schnaase in a way which corresponds to their difference over meaning: Semper conceives meaning or import in terms of *motifs*, and unlike Schnaase, not as expressive of general attitudes which are evinced in motifs. And Semper's sense of meaning absorbs the sense of skill and purpose which Schnaase excludes. For Semper, artistic meaning involves drawing upon the past and it is, correspondingly, part of the proper understanding of art that one is aware of what motifs have been drawn upon, what it is that is being re-combined or varied in a new work. But there is no presumption by Semper that the significance of a work is to be determined by its role in a developing series, nor to regard some earlier work as having a problem which the later work resolves. Each work is an independent project, however it may draw upon or be partially governed by past usage. The continuity of art history is one of motifs, of vocabulary or the language of visual forms, it is not the continuity of a single enterprise.

The serious pressure on the Semperian viewpoint was first to offer an alternative motivation for historical change beyond the requirement that an artist must rethink and not merely copy, and adapt to changed circumstances, and second to give an account of style which was not just a set of motifs, or modes of treatment of certain materials, but something which shows the motifs in a particular art as linked in a style. These were problems for the next generation.

iv. *The Motif Theory of Style and the Motivation of Change*

The writer who offered both a non-teleological theory of historical transformation and of the interconnection of motifs was Adolf Göller. Like Semper, he sees the architect as taking up and

re-using motifs and transforming them in fresh contexts and with fresh materials. But where Semper's focus had been on the origin of architectural forms, on re-understanding them, Göller's concern is different. He is interested in the underlying motivation for transforming earlier devices and forms and in the nature of the mind's satisfaction in such transformations.

Göller, writing in the 1880s, saw the architect as elaborating the functional features of a building for aesthetic purposes, that is, for the satisfaction of the eye. The most elementary building forms already contained the requirements of order which the architect could respond to and elaborate. The search for order was innate. While the first architecture elaborated basic functional features like the row of supporting posts or roof timbers, as architecture developed through history it became more and more a matter of modifying and re-combining earlier architectural elements. It is in general only the architectural forms of the past, the language which the architect uses, which enables him to generate fresh forms. He can no more step out of his tradition than a child can suddenly speak a language it has never heard.[27]

The architectural motif is in this way something which carries with it meaning from a previous architectural use.[28] But Göller's focus is unlike that of Semper in that it is directed less on the sources and transmission of particular motifs, and more on integrating them and on our restlessness with an order once established:

All formal beauty is in part simultaneous and in part the sequential idea of many such rules (lines, circles, rhythmic alternations, etc.). The more the eye unifies in a configuration, the richer it is, and the primary and most important ground of our feeling of pleasure in meaningless forms lies precisely in this, that in them consciousness grasps a large range of such regularities.[29]

And Göller cites the conventional example of the Gothic use of parallels. This conception of the mind gathering the greatest range of possible orders is couched in a way which derives directly from the psychology of Herbart.[30]

According to Herbart, the mind seeks to unify the discrete features presented to it, to find an underlying pattern or connection between them, and at the same time to assimilate new

experience to the patterns of expectation set up by previous experience; that is, in Herbart's view, we try to unify features simultaneously present and to unify what is present with our earlier experience. And just as a pattern derived from past experience may provide a way of linking a group of currently perceived features (as when hearing some notes as part of a familiar tune we can mentally fill in the gaps), so we take special satisfaction in *new* experience insofar as it helps to link together familiar but previously unconnected experiences or unconnected chains of association. Göller writes: 'through the common component of discrete ideas, a satisfying stimulation of numerous past memory images is brought to mind, like a harmonious consonance of all that is connected in our memory'.[31] Göller gives the example of the way round-arched windows are linked in San Vitale (Plate 10). Two side arches spring from the columns between the openings but lateral supports of the window arches are not columns and coincide with the support of the larger arch in which they are set.[32]

Göller's conception of the architectural motifs and their transformation combines Herbart's conception of the unifying activity of the mind, with a Semperian conception of the transmission of motifs. For Göller, architectural motifs became special cases of Herbartian 'ideas' which enter relations of reciprocal inhibition and fusion. And it is a crucial feature of Göller's theory that our 'ideas'—the forms which confront the mind—can be in conflict not just in harmony with each other— what confronts us may resist integration and conflict with our expectations:

In music the perfect harmony appeared as essential to flawless beauty for the Greeks, in that they found the interval of the third unusable, later ages, in contrast, felt the need for incomplete consonances and even dissonances, and so it was with the [architectural] orders.[33]

Göller's paradigm example is Renaissance art as opposed to Baroque. His book was published in 1888, the same year as Wölfflin's *Renaissance and Baroque*, although an earlier account of his ideas, published in 1887, was known to Wölfflin, who remarked on them dismissively in a note in *Renaissance and Baroque*.[34] Yet in *Classic Art*, Wölfflin talks of the eye as demanding more as its powers of absorption become increased and in a review

written in 1909, when he was at work on the *Principles of Art History*, Wölfflin wrote:

The eye enjoys overcoming difficulty. One must set it solvable tasks, it is true, but the whole history of art is evidence that the clarity of today is boring tomorrow, and that the visual arts can dispense with the partial obscuring of form or confusing the eye, as little as music can dispense with dissonance and an interrupted cadence. . .[35]

This dynamic version of 'motif theory' was to be central to the revision of art historical thinking in the last quarter of the nineteenth century, an important strand in a new psychologism.

Göller had shifted the focus of Semper's theory to the search for order, to the pursuit of richer elaboration and increased difficulty for perception. This pursuit of novelty, of increased elaboration, which had been a standard theme in antique rhetorical theory and which recurs in Alberti,[36] does however take on a new implication in subsequent art history: the focal interest of variation moves from the variety within a single work to the way later work can be seen as the variation upon its antecedents.

PART TWO

INTRODUCTION TO PART II

FOR THE critical historians of the next generation, writing at the end of the nineteenth and in the first quarter of the twentieth century, there was a change both in their attitude to past art and to the connection of art and the mind's freedom. The shift was in part the result of the inheritance from the earlier writers.

i. *Interpretative Vision*

The first and most striking feature of the inheritance was the range of ways in which it offered examples of 'interpretative vision'. It was through the exercise of such vision in the work of the artist, retraced by the historian, that the mind's freedom in art was manifested. This was because it was the way in which the mere material, the material in the sense of subject matter as well as the physical stuff of the work, was subsumed into something of the mind's making. This became the central topic of critical writing. Clearly, 'interpretative vision' had been integral to all the writing we have examined, but it now became much more closely tied to accounts of perception, and to the way our perception involved projection onto the visible forms presented to it.

The first mode of interpretative vision discussed earlier was that of Hegel. He had made our self-awareness of the way we perceived an object an essential part of its meaning or interest as art. This position was still like that of Kant's on aesthetic judgement. For Kant, the mind's self-awareness of its own activity was the content of aesthetic judgement. Hegel greatly enriched the forms which that reflexive relation of mind to object could take on: there was the experience of confronting an object which resisted our search for meaning—when the object's outward form resisted serving as a vehicle for the mind's life; there was the experience of an object offering itself as the natural articulation of such life, and then, at a later stage of history, we have the physical presence of the work being inadequate to the fullness of meaning which it intimated. Such different ways in which a presented object may be accommodated to our perception were to be

elaborated subsequently by Riegl and Panofsky. But they were to be elaborated in a way which called upon much more detailed psychological observation. The characteristic contrast now was between, say, the presentation of forms which appeared self-contained, circumscribed by firm outline, unforeshortened and inviting the minimum of projection on our part, and forms which were suggestive, which elicited our imaginative projection and thus made us highly aware of our own interpretative role. The correspondence between these kinds of perceptual self-awareness and the Hegelian is fairly straightforward: the shift is to much more specific psychological description.

A second conception of interpretative seeing derived in substantial part from Herbart and Semper. It is concerned with the way in which the artist may bring out, or make salient, some aspect of his material, or mask its real character in order to suggest something else; such 'evaluation' of material conceived primarily in relation to architecture, was then carried across into the analysis of painting. The transition from the sense of order in architecture to the articulation of the structure of painting is a major element in the difference between the earlier and later critical historians.

ii. *The Problem of Painting*

While architectural history had the obvious advantage, parti-cularly in classical and mediaeval styles, of a recognisable range of architectural members and correspondences—one could trace a classical column within the morphological fusion of some elaborate pier—painting had always been more difficult. While Goethe might remark to the uninitiated that the sculptor went about shallow relief, deep relief and sculpture in the round in different ways, or that if the figures of Leonardo's *Last Supper* got up they would have difficulty in finding enough space to sit down again, his description of the composition is limited to remarks on gesture and grouping.[1] What critical writers of the late nineteenth and early twentieth century discovered was, among other things, a way of showing non-literal order in which the depicted figures of the composition could be reconstituted, and doing so in a way more sustained than hitting on occasional metaphors for visual effect.

The problem of the discussion of painting as it confronted the

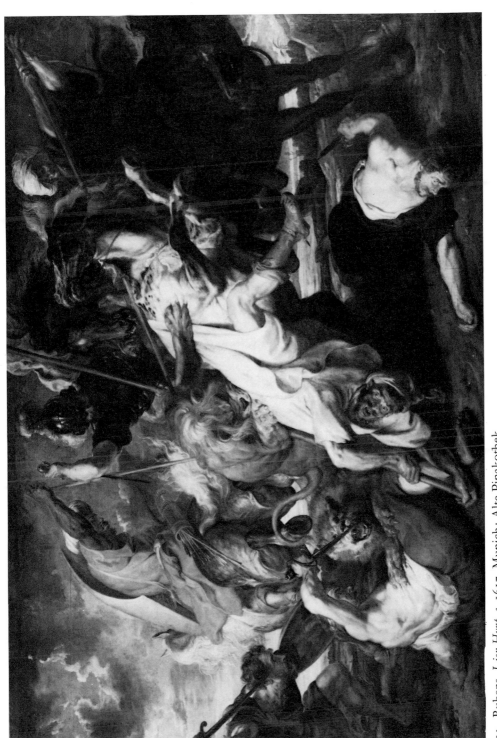

13. Rubens, *Lion Hunt*, c. 1617, Munich: Alte Pinakothek.

critical historians of the next generation may, perhaps, be brought out more clearly by looking at the late writing of Burckhardt, who died in the last decade of the nineteenth century but before the 'new criticism' of painting had developed. He writes of Rubens's *Massacre of the Innocents* as 'one of the most powerful examples of concealed symmetry and the secret operation of equivalences'. The remark is aimed to overcome a merely literal interest, and follows a much more detailed comment on the *Lion Hunt*, resonances of which we are assumed to have in mind (Plate 13). That description had started: 'In the Munich *Lion Hunt*, that incredibly instantaneous moment composed of seven men, four horses and two lions . . .'[2] and before we finish reading the sentence we have to stop, for Burckhardt is forcing us to take on the difficulty of keeping the whole configuration in mind and in detail, insisting that we do not allow ourselves to miss the components compressed into the composition.

In his account of *Carrying the Cross* (Plate 14), the sense of hidden symmetries is implicit but not focal:

The force of movement is powerfully and tragically blended with one of the great moments of the passion, and here Rubens has carried emotion to its climax in an absolutely original way: this is the great *Carrying of the Cross* in the Brussels Museum . . . the work is known in four stages . . . and at every stage the story becomes simpler, more powerful and more terrible. The spectator is made part of the long and patient suffering, the procession moving up a steep and narrow mountain path, seen from behind, but in such a way the main figures turn round and face forward. It is only in the last, maturest version that St Veronica, the women of Jerusalem with their children, and one of the soldiers holding up the cross, all grouped round the swooning Christ, form that almost symmetrical mass of light in the middle of the picture . . .

Rubens was no more able to evade the horrors than his famous Flemish predecessors in the fifteenth century when commissioned to paint the martyrdom of saints . . .[3]

The distinction of Burckhardt's criticism here is surely, in part, that he has composed an evocative description, the sequence of which leads us to hold the whole picture in mind. But despite the evocativeness, we could hardly use it as a model to develop some more general preparedness for looking at paintings—a general preparedness which would enable us to avoid falling into mere literalness or literariness.

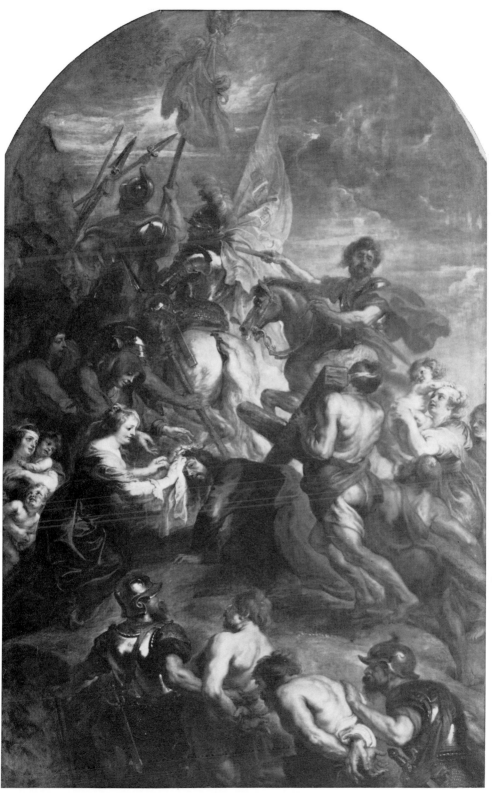

14. Rubens, *Carrying the Cross*, *c*. 1634, Brussels Museum.

This preparedness, this sense of the way the subject matter of painting was suspended within its own prosody or grammar, the way the artist's materials on the one hand, and represented subject matter on the other, interplay to produce its own distinctive order was developed on the basis of a critical model introduced initially by Adolf Hildebrand. In *Das Problem der Form in der bildenden Kunst* of 1893, Hildebrand analysed the way in which the planes of classical shallow relief could provide sufficient perceptual cues to represent figures, and at the same time to sustain their forms within planes parallel to the surface of the block. The relief artist was thus seen to select some features of the represented figure subject, to suppress others and in so doing to articulate the block itself in a series of parallel planes (Plate 15). This reciprocal relation between the artist's material and his subject was developed with reference to painting, for instance, by Wölfflin in considering the difference between a linear and planimetric style, in which line was used to bring out the continuous edge of objects and their dominant forms arranged parallel to the picture plane, as opposed to a painterly style in which patches of tone were used to suggest the object, and relations between foreground and background were accentuated. But the impact of Hildebrand's analysis was much deeper than such details suggest: it was to introduce a way of dissolving the categorical distinction between the subject and material of representation.

There was a third aspect of interpretative seeing, which should be mentioned here, although it will not in subsequent chapters be dealt with except in passing. The difference between divergent modes of representation could, without much detailed analysis, be seen to express or respond to certain attitudes to the world. This is present in Hegel and Schnaase, and it is this conception of interpretative vision which recurs, for instance, in the notion that Christian catacomb paintings show the paring away of concern with the body and nature in favour of a transcendent vision.[4] This way of regarding the difference of artistic style will enter our consideration of each of the writers to be discussed, but always as part of more exacting criticism, which does not make the style merely a natural equivalent of some such attitude. In its simple form, style as an expression of stages of world history, it no longer seems to require extended attention.

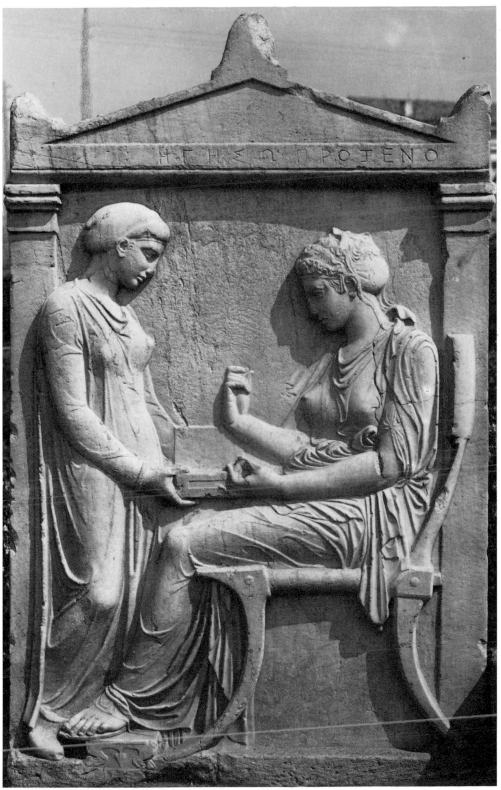

15. Hegiso Monument, *c*. 400 B.C., Athens: National Museum.

iii. *The Self-Transformation of Art*

To the conception of interpretative vision we must now add a second part of the inheritance from the early critical historians. The understanding of the art of the past was assumed to be a matter of understanding the consequentiality of its development. The sense of artistic intention and freedom was perceived in the way in which each artist, or style of art, transformed the work or style of some predecessors. Here one finds that the influence of Schnaase on the one hand, and Herbart and Semper on the other, enforce each other. The past work represents the 'material' to be transformed by its adaptation in the new work, and new material is absorbed and structured by being connected with the art of the past. The attitude was sustained, in part, by having architecture as the paradigm of art, and also by having a Herbartian theory of psychological development as a model of mental life.

The assumption that one had to examine works of art as part of a history of transformation, carried with it two problems we have already encountered—the question of how we were to understand the relation of the development of art to its surrounding conditions, and then the question: what was the relationship between the interest of individual works to the transformation in which they participated?

The conception of the self-transformation of art had implications both for the question of historical retrieval and for the connection of art and freedom. But, for reasons we shall now remark on briefly, the problem of retrieval receded in urgency.

iv. *The Changed Relation to the Past*

The loss of urgency regarding the retrieval of past art derived, in part, from a focus on what were assumed to be invariant factors of human psychology. If the human mind were stable in its fundamental characteristics and these were the characteristics relevant to the construction and interest of works of art, then varieties of past art could be seen as modifications of this underlying character of the mind, and the development of art was a manifestation of the free exercise of that underlying character.

But there was another factor which seems to have altered the level of anxiety about retrieval of the past. A new problem was

gaining prominence: disquiet about modern realism, including the realism of anecdotal subject matter in painting, and then of Impressionism. In this context, the art of the past was not nearly so alien to—for instance—Burckhardt as the art of the present.

Burckhardt, as we shall see, contrasted the grandeur and freedom of Rubens's cycle of the life of Marie de Medici, with the petty anecdotalism which he would expect if such a commission were given then, in the late nineteenth century.[5] In his study of the history of portraiture, Burckhardt points to sentimental moralising which reduced the family group portrait to trivial confusion in eighteenth-century France, under the influence of Diderot and Rousseau, and remarks: 'At another time, how marvellously Velázquez had in his *Las Meninas* shown the proper restraint'.[6] And in his *Reflections on World History*, wrote: 'What style means is that a degree of perfection once realised is retained in opposition to popular taste . . .' And that style was clearly something he saw in past art.[7]

Hildebrand, in the Introduction to *Das Problem der Form*, wrote:

It is characteristic of our scientific age that a factual work of art does not go beyond the imitative component. The architectonic component is either quite absent or is satisfied by a purely external, more or less tasteful sense of arrangement.[8]

Under the influence of both, Wölfflin wrote in his Introduction to *Classic Art*:

. . . the modern Northerner comes up against works like the School of Athens . . . so completely unprepared, that his bewilderment is natural. The spectator cannot be blamed if he secretly wonders why Raphael did not rather paint a Roman flower market, or the lively scene on a Sunday morning in Piazza Montanara when the peasants came to be shaved. The classic works set out to solve formal problems which are outside modern taste in art . . .[9]

and those formal problems were of the kind identified by Hildebrand.

Riegl, perhaps less hostile to contemporary art, was nevertheless anxious to resist, those, like Wickhoff, whom he saw as projecting modern Impressionist taste onto the atmospheric and suggestive qualities of antique art or that of the seventeenth-century.[10] and Konrad Fielder, whose influence is to be traced in

Hildebrand, Wölfflin and Riegl, in his essay *Moderner Naturalismus und künstlerische Warheit* of 1881, wrote that the realism of the earlier nineteenth century, of Courbet and Flaubert, which had broken the hold of academic stereotypes, had become trivialised and had engulfed contemporary artistic life.[11]

The invocation of past art as exemplary was not new. That had been part of Semper's and Schnaase's argument. What had altered was the sense of the art of the past as more authentically art than that of the present. In this way the problem of the absorption of past art into the life of the present receded—its role was that it was art.

A final feature of the inheritance from the earlier critical historians was that it presented the next generation with a choice: on the one hand the construction of a system of interpretation, on the other the particularity of historical detail demanded by Rumohr. The firmness of the contrast was to make Riegl, Wölfflin and Warburg much more decisive than either Schnaase or Semper had been as to what kind of enterprise they were engaged upon. They defined their work in contrast to archaeology and philology, or alternatively as recovering forgotten voices from the archives.[12]

V

RIEGL

ALOIS RIEGL began his career as an art historian by working in the Museum of Applied Arts in Vienna. His early papers included work on oriental carpets and early mediaeval manuscripts. His concern with pattern and applied art took on wider resonances by virtue of two other elements in his education. He was taught philosophical psychology by the Herbartian Robert Zimmermann and history by Max Büdiger, who envisaged a general system of world history. The Herbartian element was the more important, and if Riegl's formalist analysis of art always retained world-historical overtones, as it did, to focus upon this is to miss virtually everything that is now of interest in his writing.[1]

In 1893 Riegl published his book *Stilfragen*. Its argument is extraordinarily simple in comparison with those of his later work, but its underlying conception is one which he never abandoned; it was that we understand art as initially transforming nature and then as transforming itself from within, out of purposes which are strictly artistic.

The questions of style in Riegl's *Stilfragen* are questions of ornament; Riegl saw in the urgencies of design, rather than in the imitation of nature or the use of symbols, the motivation for the development of plant ornament in antiquity. Riegl argued that a merely naturalistic three-dimensional replication of reality requires less mental involvement than shallow relief, and relief less than the abstraction of line. Once the linear motif of the lotus was formed in ancient Egypt, its development into the palmette, the plant with 'Ionic' volute-like leaves, and then into the acanthus, was not due to the carver's recourse to new models from nature but could be explained as an internal development of design, a search for interconnectedness, variation and symmetry.[2]

At this stage of his thought, Riegl's notion of style is of the transformation of motifs. By the time he comes to write the first of his two major books, the *Spätrömische Kunstindustrie*, his notion of style linked the transformation of motifs to changes in attitude. The search for pattern and order had taken on a new kind of

psychological urgency. The inheritance from Semper and Herbart became increasingly dominated by that from Schnaase.

Riegl characterised the situation out of which the visual arts first emerged among the people of antiquity in *Spätrömische Kunstindustrie*:

Their sensory perception showed them external objects in a muddled and indistinct fashion; by means of visual art they isolated individual objects and set them in their clear circumscribed unity. Consequently, the visual art of the whole of antiquity had sought its ultimate goal in the representation of external objects in their clear material individuality, and in contrast to the accidental appearance of things in nature, avoided everything which might disturb or weaken the immediately convincing impression of material separateness.[3]

The conception of self-containedness had three overlapping implications. First, the represented object was to be unconnected with other objects in its context: it was to be a continuous unbroken form enclosed within a boundary, as we feel our own bodies to be both internally continuous and distinct from things around it. Second, this ideal of circumscribed unity concerned not only the relation of a represented object to its context within the representation, but in relation to the spectator:

To start with people endeavoured to comprehend the individual unity of objects by way of pure sensory perception, with the most complete exclusion possible of all ideas based upon past experience. For insofar as objects were assumed to be really independent of us, every recourse to subjective consciousness must have been instinctively avoided as interfering with the unity of the object under consideration.[4]

The assumption here is that our perception of what is really present is constructed by combining discrete atomic sensations, and also by projecting or interpreting what is present on the basis of past experience, e.g. using the visual cues of overlap, change in scale and shadow as indications of depth. Ideally, Riegl implies, men in antiquity would have used no such subjective mental procedures, insofar as they were concerned with the circumscribed independence of objects, and would have attended to objects only as independent, in the way that an object of touch is felt as independent. But even they were dependent on vision, and its power to unify sensation:

The eye completes the operation of multiplying single sensations far more quickly than the sense of touch, hence it is for the most part to the

eye that we owe our knowledge about the height and width of objects.[5]

So some element of spectator supplementation—of subjectivity—was inevitable.

There is a third implication of Riegl's conception of the ancient world's aesthetic ideal of self-containedness; not only the isolation of the object from its context and the insistence on its separateness from the spectator, but the suppression, as far as possible, of suggestions of space, of the third dimension:

The art of antiquity . . . had deliberately to deny and suppress the existence of space, for it was detrimental to the clear appearance of the absolutely isolated individuality of external objects in the work of art.[6]

Here too a certain degree of compromise was necessary, if only to establish figure against ground. The suppression of the sense of space follows from eliminating as far as possible the subjective projection of the spectator. It results in the maximum correspondence between the depicted object and the real surface of the relief or painting. Riegl's position here is interestingly different from that of Hildebrand, to whom he is heavily indebted. Hildebrand sought the forms which would be most fully space-revealing, without relying on retinal disparity and head movement, and without losing our sense of the real surface. Riegl, on the other hand, sees the earliest antique art as deliberately avoiding the spatial effect in favour of the sense of the surface, not as reconciling the two.

i. *Relief Sculpture*

The ideal of self-containedness, which Riegl sees exemplified above all in Egyptian relief (Plate 16), is an extreme which he sees as gradually modified in the course of ancient Mediterranean art. In his account, the ideal of self-containedness is maintained throughout antiquity, but undergoes transformation. In effect Riegl keeps changing the definition of what is to count as self-containedness.

Riegl sees antique relief as starting with the strictest adherence to the plane, the isolation of figures and the minimal call upon the projection of the spectator. But when he comes to classical relief (Plate 15), the sense of self-containedness shifts; relations between figures are admitted for he acknowledges that there is an increase

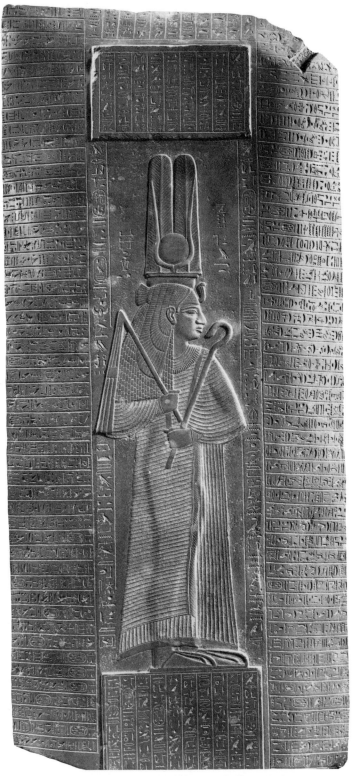

16. Relief from sarcophagus of Ankhnesneferibre, sixth century B.C.,
London: British Museum.

in modelling and that the mobility of turning forms gives a sense of the space in which they turn. The sense of self-containedness now becomes a matter of the coherence of the relief form, in which the figures are contained; that is, self-containedness now becomes a matter of the way in which the figures are seen to lie in the plane of the relief or in a series of overlapping layers, so that the continuity of the relief form is sustained.[7] When we come to late antique relief (Plate 17), self-containedness takes on a third sense: individual figures are again, as in Egyptian art, separated, and we might think this a regress to an earlier type of coherence, but the unity or coherence is now understood as that of the excavated space in which a figure is set. It is the *spatial niche* which is circumscribed. But there is yet a further development in late antique relief (Plate 18). The carving of limbs and the folds of drapery becomes so deep that it dissolves the unity of the body, and coherence is then conceived in yet another way; having dissolved the self-containedness of the bodies and so the distinction between those bodies and the space around them, what is left is simply the homogeneous optical plane which contains both.[8] Overcoming or dissolving the division between figures in this way takes on considerable importance for Riegl (and in this he is to be followed by Panofsky): it is treated as a way in which objects and their surrounding space become seen as features of one homogeneous continuum—the continuum of the plane, and this sense of a homogeneous continuum is seen as a precondition of developing a sense of the homogeneous continuous space and so a precondition of later perspectival representation.[9]

Riegl surveys the variations of coherence in antique relief in another way when he describes early relief as near-sighted, classical relief as normal sighted, and late classical relief as long-sighted, so that it gains its coherence by the pattern of light and shade;[10] this is an even further remove from the self-contained *object* of the first stage than the self-contained *group* of the classical relief, for it is a coherence of pattern irrespective of objects. The lack of consistency here is revealing. It shows Riegl attempting to accommodate a variety of different perceptions into his theory, and it enforces our sense that his idea of coherence should not have been tied to his rather primitive theory of perception, but the coherence of early antique art is a paradigm for coherence in general, which may appear in quite different ways.

Riegl writes as if he conceived of two possible ideals for art, on the one hand the tightly circumscribed and tactile, and on the other the open, suggestive and optic; but there is really only one ideal, that of unity or coherence, which is gradually extended—from the initial tactile circumscribed unity—to admit increasing levels of visual effect and subjective involvement, and art was able to admit the increase of optical effect and subjective involvement just insofar as it could give those subjective factors a structure. It was not Riegl's view that art should ever offer an experience which was just like ordinary fleeting perception. At the point where it approximated to ordinary subjective visual experience (Riegl sometimes implies that this is so in Impressionism), there is a need to revert to the limitations of earlier art.[11]

ii. *Architecture in Late Antiquity*

When Riegl applies his concepts of tactile and optic to architecture, he has two, as it were, ready made 'oppositions' onto which to attach his fundamental dichotomy. The first is the opposition between the interior and the exterior of a building.[12] Concern with the exterior of the building can plausibly be made to correspond to a building being object-like, and so a concern with its tactile quality, while the interior is thought to correspond to the interest in space, and therefore eluding the flat, tactile plane, and so 'optic' in its interest. And here Riegl can provide a convenient selective history. The concern for space within the Egyptian pyramid was minimal: its chambers were small, its courts broken by great columns which destroyed the sense of continuous space. The exterior, together with its sense of mass, was plausibly regarded as dominant. The Greek temple required a certain interior space, but was mainly conceived as being seen from without. It is in Roman architecture that we have the novelty of defined interior spaces, and Riegl's central example is the Pantheon (Plate 19): 'What is new in the Pantheon as rotunda is the closed space of its interior.'[13] Mausoleums were spaceless, and amphitheatres roofless; they did not, therefore, define space (they were not, in Riegl's view, really part of canonical architectural history at all). In the interior of the Pantheon 'everything is calculated to give the spectator a sense of the material limits of space', not the suggestion of indefinite space but a single clearly circumscribed space: 'in [the Pantheon's] lowest zone there is a row of niches, half covered at the entrance by pairs of columns'.

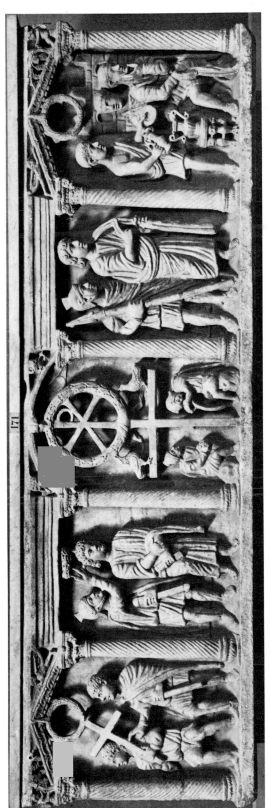

17. Christian sarcophagus, c. A.D. 400, Lateran Museum.

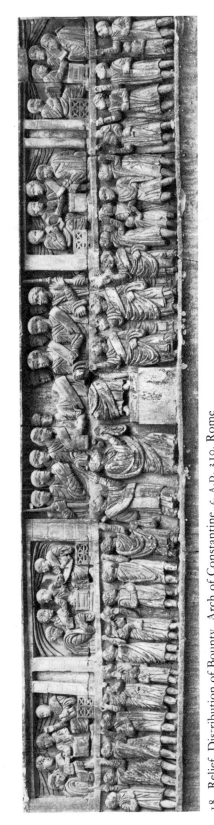

18. Relief, Distribution of Bounty, Arch of Constantine, c. A.D. 310. Rome

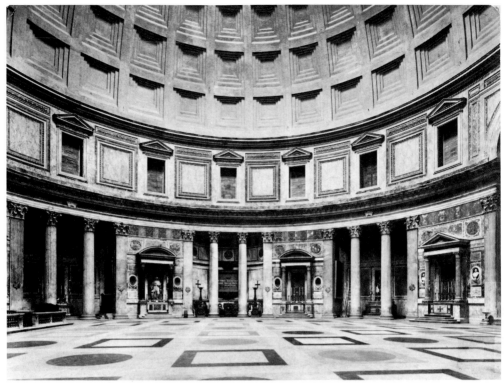

19. Pantheon, interior, Rome.

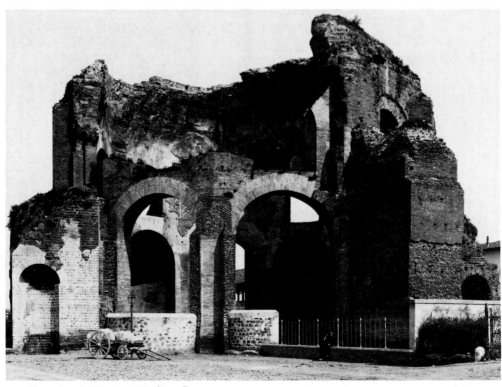

20. Temple of Minerva Medica, Rome.

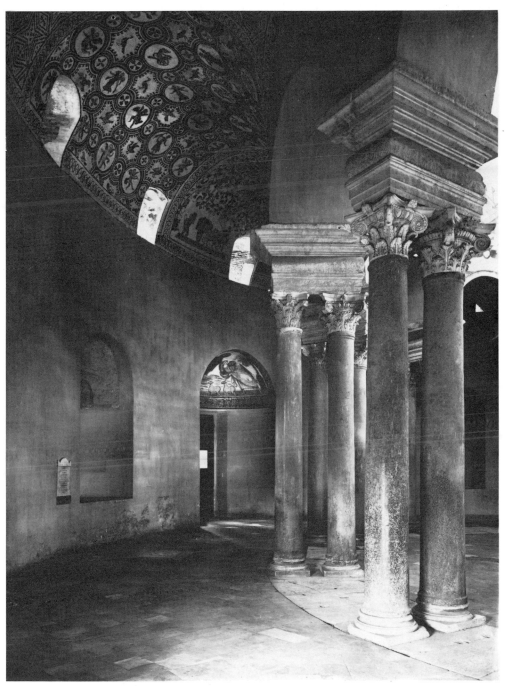

21. Santa Costanza, interior, Rome.

The effect, Riegl writes, is that they appear as separate side rooms, and so provide a background which enhances the self-containedness of the central space.

The next stage in the increase of spatiality is seen in the temple of Minerva Medica (Plate 20); there the interior apsidal spaces now thrust outward and appear in the external form of the building.[14] This both develops the sense of space and yet still remains consonant with the opposite ideal of self-containedness by making the central structure seem a single entity, and this is like the way in which the side spaces inside the Pantheon appear as satellites enhancing the central space. 'It is still fundamentally a matter of presenting the enclosed unity of a material particular. But this is no longer set simply in the plane and connected with it, but in its full three dimensionality it is freed from the ground plane. Consequently between that ground plane and the three-dimensional object a series of smaller individual components is interposed which accents its separation from the plane.'[15] Here Riegl is surely writing about a two-dimensional representation—the photograph rather than the building itself.

The next stage of the development is marked by Santa Costanza (Plate 21); there 'the garland of niches is welded into a continuous passage divided from the centre by a series of double columns. Thus there are two concentric rotunda of which the inner one is dominant.' The stylistically important innovation for him now lies in 'the suppression of all limbs [niches] in favour of a simple mass-like outline'.[16] This looks like a return to a Pantheon without the niches. But Riegl's point is that the central space opens more freely into the ambulatory, and the circle of windows enhances the sense of openness to space beyond.

Riegl calls upon a second real contrast in respect of late antique architecture to give specificity to his tactile-optic polarity: the contrast between centrally planned and longitudinal buildings. The centrally planned building in antiquity was thought of as having an object-like character and conformed in this way to the ideal which Riegl had posited for antiquity. But, says Riegl, the generative factor gaining ascendancy within late antiquity was spatiality; and this came to be felt pre-eminently in the longitudinal building: 'the longitudinal building is produced for men to move about in: movement, however, requires the abandonment of the plane, the concern with depth . . .'[17]

Riegl's thought here clearly uses and responds to ideas of Schnaase. Schnaase had seen parallel rows of columns in the Gothic interior as eliciting a sense of perspective, but Riegl was anxious to resist dating the emancipation of spatiality to late antiquity and early Romanesque. The Romanesque architects, says Riegl, covered their longitudinal building with a timbered roof. Thus although the early Christian basilicas may seem to imply a perspectival effect with their rows of columns, that is, says Riegl, an anachronistic response (Plate 22). If that is what they had wanted they would have had a properly enclosed space with vaulting, not a mere timber roof,[18] a clear adaptation of a point made—with a different purpose—by Schnaase.[19] In Riegl's historical scheme, perspective had connotations similar to those it had for Schnaase; it was an image of Christian community. But had Riegl allowed Old St Peter's to be a genuinely perspectival building, his co-ordination between the history of architecture and painting would have been disrupted.

According to Riegl the interior proportions of the height to width and the symmetry of the side aisles in the early Christian basilica, lead us to see them as in a plane, that is, as if projected onto a plane. The notion of projection also enters his account of the exterior of the basilican church. The exterior disrupts the object-like coherence of earlier architecture. The wall is pierced by shadows, and (for instance in S. Apollinare in Classe) it is as if a series of discrete buildings, the tower, apses and atrium surround the central building and each is to a substantial degree independent. It is, says Riegl, as if people 'had set out deliberately to avoid all visual realisation of the causal connection between the parts'. And he sees this as like the breaking down of figures in contemporaneous sculpture, where the deep shadows separate limbs from bodies, and all is dissolved into an optical pattern of light and shade.[20] Riegl's account of ancient and early mediaeval architecture is continually strained by his attempt to treat it as if its interest lay in the way it could be represented on the picture plane or in relief. This was also an implication of his attempt to give a description of stylistic change which would span the visual arts.

iii. *The Dutch Group Portrait*

In *Holländisches Gruppenporträt* Riegl sets out to give an account of painting which has an ideal or intention diametrically opposed to

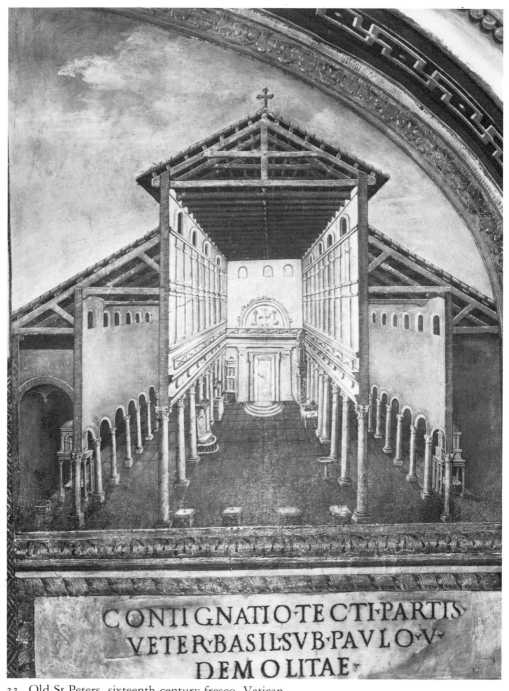

CONTIGNATIO·TECTI·PARTIS
VETER·BASIL·SVB·PAVLO·V·
DEMOLITAE·

22. Old St Peters, sixteenth-century fresco, Vatican.

that of antique art. Where antique art had been concerned to establish a self-contained, circumscribed object independent of the spectator, Dutch art of the sixteenth and seventeenth centuries aimed at involving the subjective life of the spectator; where antique art had aimed at the definition of an object as materially present to touch, Dutch art aimed at creating the sense of an immaterial presence, of something essentially unavailable to perception and known by intimation or suggestion. Thus Riegl continues in his account of Dutch art an eighteenth-century notion of the sublime and its Hegelian derivative, the notion of painting as an art which intimates a spiritual content for which there could be no adequate sensory realisation.

Riegl sees the development of the Dutch group portrait as representative of Dutch painting in general. However, its development is in his account generated by the specific problems inherent in the enterprise of painting a group portrait: the tension between, on the one hand, combining the members of the group in some dramatic way, which appears to the spectator as a self-contained fictive world, and on the other, retaining a sense of the individual portraits which are not absorbed into a story. The double demand is not really exclusive to the group portrait (although Riegl does not mention this), it was also present for the painter of altarpieces; a 'Madonna and Child' had to have some internal dramatic relationship with each other and surrounding saints, and also be felt to be presenting themselves to the spectator as the focus of prayer or communion. This tension between two demands in the group portrait is seen, by Riegl, not only as one between the narrative and presentational character, but as a tension between the interest in the individuals and in the group as a whole. ('The essential Dutch portrait group . . . can only begin when each person has an independent role which yet serves the whole'.[21])

As Riegl analyses these problems—narrative versus presentation, group versus individual—they are seen to involve two kinds of unity or coherence: the coherence formed by the relations between the figures in the group portrait, which Riegl calls its interior unity, and the coherence formed by the *spectator's* relation to the portrait group, which he calls its exterior unity.[22] This distinction is one which Riegl can feel is well established. It corresponds to Burckhardt's distinction between narrative

altarpieces and those in which the figure within the altar is placed in direct relation to the spectator, addressing him; and beyond that, and giving his criticism much more of its vividness, is the Hegelian distinction between sculptural completeness and the way in which 'the spectator [of a painting] is from the beginning counted in with it . . .'[23]

The militia company provides one of the main subjects for the group portrait. One of the first Riegl describes was painted by Dirk Jacobsz. in 1529 (Plate 23), and it presents a number of half-length figures, arranged in rows, their heads seen in three-quarter view, and looking out of the picture. Here unification within the picture, interior unity, is limited to the way in which members of the company point toward the captain. But these gestures not only provide a minimal interior coherence, they are made on behalf of the spectator, they are pointing out the captain to the spectator. In this way the gestures are acknowledging our presence and doing so in a way over and above the fact that the figures look out into the world which we, the spectators, inhabit. In this way, the interior or narrative coherence already implies the spectator's presence, and so some degree of external coherence.

A device for enhancing the interior, narrative coherence in paintings of militia companies was to show the company having a celebratory meal,[24] as in the group painted by Cornelius Teunissen in 1533 (Plate 24). But if the character of the group portrait was to be sustained, this must not be allowed to degenerate into a *merely* narrative scene. And one of the ways in which the strength of the narrative coherence is curtailed and the composition prevented from descending into a mere genre scene is by virtue of the fact that the meal has a ritual connotation, thus limiting the narrative effect. Nor is it just the depiction of a particular event but of a repeated form of event, itself symbolic, just as members of the group may have symbolic attributes.

Another form of militia company group portrait is a presentation ceremony, or a company forming up for a parade or march. Here the two kinds of coherence, interior and exterior, interact in a more striking way. Thus in Thomas de Keyser's company of Allaert Cloeck of 1632 (Plate 25) the officers are in the centre foreground on a podium, which other figures from further back are mounting, so that foreground and background figures are linked.[25] In this way the group has an internal coherence,

23. Dirk Jacobsz. *Militia Company*, 1529, central panel, Amsterdam: Rijksmuseum.

24. Cornelius Teunissen, *Militia Company*, 1533, Amsterdam: Amsterdams Historisch Museum.

25. Thomas de Keyser, *The Company of Captain Allaert Cloeck*, 1632, Amsterdam: Rijksmuseum.

which involves subordination to the captain; at the same time the captain and his officers seem to be presenting the company to the spectators toward whom they look. This is a motif very close to that of Rembrandt's *Night Watch*, but before we go on to Riegl's account of *The Night Watch* there are several notions which Riegl uses which need to be distinguished. Riegl's account of Thomas de Keyser's painting gave some weight to the notion of the subordination of the company to its captain. This notion of subordination (as opposed to co-ordination) has not only the straightforward social implication, but an aesthetic one: that is, we may see a group of figures as more or less absorbed within, or subordinated to, an overall configuration. Riegl develops this particularly in his account of yet another kind of group portrait, the anatomy lesson. He contrasts (Plates 26 and 27) Rembrandt's *Anatomy of Dr Tulp* of 1632 with Thomas de Keyser's *The Anatomy of Dr de Vrij* of 1619.[26] Rembrandt, Riegl points out, has heightened the degree of subordination to the speaker. Where de Vrij looks at the skeleton in his demonstration, Dr Tulp looks at his colleagues, and while de Vrij's colleagues attend to the skeleton, Tulp's colleagues are (in Riegl's view) responding attentively to Tulp, although in different ways. There is one exception among his hearers: the surgeon at the apex of the pyramid gazes directly at us. And for Riegl this figure at the apex is extremely important, because it is to this figure that the whole action, including the subordination of the group to Tulp, is itself subordinated. The relation to the spectator subordinates or gathers within itself the internal dramatic unity. It is as though Riegl were saying that the relation to the spectator, created by that choric figure, puts the whole action into inverted commas. (Riegl's analysis is not necessarily undermined by the discovery that the surgeon at the apex was a later Rembrandtian addition: for if we disregard him, the surgeon on the left, whom Riegl describes as looking out, but with sightless gaze, could be seen as looking out *at us*. Whether we accept Riegl's sightless gaze interpretation or not, there is a perfectly good sense in which we should be more inclined to allow it given the presence of the figure added above, while without the additional figure looking out from the apex of the group we should be intuitively more comfortable if we regarded the surgeon with the list looking out at us.[27])

Riegl sees the subordination of the action to a single figure, like

any other narrative device, as threatening the character of the work as a portrait. Such dramatic connectedness will tend to make the picture into the representation of a self-contained world. What Rembrandt has done here, according to Riegl, is both to heighten that internal coherence and to overcome it, absorbing it in an external coherence.

In *The Night Watch* (Plate 28) both subordination and interconnectedness are strong. The painting is of the company of Captain Banning Cocq, and a note describing the painting in Cocq's album is quoted by Riegl: 'The captain gives his lieutenant the order for the company to move off.' The subordination of the whole company to the captain is clear.[28] How, therefore, does Rembrandt avoid making the group portrait into a dramatic event as in Italian Renaissance and Baroque painting?

First of all, in Riegl's view, there is Rembrandt's sense of the single moment; it is the moment at which the company is responding to—has almost anticipated—the command; the figures are seen as, in various ways, preparing themselves to move. For us to see them in the process of getting ready implies that we are imaginatively projecting into the still picture—that it has elicited from us a sense of tension and anticipation. But Rembrandt has also used subordination in inner—dramatic— coherence in a way which produces a new level of outer coherence:

The contact with the beholder is not through a mere gaze into the distance, but through attention particularised in a specific direction. The outstretched hand of the captain, pointing in the direction of the beholder leaves no doubt that in the following moment this whole company, under his command, will move toward the spectator.[29]

In this way the inner organisation is turned into a way of bringing the whole scene toward the spectator—into the spectator's world. In this way inner and outer coherence are more completely integrated than in *The Anatomy of Dr Tulp*, where the interior dramatic coherence of the speaker and his hearers was ultimately subordinated to the relation to the spectator established by the figure looking out at us. But so far the relation of inner and outer coherence is very like that of Thomas de Keyser's *The Company of Captain Allaert Cloeck* of 1632. In order to fill out Riegl's account we need now to introduce his

26. Thomas de Keyser, *The Anatomy Lesson of Dr de Vrij*, 1619, Amsterdam: Rijksmuseum.

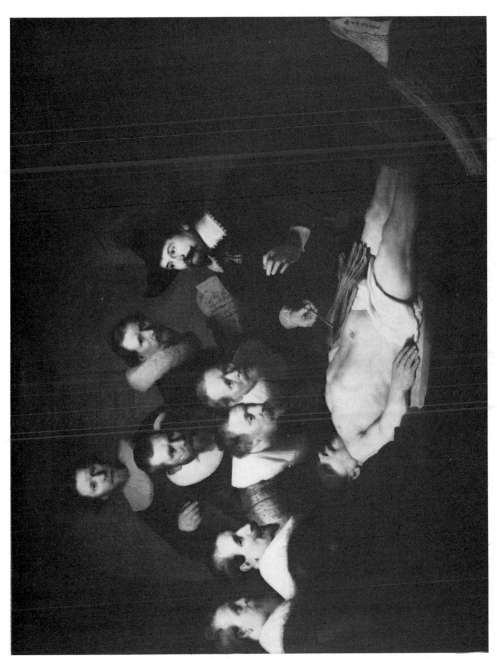

27. Rembrandt, *The Anatomy Lesson of Dr Tulp*, 1632, The Hague: Mauritshuis.

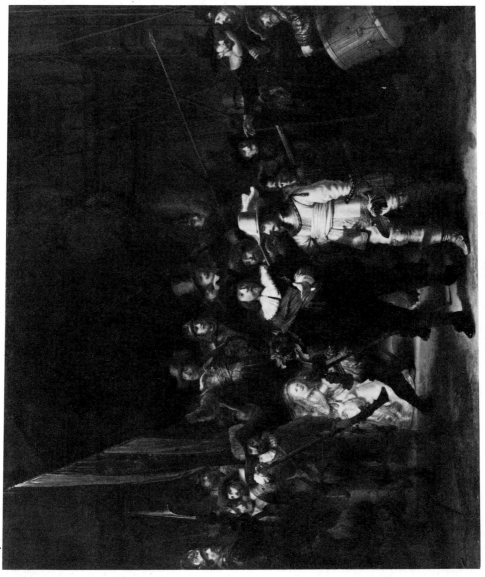

28. Rembrandt, *The Night Watch*, 1642, Amsterdam: Rijksmuseum.

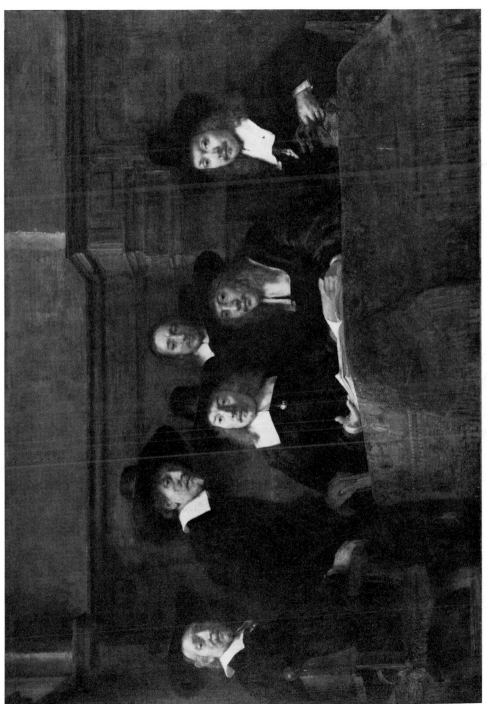

29. Rembrandt, *The Syndics*, 1662, Amsterdam: Rijksmuseum.

notion of the expression of inward subjective life. The subjective
life which Riegl sees in Dutch art is not an expression of the will
which can issue in action, nor of emotional responses to events;[30]
it lies in mental alertness, in watchfulness, in attention, expressed
pre-eminently by the gaze of the depicted figures. The gaze of a
figure is interpreted as *attention* where it is dissociated from the
movement of the body, or where it is directed at something not
visibly present to the spectator, or something which could not be
visibly present to the spectator, as where a depicted figure
entertains a thought, or where men attend to each other's speech
(as in the *Anatomy of Dr Tulp* or *The Night Watch*). Such elements
require the spectator's imaginative supplementation. Thus, where
Riegl talks about attention he implies that the spectator too attends
to something not sensibly present.[31]

The participation in the reflective life of the depicted figures is
seen by Riegl as a central way in which the spectator is engaged by
Dutch painting, and he contrasts it with the attitude elicited by
Italian Renaissance and Baroque painting, in which we observe
the action and reaction of figures on a self-contained stage,
presented to the spectator as explicit and complete.

There is a further way in which, in Riegl's view, the spectator is
drawn into such painting, beyond the way he is drawn into Italian
Renaissance and Baroque painting: this is the increasing capacity
of the painting to surround the presented objects with a sense of
atmosphere, so that the spaces between objects are felt as part of a
homogeneous optical effect. Here Riegl enters a caveat. We must
not mistake this for the impression of modern art, which is
conceived as constructed from one beholder's viewpoint;[32] the
presence of the subject matter is not treated as the casual
impression of the beholding subject—objectivity has not been
dissolved into passing subjective impression. Seventeenth-
century Dutch art represents objects as having an existence
independent of us, but does so in a way which leads us to be aware
of an interplay between those objects and our own mental life.

Nowhere is this attentiveness in its many forms, and the
integration of internal and external unity, so richly exemplified as
in Rembrandt's *Syndics* (Plate 29). Here we are presented with a
group of men who look across a table into our space, their gazes
converging at one point, but their direction is somewhere just to
our left, and we feel convinced that in our space there is someone

or some group of people we cannot see, from whom both we and the Syndics await an answer. Our presence as spectators is thus linked both to the addressee who, like us, confronts the depicted Syndics and to the Syndics who await his response.

iv. *Senses of Artistic Intention*

So far I have described Riegl's theory as a typology, as giving an account of a number of different kinds of visual coherence, and placing them in an order of development. But Riegl regarded his theory as something more: as showing an inner necessity which governs artistic performance, that is, as showing the way in which the artistic intention is self-generated and not a response to purposes outside itself—purposes like conveying ideas or imitating nature or serving functions which lie outside the creation and appreciation of the visual form. The main lines of his thought were already present in that earlier book, *Stilfragen*. There he traced the development of the plant motif, the lotus, of early Egyptian art into the palmette, acanthus and its subsequent development in mediaeval ornament. The striking feature of Riegl's account was his assumption that the generative force in the development was man's innate sense of pattern and symmetry and the urgency to combine discrete elements in an order. It is characteristic of Riegl's argument that he saw the emergence of the motif with two leaves curving down on either side of the central upright form, not as the imitation of a lotus of which the petals have drooped, as had been suggested in earlier literature, but as a formal elaboration; correspondingly, he does not see the later emergence of the acanthus as derived from the acanthus directly but from the development of earlier motifs into a pattern which already suggests the acanthus leaf. This explanation of the change in plant ornament by reference to our innate urgency for gap filling, repetition and symmetry produces a sense of autonomy or inner necessity in the history of ornament. In the *Spätrömische Kunstindustrie* and *Holländisches Gruppenporträt* the sense of necessity is the same, but the unity which the artist achieves is infinitely more complex, for it is brought about through much more charged and subtle elements.

It is perfectly clear that the critical strength and continuing interest of Riegl's writing is closely tied to an absurd programme:

the search for a continuous development of visual form through the history of art. But his treatment of works as representative of stages in the self-transformation of visual style led to an extraordinary range and delicacy of description. As each critical feature of a work was thought to belong to a developing series, you had to probe earlier and later works for its counterpart. If you observed several features in one painting, e.g. the type of pattern, the kind of dramatic coherence, the sense of social hierarchy, the type of atmospheric effect, the degree of symmetry, you would, following the developmentalist programme, have to look for their counterparts in earlier and later works. Once you had done this you would have to correlate each of these series of variations for each particular work, or each stage in the history of style. This probing backward and forward and correlating 'vertically' was an extraordinary way of defining variations between paintings and the interaction of features within them. It was at its most strenuous and telling in Riegl's *Holländisches Gruppenporträt*. The programme led to observations, to an articulation of paintings which it would be hard to imagine reaching without it.

Riegl's theory of the *Kunstwollen* has been regarded as merely reviving the view of the development of art advanced by Schnaase in *Niederländische Briefe*. The close relation is clear, particularly in their accounts of the history of architectural forms. But, unlike Schnaase, Riegl develops concepts of pictorial coherence quite unanticipated by Schnaase—concepts which register differences between overall effect and detailed attention, between degrees and types of the beholder's involvement.

There is a second important difference, and it concerns the use of a teleological theory of artistic development. While Riegl follows Schnaase in seeing the understanding of art as a matter of following the comprehensive development of art, and while both assume there is a necessary direction of development, Riegl sees the *objective* of that development as constantly changing. The result is that so far from seeing earlier stages as mere preludes or incomplete forms of some final triumph, he insists on all stages as of equal value. This, it might be objected, just shows he was even confused about how to set up a teleological scheme, or that he failed to have a coherent scheme of procedure at all.

But this criticism would be too facile. For Riegl the *Kunstwollen* carried several implications which we should now want to

distinguish: first, that all art possesses intentionality, or purposiveness, while allowing that in each period or culture the artistic purpose may be different. From this it follows that we need to distinguish the general notion of the *Kunstwollen* from its manifestations at different times. But there is another strand in the notion of the *Kunstwollen*: the conception of a continuous linear development of art history. We might save something of Riegl's theory here if we interpret this to be an insistence that artistic intention must itself be drawn out of potentialities already latent in the current tradition. Finally, these theses may apply *either* to a style or genre *or* to a particular work, like Rembrandt's *Syndics*.

Breaking Riegl's notion of the *Kunstwollen* into these component theses and then revising them does not vindicate his confusions, but indicates how we may still be interested in Riegl's theory without subscribing to it, and why we might continue to find it critically suggestive. Riegl's application of his notion of the *Kunstwollen* to the applied arts as well as the high arts, to whole styles as well as individual works, and his refusal to regard the art of any one period as a general norm, has given rise to the assumption that his analysis is value free. But valuing does not have to be applying norms or grading; it may be simply attaching value to something, appreciating it, endorsing the intention perceived in it. If Riegl's theory were value free, what things were like would be a matter of no importance or excitement for him, which is obviously false, and what he wrote would not be critical history at all, but at best archaeology.

VI

WÖLFFLIN AND CLASSIC ART

OF THE critical writing discussed in this book, that of Heinrich Wölfflin is by far the most widely read. There have been repeated attempts by art historians to belittle or dissociate themselves from Wölfflin's general position while following the procedures of his detailed critical analyses. No great discernment has been needed to recognise that Wölfflin's formalism is seriously limited, that there is something strained about the way he yokes architecture and painting, and that his cyclic view of art history, according to which a classic style is followed by a baroque elaboration and then the whole thing starts again, is illuminating but, as it stands, untenable. But Wölfflin's critics have not made clear the borderline between the critical strengths and the theoretical weaknesses.[1] And this is of some current interest. For many of us, whatever our reservations, it would be hard to find a replacement for *The Principles of Art History* as a model for the analysis of painting.

For thirty years, from 1886, Wölfflin constantly revised his position, taking at least four substantially different viewpoints. His first two major works, *Renaissance and Baroque* (1888) and *Classic Art* (1899), undermined their own explicit programmes, as Wölfflin himself was aware. Each new book and each major paper can be read as a revision of the one before. Wölfflin's adjustments to his own position are not simply a set of corrections. They are shifts of focus; they involve losses and gains, so that each illuminates the central insights of his work.

When Wölfflin set out on his career as an art historian, having started university life as a student of philosophy, he carried with him the neo-Kantian philosophical psychology which was dominant in German universities in the last half of the nineteenth century. The issue at the centre of this philosophical psychology was to explain how our minds and our perception led us to see the world the way we did. This could be an epistemological concern about our knowledge of the external world in general, and how that knowledge was dependent upon the nature of our minds. On

the other hand, it might take our knowledge of objects in the
external world for granted, and examine how we projected upon
them or interpreted them in special circumstances, in particular
the circumstances in which we confronted architecture, music and
painting, which is what concerned Wölfflin.

i. Renaissance and Baroque

Wölfflin writes of his project for a critical or interpretative history
just after finishing his doctoral dissertation, in a letter of 1886:

It is essential that systematic historical knowledge must be re-cast as a
psychological interpretation of historical development. What can be
achieved through philological methods is shown by archaeology.
Someone who can combine archaeology with that other enterprise will
achieve a great deal. From philosophy I shall draw a stream of new ideas
and inject them into history. But first I must become master of the
historical material, and I must become its complete master. I shall take as
the first example of this enterprise the art of the Baroque . . .[2]

Wölfflin was distinguishing his enterprise from that of archae-
ology, from the philological study of art—from the straight-
forward documentation of works of art, the recital and
cataloguing of architectural features, the dissective analysis—
without asking about the principles governing and expressed in
their appearance. His enterprise, like that of Riegl, was concerned
with finding general principles of interpretation. It is in this
respect that Wölfflin's procedure is most clearly at variance with
that of Burckhardt, the art historian who taught him and to whose
chair he succeeded, for Burckhardt, using the traditional classi-
fications of genre, gave no systematic consideration to his
descriptive concepts.

 Wölfflin's conception of interpretation, while unlike those of
Semper and Schnaase in being explicitly based upon psychological
theories of *perception*, nevertheless resembles theirs in the way that
it was, from the start, linked to the sense of transformation of art
through history. There were really three theories of development
which were available to Wölfflin: that the development of art was
a reflection of a cultural change; that it had a teleological character
of its own, as suggested by Schnaase; and that it developed by a
process of enriching and elaborating and then transcending those
modes of formulation which had become familiar and dull in the

way Göller had suggested. Wölfflin became engaged with each in
turn. The problem of how to account for the transformation of
style was closely tied to the problem of transcending literal
perception by critical interpretation, and the two problems remain
yoked for Wölfflin throughout his career. The search for a princi-
ple of interpretation, and with it a theory of the transformation of
art, is made completely explicit in *Renaissance and Baroque*:

What determines the artist's creative attitude to form? It has been said to
be the character of the age he lives in; for the Gothic period, for instance,
feudalism, scholasticism, the life of the spirit. But we still have to find the
path that leads from the cell of the scholastic philosopher to the mason's
yard.[3]

In order to answer the question of the artist's creative attitude to
form, Wölfflin explicitly invokes empathy theory: 'we always
project a corporeal state conforming to our own' onto the object
of interpretation. He had already given a very full exposition of
empathy theory in his doctoral dissertation, *Prolegomena zu einer
Psychologie der Architektur*.[4] There Wölfflin adopted a generally
current view according to which empathic projection was given a
very broad interpretation: it came to mean endowing inanimate
objects with a sense of body posture and mood; seeing them in this
way was compared to hearing in music the impulses of feeling and
the resolution of tension, which could not be attributed literally to
mere sounds.

When Wölfflin puts empathy theory into practice in *Renaissance
and Baroque* it undergoes a radical transformation. The basic and
rather primitive theory of empathy—projecting a sense of the
inward feeling of our bodily state onto the inanimate object—
becomes merely one example of a much wider conception.
Without Wölfflin himself seeming to be aware of it, he transforms
the basis of critical or aesthetic understanding from the model of
empathic identification to another model, the model of seeing in
what is literally present the suggestion of what is not. For example,
in contrasting the general ideals of Renaissance and Baroque
architecture he writes:

The Baroque required broad, heavy, massive forms. Elegant pro-
portions disappeared and building tended to become weightier, until the
forms were almost crushed by the pressure.[5]

To say that 'buildings tended to become weightier, until the forms

were almost crushed by the pressure' is indeed to interpret the forms of masonry, but it is not to interpret them by identifying our own bodily states with them, or at least, not more so than when we do really see two objects crushed together (Plates 30 and 31). It is not the empathising, the reference to our own bodily states, which distinguishes our attitude to architecture from our non-aesthetic observations of material objects, but our sense of fiction, of things *seeming* to be pressed together. For example, the columns on the ground floor of the Farnese palace courtyard may seem compressed by their flanking pilasters, similarly the reduplication of supporting members above gives a sense of weight and pressure in contrast to those of Bramante's courtyard of the Cancelleria. Wölfflin is quite clear about this, as when he talks of the distinction between what is really there and what appears:

To exaggerate the point, one could say strict [Renaissance] architecture makes its effect through what is really there, through its corporeal reality, painterly architecture on the other hand, through what appears, through the impression of movement. But of course no particular example is completely one or the other.[6]

When a Renaissance architect uses engaged columns, pilasters and pediments on a church façade, just as when a Baroque architect breaks a pediment or suggests a swerving movement in the form of a portico, we are already engaged in architectural fiction—in observing a seeming structure—which can never be completely distinguished from the mechanics of real supports and pressures (Plates 32 and 33).

Wölfflin's point can be more fully appreciated by the way he used the concept 'painterly'. This is introduced at the beginning of *Renaissance and Baroque*, among four general concepts for the classification of the Baroque as opposed to Renaissance architectural style: painterliness, grandeur, massiveness and movement. 'Painterliness' is the term which most clearly suggests the sense of architectural fiction or suggestiveness. In a painting, the solid forms of architectural masonry could appear elusive and suggestive by virtue of the play of light and the adoption of oblique angles of vision, and this transformation of real architectural forms, within a painting, was seen as an analogue of the transformation of Renaissance forms in Baroque architecture.

There can also be a 'painterly' as opposed to 'draughtsmanly' painting or drawing (Plates 38 and 39):

30. Courtyard of the
Palazzo Farnese, Rome.

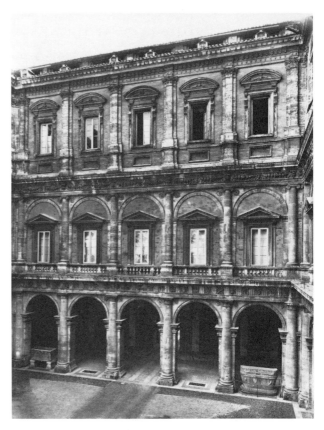

31. Courtyard of the
Palazzo della
Cancelleria, Rome.

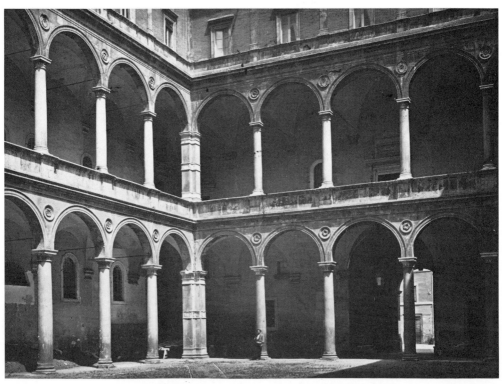

Draughtsmanly style uses the pen or hard pencil, the painterly uses charcoal, soft red conté or the broad sketching brush. The former is defined or sharply circumscribed, the main means of expression lay in the contour; in the latter case in the masses, broad, uncertain, the contours only fleetingly indicated . . .[7]

Just as hard 'pietra serena' is naturally suitable to clear Renaissance definition, the soft Tavertine is to the merging, suggestive effects of Baroque.

The sense of 'painterly' thus extends across both painting and architecture; architectural features may suggest what is not literally present, or only *suggest* what is really there without making it clearly graspable. Correspondingly, in painting, features may be so treated that what is suggested is not defined, and things may be suggested which contradict what is literally depicted, as when a cast shadow seems to be an object, or where a number of discrete objects suggest one continuous mass, or a single edge seems to 'dissolve into a formative zone'. What is painterly in representational painting is what goes beyond or is in conflict with the real character of what is depicted, and what is painterly in architecture is what goes beyond or contradicts what is really there. The 'painterly' is a particularly well defined species of the genus of interpretative seeing. It is this wider sense of interpretative seeing, rather than the narrower idea of empathy, which forms the most sensitising factor in the critical procedure of *Renaissance and Baroque*.

The book nevertheless does present a general theory of interpretation based on empathy, and this has serious difficulties as it bears upon other problems, not only on interpretative seeing. The first difficulty is that the theory seems intended as an account of the interest of architecture which is separate from the other aspects of the period (the historian who invokes the spirit of the age as a psychological explanation of change is treated dismissively), and yet the way the theory is presented suggests we do directly perceive the spirit of the age in the physiognomy of a building; that is, Wölfflin gives empathy theory two incompatible roles: providing an account of the distinctive character of architecture and an account of its link with surrounding culture. In detail, Wölfflin is highly specific about the metaphorical quality of architectural forms and he makes quite precise analogies with painting and poetry. He does not rely on vague gestures to the

spirit of the age or taste but the theory he says he is adopting does identify the aesthetic character of the work as that which is recognised by empathy, and that, in turn, is an extension of the cultural temper, with 'what the race has to say', with its *Lebensgefühl*, or an idealisation of this *Lebensgefühl*. Empathy theory makes the temper of the age immanent in the style.[8]

The second difficulty of Wölfflin's position concerns the role of the spectator. The spectator must be able to distinguish architectural members just as he has to be able to follow the syntax of a poem, before he can understand it. Without this capacity to see a pediment as broken, the pilasters as clustered, or that Brunelleschi has augmented a column as if it were incorporating a section of entablature above the capital, his perception would be capricious and insecure. In fact, Wölfflin's critical analysis throughout implies that we recognise the objects we see in paintings, that we discriminate the architectural members in buildings and see what has happened to them, just as his analysis of poems depends on precise observation of their syntax. We are never left to merely unarticulated empathy.

There is a further problem involved in Wölfflin's use of empathy theory. He talks of *the cause* of a change in style, where this is taken to be a change in taste. Wölfflin, in tracing a change in style of architecture to a change in the taste of a society, has presupposed the continuity of architectural tradition. But he does not allow any 'generative force' to that tradition. That is, he does not allow in his *theory of change*, that the very motifs of past architecture offer the architect opportunities for elaboration and the basis for novelty, because he looks for a single cause for the change of style outside art itself. He rejects a theory which he himself hints at here—and uses later—that of Göller, according to which artistic change occurs through a style or convention becoming so familiar that our sensibilities become numbed to it and artists have to seek new forms which they do by elaborating inherited ones.[9] He rejects this view on the grounds that it treats men as merely form-responding creatures, while nothing in human life is conceivably unconditioned by the sense of life at the time. What is striking here is the sharpness with which Wölfflin sees the alternative between a change in artistic style generated from within the tradition of the art, and change of style produced by the surrounding culture.

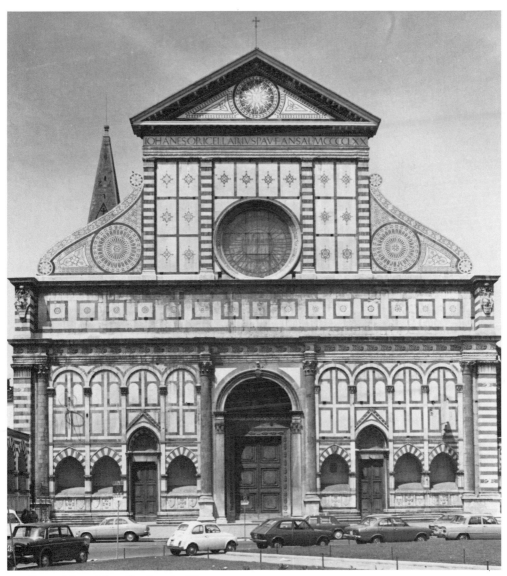

32. Santa Maria Novella, façade, Florence.

33. Santa Maria della Pace, façade, Rome.

ii. *The Teleology of the Triumphal Arch*

Wölfflin changed his theoretical stance in a paper of 1893, 'Die antiken Triumphbogen in Italien'.[10] Here he took up a position which in crucial respects reversed that of *Renaissance and Baroque*. He gave up empathy theory as a basis of critical interpretation, and replaced it by a conception of visual ordering. He also reversed his view regarding the source of stylistic change, which here he comes to trace in the internal dynamics of art itself in its pursuit of order. Now the surrounding culture and *Lebensgefühl*, previously adduced as the source of stylistic change, become a background condition for the internal logic of development of an architectural genre. He takes a single type of object, the Roman triumphal arch with a single gateway and four columns, and says that he is not concerned with how this type of arch originated (Plates 34 and 35). He is interested in it once it had established itself, and is interested in it in a restricted respect: the way in which the arch motif and the tower are interrelated:

The essential factor is how the arch is linked with the arrangement of columns, how the piers or the opening of the arch is treated, how the filled planes are related to recesses, and the proportions of the crowning members, the attic and triumphal statue, to the structure of the arch itself.[11]

In his first example, the arch at Aosta, he remarks on the dwarf supports of the arch which rest on the same base as the tall supports of the entablature, thus making the arch supports look squat and stunted. Also he sees the relation of the narrow side walls to the broad opening as awkward, as well as the way the curve of the arch is cut sharply by the heavy entablature and the springing of the arch is masked by the columns '. . . a more mature style never tolerates concealment of the springing of the arch . . .' We watch these difficulties gradually disappear. The side areas of the arch of Garvi were given a better relation to the central arch by being extended. The slender proportion of the arch allows the supporting members greater height (that is, given the same size of structure, a smaller circle for the arch will narrow it, allowing both taller supports and wider side walls). Then, in the arch of Titus, the supporting members of the arch and of the entablature were firmly differentiated. Finally, the inclusion of a

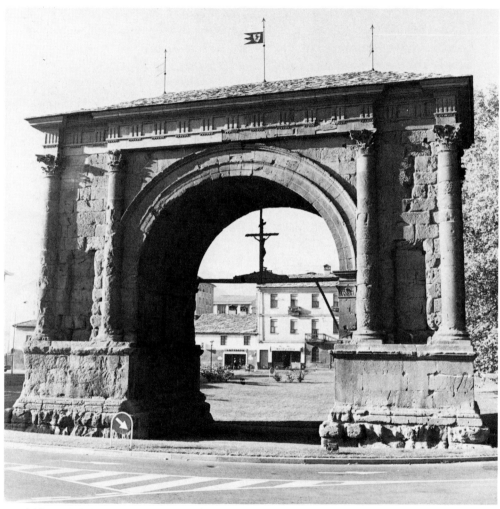

34. Triumphal Arch, Aosta.

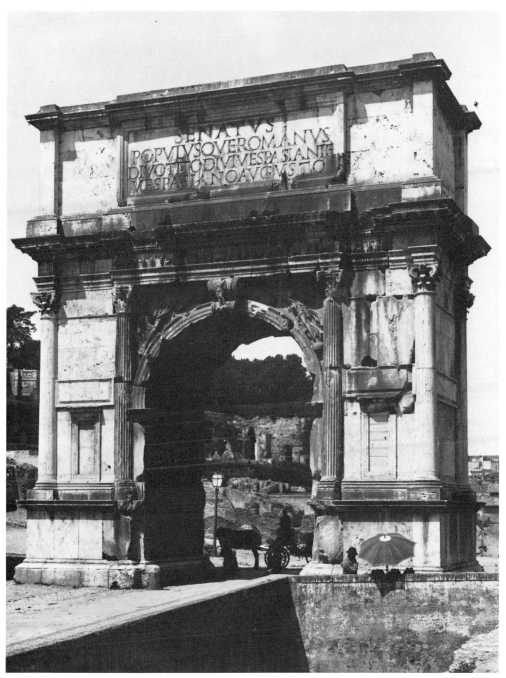

35. Arch of Titus, Rome.

console relates the arch and the entablature, and the curve of the arch is more fully articulated in relation to the wall.

Wölfflin's paper raises the problem already considered in commenting on Schnaase: the later work within the genre is seen to solve a problem that was previously present. But for *whom* was there previously a problem? Do we assume that there was some ideal to which all artists working in the genre were striving? Do we believe, for instance, that when the builders of the arch at Aosta masked the point from which the arch sprang, or let the entablature press against the vault, they were doing unsuccessfully what the architect of the arch of Titus was doing successfully? From the viewpoint Wölfflin adopts in this paper, no distinction is made between artists *seizing an opportunity* for enhancing elegance and integration, and *overcoming a difficulty*, felt as a defect, in earlier works. It might be argued here in Wölfflin's defence that he need not be holding such a firm teleological view but, like Aristotle on the development of tragedy, merely giving an account of a genre reaching its optimum organisation: but the defence breaks down because, unlike Aristotle, he describes the development as one of later works overcoming problems in earlier works.

Wölfflin never returned to a teleological argument of the kind used here, but his position in this paper possesses two fundamental features of his later theories: first, the assumption of an autonomous visual tradition with its own principle of development; second, the sense that the achievement of each group of works is understood by the way it transforms and transcends its antecedents.

iii. *Wölfflin, Burckhardt and the High Renaissance*

In 1893, the year in which Wölfflin published his paper 'Die antiken Triumphbogen', Adolf Hildebrand published *Das Problem der Form in der bildenden Kunst*.[12] Wölfflin had known Hildebrand, who was a generation older, for some years, and he reviewed the book in a very succinct article giving a clear account of its argument. Hildebrand was a close friend of the philosopher Konrad Fiedler, and *Das Problem der Form* fits within the broad outline of Fiedler's conception of art.[13] Like those who developed Schopenhauerian and Hegelian ideas into empathy theory, Fiedler started from the assumption that our perception of art had to be

distinguished from our perception of things in ordinary, everyday experience. But Fiedler saw this as achieved not by projecting physiognomic qualities or inward states onto the objects of perception, but by articulating and ordering our perception beyond its ordinary fragmentary character. The raw materials for such ordering were the visible qualities of the represented subject, as well as the visible qualities of the artist's material. For Fiedler the artist's formulation was the visual counterpart of the development of conceptual knowledge in philosophy; art was understood by Fiedler as an autonomous exercise and not as reflecting, or produced by, social conditions. It was a free development of our minds in the area of vision. Hildebrand's *Das Problem der Form* is very much narrower than this general theory. The problem of the title is that of how to construct objects of perception which will enable us to gain a clear three-dimensional grasp from a single viewpoint. This was a problem on the assumption that our eyes were only able to obtain two-dimensional impressions, and that we had to infer the three-dimensional character of objects from two-dimensional features. The basis on which we made such unconscious inferences were such visual cues as overlap, cast shadows, differences of apparent size of similar objects, relating the different impressions of the same object received by our two eyes, and by registering the difference between impressions of the same object when we moved our heads. Hildebrand assumed that we had a very clear apprehension of forms running at right angles to our line of vision, but a wavering and uncertain sense of relations in depth. We might be inclined to say that he had projected onto ordinary perception the problem of the representation of form in painting and relief. But this was precisely what the perceptual psychologists of the nineteenth century had already done, in assuming that we build up our three-dimensional grasp of the world on the basis of what initially appeared to us as flat pictures.

The belief that forms that lay in the plane at right angles to the line of vision could be firmly grasped and that all other relations should be approximated as nearly as possible to this plane, or to a series of contiguous overlapping planes, was enforced by the example of classical relief sculpture (Plate 15). In such relief, figures were, where possible, so placed that their most revealing and lucid contours appeared in the relief plane. The representation

of depth was achieved in two ways: first, by use of forms which we could see both as lying in the plane *and* as suggesting depth, without our making any abrupt break between the two interpretations; then, secondly, when one form lay behind another, this was shown by one form overlapping another, but in such a way that we did not feel forced to decide whether the overlapping shapes were contiguous or far apart (overlap, as a cue, does not in itself reveal the distance between the object in front and the one behind). Furthermore, as far as possible, this ideal of relief involved adjusting discrete features to make a continuous form across the relief surface.

For Wölfflin, the ideal of classical relief sculpture, which was firmly part of his Burckhardtian background, would have underpinned his adherence to Hildebrand's analysis. Classical relief represented an achievement which was not only an adjustment of the medium to what it represented but, for Burckhardt, a way in which the sensibility of antiquity extended its own sense of inner poise:

In the representation of the figure Greek art discovered, after a long search, that beautiful intermediate position between profile and frontal view, which, in the most lively moments seen in profile, revealed the body in its fullness and knew how to develop the upper part of the body in the most pleasing way . . .[14]

It is this poise, and this order which came together in Wölfflin's *Classic Art*.[15]

In the more theoretical part of *Classic Art*, Wölfflin gave a general explanation of the transformation of Italian art from the quattrocento to that of the cinquecento, and he described this transformation under three headings: the new temper or ideals, the new beauty, and the new pictorial forms.

The new temper is characterised by an urbanity of deportment. Comparing the *Baptism* by Andrea Sansovino with one by Verrocchio (Plates 36 and 37), Wölfflin writes:

The Baptist is not arriving on the scene, he stands there quite calmly . . . and only the vigorous turn of the head goes with the direction of his arm, fully extended and holding the vessel over Christ's head. There is no anxious following up of the movement, no bending forward; the act is performed with ease and restraint . . .[16]

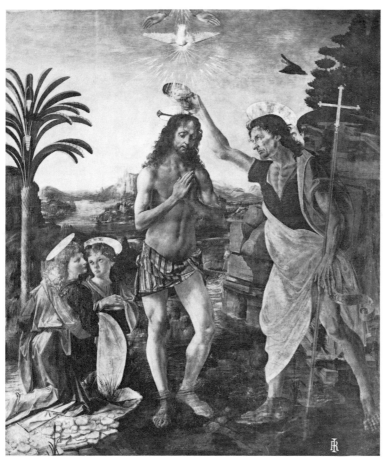

36. Verrocchio, *Baptism*, c. 1470, Florence: Uffizi.

37. Andrea Sansovino, *Baptism*, c. 1502, Florence: Baptistry.

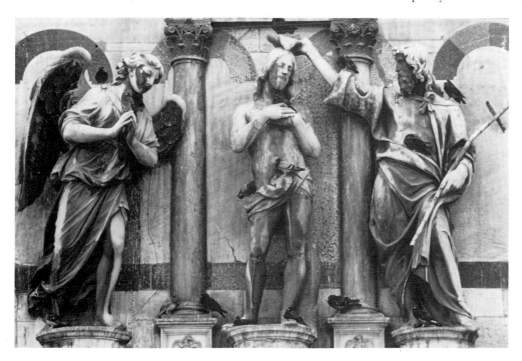

And on Raphael:

What grandeur of perception animates the drawing for a tapestry of the Coronation of the Virgin, what a sweep in the gestures of giving and receiving! It takes a strong personality to keep these powerful expressive motives under control . . .[17]

The new temper transforms a bourgeois art of anecdotal interest and everyday subject matter into an aristocratic art of symbolic and reserved dignity.

When Wölfflin comes on to the new beauty, he writes:

. . . The real kernel of the style is the new outlook upon the human body and in new ideas about deportment and movement . . . The actual gait of the women has changed entirely; instead of a stiff mincing it is a composed and dignified motion—the tempo has slowed to *andante maestoso* . . .[18]

Wölfflin's new temper and new beauty are hardly very distinct and it comes as less than a surprise when at the end of the book, they are in effect, elided. His real distinction is between, on the one hand, beauty and temper taken together, and on the other, the new pictorial form:

The real artistic principles are on the one hand, clarification of the visible object and simplification of appearances, and on the other, the desire for ever greater variety of content within the field of vision. The eye desires more, because its powers of absorption have been increased, but at the same time, pictures have become simpler and more lucid, insofar as the objects represented have been better prepared for the eye.[19]

Hildebrand's conception of relief was a paradigm of such ordering.

There had been an awkward change of plan in the writing of the second half of *Classic Art*; a switch from three critical conditions of style to two. It starts with the three-fold division which corresponds to Burckhardt's account of the decline of ancient art in *The Age of Constantine*: the decline of the human physique, the move toward fussy, more elaborate clothing and coiffure, and the movement of art toward 'coarse naturalism'.[20] In fact, Wölfflin's account of the rise of classic art in the cinquecento seems to be a neat reversal of Burckhardt's account of the decline of ancient art. That Wölfflin abandons this model is one symptom of the difference between their positions; while Burckhardt had seen all

three factors as part of a global picture of ancient culture, Wölfflin was concerned to put the surrounding culture on one side and the visual tradition on the other.

Wölfflin treats the—supposed—change in social ethos and the visual tradition as joint conditions of the new art. He deliberately avoids making either appear as *the* determinant of artistic change, and he avoids asking the question whether the strength of personality which keeps 'powerful expressive motives under control', was quite independent of the 'power of grasping the variety of things in the field of vision as a single unit' and 'the desire of the cultivated eye for ever richer and more significant images'.

The two components of Wölfflin's view, the change of social attitudes and the development of the visual tradition co-exist unrelated, and yet this lack of relation does not appear to worry Wölfflin. Perhaps this was because of the parallelism between them: both involve rising above the detail of everyday experience.

Another contrast between Burckhardt and Wölfflin appears if we turn to Burckhardt's later writings. Thus, after remarking on two quattrocento paintings of the *Pietà* by Perugino and Francia, Burckhardt wrote:

The sixteenth century opens with several works which have an ideal quality and a grandeur through simplification. The wonderful image by Fra Bartolomeo ... perhaps surpasses all in moving beauty so economically achieved[21]

Grandeur, simplification and economy are part of one family of concepts, and in their use the social and visual factors of style do not seem separable. A further example of such indissoluble unity of social and artistic appears in another passage. In his *Recollections of Rubens*, Burckhardt compared the way in which Rubens set about his series celebrating the life of Marie de Medici, with the way in which a nineteenth-century artist would have been required to work:

First he would have been expected to paint the whole past history of Brabant and the rest of the Netherlands, realistically, in historically accurate costume, with the old battles, rebellions, festivals and so on, and all that not on account of its artistic quality, but in the name of patriotism and even progress ... Rubens, however, did not do what the prevailing opinion of our day would expect him to do. He accepted, in

perfect freedom, a commission from a foreign sovereign which he could just as well have refused. But it appealed to him, and by far the larger number of paintings in the series show that it appealed to him, since he was, for the most part, able to suggest and invent them himself.[22]

Rubens's *artistic* freedom and grandeur are opposed to the *artistic* servility of anecdotalism. Here again, we would seem to have no way of deciding whether to regard this as a difference of society or visual style, not now because Burckhardt is seeking a global account of cultural history as he had been in *The Age of Constantine*, but because in looking at the paintings his focus was single and not double; for him the visual performance is permeated with social attitudes, with qualities of mind and personality.

When Burckhardt considered the shift between quattrocento and cinquecento art, he raised the problem of separating and connecting its social and visual determinants, perhaps with Wölfflin's approach in mind:

How far the later art is the manifestation of a new project on the part of the artist, or of those represented and their social level, or how far it is a combination of the two, one has to decide in each particular case.[23]

But reserve of this kind which remained absorbed in the intricacies of the particular case was not something Wölfflin was able to accept. His response is developed in *The Principles of Art History*.

VII

THE *PRINCIPLES* AND ITS PROBLEMS

AFTER WRITING *Classic Art*, Wölfflin saw that he had an unresolved problem. What he did was to decline its challenge and attempt to consider the performance of artists simply from the point of view of the cultivation of the eye. In this, his real interest lay in an extremely refined visual analysis of painting. It developed out of two models: on the one hand, Hildebrand's *Das Problem der Form*, and on the other, the sense of the way architecture transforms and re-presents the forms of earlier architecture. Where Wölfflin says even painting owes more to earlier art than to nature, where he gives priority to the sense of design over representation, we can feel the force of the paradigm of architectural history. The ways in which it can and cannot serve as a model for the study of painting are an integral part of the interest of Wölfflin's book.[1]

We have seen how later architectural forms reproduce earlier architectural forms—they *re*-present them, and in so doing they sophisticate and elaborate those earlier forms, for instance, the way clustered pilasters are carried into and interpenetrate the broken pediment. If we turn to the history of painting and drawing the analogy may seem to break down; as a general rule we cannot say that one painting *re*-presents forms of earlier works, as one piece of architecture invokes and varies the form of an antecedent building. But what we can say, often, is that the technique or style of one drawing, sophisticates and plays a variation on the technique or style of the other. And this is what Wölfflin held in the *Principles*.

i. *The Descriptive Scheme*

I shall give a brief account of the descriptive concepts which constitute the core of the book, before going on to questions of the way they are given their theoretical status. It seems appropriate to vary Wölfflin's examples to some extent to bring out different factors covered by his terms.

The first pair of concepts in the book designed to characterise

the shift from High Renaissance to seventeenth-century painting, is that of 'linear' and 'painterly':

The meaning of seeing linearly is that the sense and beauty of things are sought first of all in outlines—interior forms also have their outlines—so that the eye is led along the outer limits and drawn to a sense of the tangible edge of objects . . .[2]

What Wölfflin is picking out with his notion of linearity is, first of all, a *relation* between medium and object: it is not a matter of drawn lines or of edges, but a correspondence, a use of one to pick out the other. And it is not merely a certain kind of equivalence between object and medium, but one with a particular purpose: to achieve clarity in the spatial separation and relation of objects. This notion of a lucid outline therefore implies that figures or forms must be presented to the eye in a position from which they are readily intelligible.

Painterliness too has a general objective, the search for elusiveness as opposed to the tangibility and clarity of linear art. And, correspondingly, painterly art is characterised both by certain kinds of equivalence between medium and represented objects as well as the selective attention to certain aspects of those objects: 'attention is withdrawn from the edge and . . . outlines become a matter of more or less indifference as guidelines', so that the eye's grasp of objects depends primarily on the impression of patches of light and shade.

We can illustrate the distinction by contrasting a drawing by Raphael with one by Rembrandt (Plates 38 and 39). Although Raphael's line, marking the folds and swellings of drapery, may seem to disturb the main sense of the body's volume, it in fact amplifies and clarifies it; the lines mark the edges of the subordinate shapes which in turn give definition to, for instance, the shoulders and thighs.

In Rembrandt's drawing of the seated nude in profile, if we look at the line of her back, we may at first see this as a thoroughly linear definition; but the continuous line is far from constituting a continuous edge. A synoptic view keeps it as a single form, where detailed attention makes us aware of the multiplicity of direction—the number of forms—which is unified and related by being caught up in it. Another departure from the demands of linear drawing occurs in the treatment of the forward shoulder,

the definition of which is so strongly suggested without the edge being marked. There is a related device in the etching of the head of Saskia (Plate 40); we have to search on the left of the head for the disappearing edge of the form, but the elusiveness of the edge we cannot see is made the more palpable by the way we can almost confuse it with the shadow cast by Saskia's hand; it offers us a false resolution of our search for the form.

In these departures from linear art, expectations are set up and counterpointed; we are led to search for contours which are not explicit, or we are offered 'continuous lines' which on closer attention do not register a single continuous edge. But the departure from the linear does not always involve counterpointing our expectations.

Wölfflin describes the painterly 'liberation of areas of light and dark from the definition of the form' as 'alienated' from form. This could suggest that the painterly use of light was cut loose from the role of defining forms and spatial relations, whereas the areas of light and dark themselves register the spatial interrelation of forms, even if they disturb more obvious cues of recognition. Thus, in Rembrandt's etching of *Adam and Eve* (Plate 41), Adam casts his shadow across the belly of Eve and light from her seems to be reflected onto his side; the play of shadows both complicates and establishes the relations between figures.

Wölfflin's second pair of concepts, planimetric and recessional, are closely tied to the first pair and derive explicitly from a conception of classical shallow relief. The term 'relief-like' recurs throughout the section. Firstly, in planimetric composition as in classical relief sculpture 'objects are ordered in strata parallel to the picture plane'. That is, objects are presented so that they are clearly readable in the plane, without our being prompted to imagine ourselves looking at them from some other angle; i.e. there are no awkward foreshortenings. Spatial suggestion is rendered by forms which read easily in the plane as well as suggesting depth and more abrupt changes in depth are achieved by 'overlap', in which the distance between front and back shape is left indeterminate. 'Plane and recession,' writes Wölfflin, 'have become one element, and just because the whole is interspersed with foreshortened forms, we feel that their acquiescence in the order of parallel planes is done freely, and obtain the impression of richness simplified to the greatest repose and explicitness.'[3] If we return to the drawing

38. Raphael, drawing for the Alba Madonna, *c.* 1511, Lille: Musée Wicar.

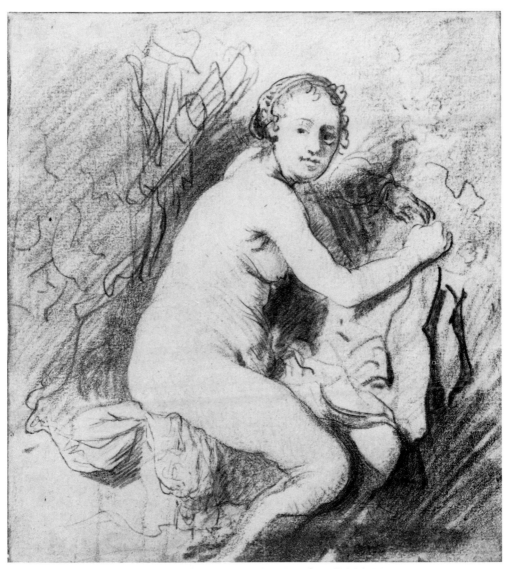

39. Rembrandt, study for Diana, drawing, *c.* 1630, London: British Museum.

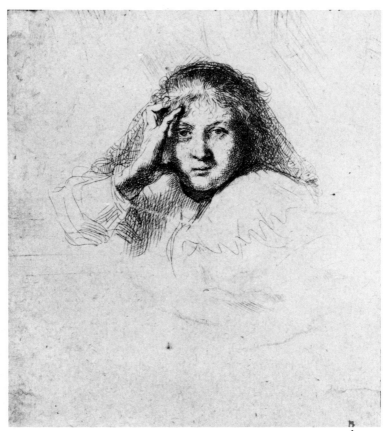

40. Rembrandt, *Head of Saskia, c.* 1637, etching, London: British Museum.

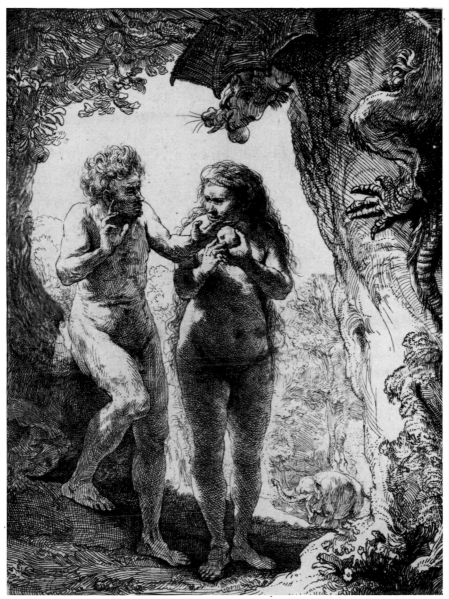

41. Rembrandt, *Adam and Eve*, 1638, etching, London: British Museum.

for the Alba Madonna (Plate 38) we can surely use the notion of the acquiescence of the foreshortened forms of the forward leg and the bent arm in the relief-like order.

We can observe the application of this principle in detail in the *Madonna and Child with St John* in the London National Gallery (Plate 42), in which the oblique angle at which the Madonna is seated opens up the space in which the Christ Child is set so as to bring their combined forms into co-ordination with the plane parallel to the picture surface. This recurs in the way St John fills the space opened up by the way the Madonna extends her left arm; the complementarity of their forms is made exact by the coincidence of the definition of the Madonna's hand and the shoulder of St John, and by the continuity of the movement of the Christ Child's arm and the curve defining the Madonna's shoulder. These linear continuities run both through discrete forms and through variations of spatial direction, enhancing the volumetric lucidity in so doing.

It is an aspect of relief-like composition, even when it includes the representation of recession into distance, as in Mantegna's *Crucifixion* or Ridolfo Ghirlandaio's *Christ Carrying the Cross* (Plates 43 and 44), that the main order of the composition lies parallel to the picture surface. It runs from side to side. What Wölfflin contrasts with this is the painting in which 'the contents of the picture can no longer be grasped in plane sections, but the nerve lies in the relation of foreground to background parts', as in Rubens's *Coup de Lance* and *Carrying the Cross* (Plates 3 and 14), and Rembrandt's *Adam and Eve* (Plate 41). It is a contrast too between the ordering of Titian's *Woman at her Toilet* and Rembrandt's Edinburgh painting of a woman in bed (Plates 1 and 2).

A third distinction which Wölfflin introduces is that between closed and open form. This is a distinction between works in which the depicted contents seem to stand in a clear relation to the edge of the depiction, so that the viewer in his turn can regard his relation to the edge of the picture, particularly the bottom edge, connecting his position with the subject's, as in Titian's *Woman at her Toilet*. We can have no such clear spatial relation to Rembrandt's figure as she leans forward holding the curtain. The distinction can be made in the case of the other works we have been considering.

The calculated curve of the summit of Calvary in Mantegna's *Crucifixion* gives the suggestion that it drops below the bottom

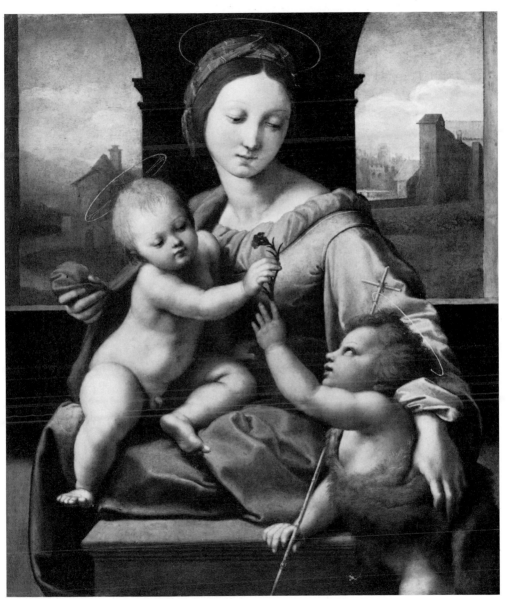

42. Raphael, *Madonna and Child with St John*, c. 1510, London: National Gallery.

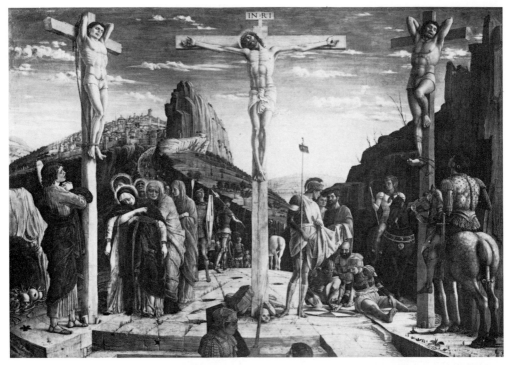

43. Mantegna, *Crucifixion*,
1457–9, Paris: Louvre.

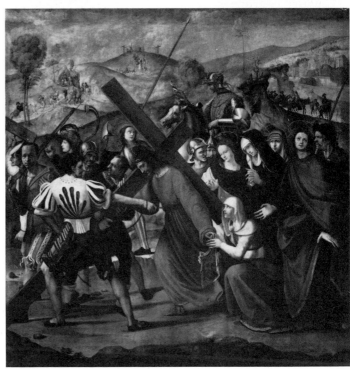

44. Ridolfo Ghirlandaio,
Christ Carrying the Cross,
c. 1520, London: National
Gallery.

edge of the painting, just as that edge occludes our view of the foreground soldier below the shoulder. There is no such relatability between the ground plane or the figures and the edges of Rubens's *Coup de Lance*. Figures to the left are cut off from view but surely not spatially relatable to the edge, and the base line of the picture can hardly be related to the ground plane within the depiction, because the ladder in the foreground—so far from being close to the edge of the fictive space—actually slopes toward us, so that the depicted space reaches much further in our direction than the point at which the ladder rests.

In the contrast between open and closed form, Wölfflin includes further ways in which orientations within the picture are enforced by, or disengaged from, the picture's frame and surface. On open form—and this is particularly pertinent to Rubens's painting—he writes:

There is no longer an affinity between the lines of the figure and the rectangle of the depiction. The distance of the figure from the frame is no longer a constituent of the pictorial character. Even when the body is presented frontally, it does not take on this frontality by relation to the surface. Pure oppositions of direction are eluded, and in the body the axial relations make themselves felt only implicitly and, as it were, from within.[4]

Wölfflin's two further contrasts are elaborations of the first three. It is not, I think, difficult to see the general continuity between the oppositions which Wölfflin is considering. The linear explicitness, the coincidence of real mark or outline with the lucid space-revealing edge, is set against a mode of presentation in which we are left to search for the space defining edges, where the coincidence between spatially revealing cues and painted or drawn marks is made less complete, allowing the artist more refractory positions and conditions of illumination. In the planimetric-recessional distinction we have an extension of this: in planimetric painting the overall arrangement of the components is subjected to relief-like ordering, which again means the greatest coincidence of the spatially suggested form with the surface, or the surface conceived as shallow space. When this is breached, it is done so that we no longer read across the surface but make crucial connections between the foreground and background. And this may mean we have to look for relationships less immediately

graspable. In this way the third antithesis, between closed and open form, is related to the first two; in the linear and planimetric and closed form there is a neatness of fit between the physically present surface—its edges, its direction and the marks on it—and the depicted subject; in the painterly, recessional and open form, this neatness of fit is abandoned.

The later categories—the painterly, the recessional, the open form—avoid those more fundamental factors which define for us the world as a world of discrete objects set out in space, and they avoid the more obvious kinds of equivalence between subject and medium which characterises the linear, planimetric and closed form. The later style, in presenting more uncertain relations, leaves to the spectator a more exploratory role.

It is in a brief passage on Titian that Wölfflin perhaps gives the clearest sense of how he sees the change in style being generated:

If the great individual like Titian incorporates perfectly new possibilities in his final style . . . these possibilities of style first came in sight because he had already left so many possibilities behind him. No human being, however distinguished, would have been able to conceive these forms if he had not previously been over the ground which contained the necessary preliminary stages.[5]

What is suggested here is a very general theory to account for the change in style; it is very much more general than the particular stylistic development he in fact traced. It is in terms of growing familiarity with a family of forms which, we must assume, makes new kinds of elaboration possible and desirable. This wider thesis, the account of the development of art by reference to the growing familiarity in the handling of forms, is suggested fairly frequently in Wölfflin. Thus, at the end of the *Principles* he writes about the emergence of Baroque art:

The development will only fulfil itself where the forms have passed from hand to hand long enough, or, better expressed, where the imagination has occupied itself with form actively enough to make it yield up its baroque possibilities.[6]

This gives us the central features of Wölfflin's position in the *Principles* with regard to painting and drawing. What problems does it raise?

ii. *The Separation of Visual Tradition*

The descriptive skill, the economy and perspicacity of Wölfflin's schemata or ideal types have never been in doubt. What has been challenged is the theoretical force or status of his concepts, the importance or significance which he gives to them.

The first, implicit claim for this account of visual style is that it shows the nature of the artist's own achievement as opposed to the impact of cultural conditions on his work; these fundamental visual forms mark out the zone of the artist's contribution—the artist is the formulator and he formulates in systems characterised by these concepts. This position has an obvious difficulty: how the artist illuminates his subject matter and how he produces dramatic effects in, say, a *Pietà* or *Raising of Lazarus* is left out of this account. Assuming that some factors like those which Wölfflin analyses must feature in any account of the artist's performance, they could not constitute a *sufficient* account of his performance.

This may be brought out more fully when we look at the second role which is given to the visual categories, that of accounting for the historical transformation of art. For clearly Wölfflin sees a consequentiality in the development of art:

Someone who looks at the world with the eye of an historian knows the deep sense of good fortune when things appear in a clear order of cause and effect—if only for a limited span; when what confronts us loses its sense of the accidental and becomes intelligible as something coming into being, and coming into being necessarily.[7]

But how are we to understand this consequentiality? First of all it would appear to be the way in which one artist draws upon and modifies the work of his predecessors. But when an artist draws upon earlier work he derives from it not simply visual forms but dramatic dispositions, not only ways of defining forms but sensitivity toward the character of what is depicted.

For example, Rembrandt's *Deposition* clearly has as one of its sources the *Deposition* of Rubens (Plates 45 and 46). Rembrandt has turned the main group and set it obliquely to the spectator; he has concentrated the light where Rubens had diffused it more evenly, and in doing these things he has re-interpreted the event. These are the kind of changes we can describe in Wölfflinian terms. But there are others. The idealised body of Christ is avoided by Rembrandt, in whose treatment the muscles of the body have gone slack. The

45. Rembrandt, *Deposition c.* 1633,
Munich: Alte Pinakothek.

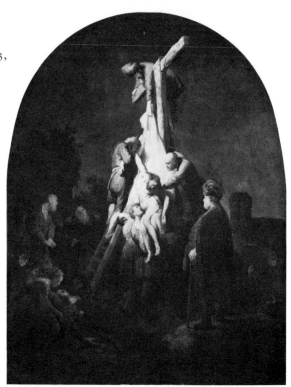

46. Rubens *Deposition c.* 1614,
London: Courtauld
Institute of Art.

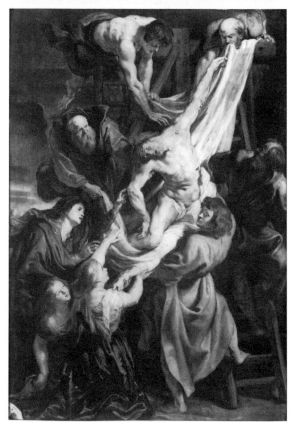

nature of the pathos is quite different. With the concentration of the light, have come other changes: there is a sharp separation of the group with Christ from the scene of the Virgin at the foot of the Cross, which becomes a kind of sub-plot. There is then the contrast of the grief of the figures on the left and the figure of Joseph of Arimathaea planted firmly on the right, who is given an importance which he does not have in the Antwerp altarpiece.

Wölfflin's theory of two roots of style would exclude such features from the visual root of style, and so, we must assume, from the tradition internal to the art of painting. If we follow Wölfflin, we shall try to explain these other changes by referring them to the surrounding culture: to such facts as that Rubens was painting an altarpiece for a Catholic cathedral, and Rembrandt a series of narrative paintings of the life of Christ within a Protestant milieu in which, among other things, Joseph of Arimathaea might have been seen as an exemplary elder of the community taking responsibility. But this account imposes implausible restrictions on how we may see one artist drawing upon the work of another; it assumes that the respect in which he learned from earlier artists is restricted to the visual procedures and sense of design, all else being put to the account of contextual factors. But it is not clear that the emphasis given to Joseph of Arimathaea was something that Rembrandt did not derive from a visual example. Rubens's composition was itself developed from Michelangelo's great *Pietà* in Florence, transforming Michelangelo's sculptural composition into painting (and each in turn used the classical Laocoon figure to provide a model for the representation of Christ). Perhaps Rembrandt too had looked not only at Rubens, but at an engraving of the *Pietà* by Michelangelo. There he would also have found Joseph of Arimathaea playing a major role. The point is that we cannot assume that differences other than of the kind Wölfflin considers do not derive from earlier works of art. We have no way of determining in principle, what an artist may take over from earlier artists, as opposed to what he takes over from other sources within his culture.

The relation of an artist to the tradition in which he works, that is, to earlier paintings which are exemplary for him of what his art is and what his art can do, is not merely a matter of the visual morphology unless this is understood so broadly as to include dramatic motifs, procedures of drawing and composition, and the

whole scope of the painter's achievement. Thus, the division between two roots of style, where one root is the link with previous art, and the other root the link with the surrounding culture, cannot—as Burckhardt made explicit—be subjected to some general rule. Because there are no limits in principle as to what ideas may inform the visible character of works, there is no limit in general as to what may feature within a visual tradition. This is not to say that there is no distinction to be made between an artist's relation to past art and his relation to social factors outside his art, but only that there is no general demarcation which can be put, *a priori*, to what can be learned from a work of art by a later artist.

There is another implication to Wölfflin's separation of the two roots of style which has not so far been remarked on. Let us take a second comparison, that of Giotto's *Raising of Lazarus* and the same subject treated by Ghiberti (Plates 47 and 48). It is clear that Ghiberti has taken from Giotto the dramatic device of the turning figure in the surrounding crowd who mediates psychologically between Christ and Lazarus. But the treatment of the miracle has undergone a substantial change. Where Giotto has separated two parts of the story, the appeal by Mary and Martha to Christ, and his raising Lazarus, and has given Mary and Martha the same pose, Ghiberti has allowed the figure of Martha to interrupt the narrative relation between Christ and the dead man, thus giving a new importance to the mediating figure. He has also introduced the motif of the lying figure of Mary, distraught at Christ's feet, and in this way he has marked the difference between the two sisters.

We might interpret the change which Ghiberti makes on the schema of Giotto's composition as a matter of producing a variation on the simpler formulation, intercepting one narrative line by another, making the composition more integrated but also more complex. While this would not be a Wölfflinian analysis in a narrow sense, it would consider the second composition as a development discussed within the history of visual formulation, where this was interpreted liberally to include dramatic devices.

But there is an alternative way in which the difference between the two compositions might be considered. In St John's Gospel, the only gospel to describe the episode, it is first of all clear that Christ allows Lazarus to die, in order to perform the miracle for all

to see; the mediating figure and the crowds around him are therefore integral to the story. Further, in the text the responses of Mary and Martha to their brother's illness are distinguished. Martha goes straight to Christ, while Mary—in her misery—remains at home; when she does come she, but not Martha, is described as falling down at his feet. But Giotto has not necessarily been a more careless reader than Ghiberti in showing the two sisters so exactly parallel. For when eventually Mary approaches Christ her words exactly repeat those of Martha earlier in the story: 'Lord, if thou hadst been here my brother had not died.' Considering the two treatments of the *Raising of Lazarus* as if one developed out of the other, seeing Ghiberti as complicating Giotto's design, and considering them in relation to the text are obviously not mutually exclusive alternatives, and from this a further consideration arises. One way of putting it might be to say that for Ghiberti the text must have been permeated by Giotto's depiction just as Giotto's depiction must have been permeated by the text. The notion of a purely visual tradition presupposes a devisualised culture to complement it.

There are thus two complementary difficulties about Wölfflin's conception of an independent visual root of style. First, it presupposes that we can delimit a class of features in works of art which constitute the artist's contribution *qua* artist and which later artists draw from the work of their predecessors, but, in fact, we could have no general way of delimiting that class of features. Correspondingly it assumes there is a non-visual root of style devoid of visual articulation. These criticisms cover not only Wölfflin's theory but also any others constructed on the same principle of isolating a visual tradition.

iii. *The Transformation of Art Through History*

Let us turn now from Wölfflin's conception of the two roots of style, to his related conception of the self-transformation of style through history. The first problem which this presents is that it is unclear how the transformation of style is related to the understanding of particular works. For if the transformation of style from linear to painterly, planimetric to recessional, and so on, is regarded as a generalisation made on the basis of finished works, we are confronted by the problem of how far the characteristics

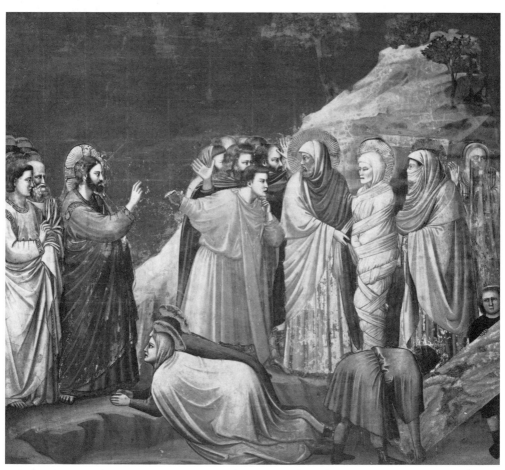

47. Giotto, *Raising of Lazarus*, c. 1310, Padua: Arena Chapel.

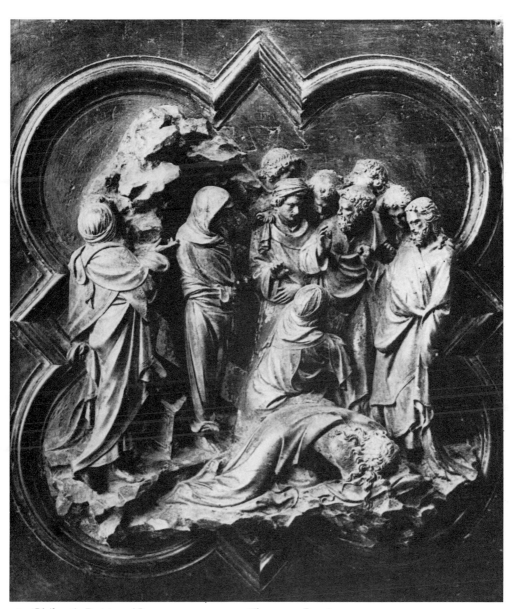

48. Ghiberti, *Raising of Lazarus*, *c.* 1410–20, Florence: Baptistry.

thus abstracted can illuminate the works which bear the characteristics. Could we not generalise across finished works and abstract quite unilluminating factors? We might, for instance, distinguish a gradual tendency for compositions to have their focus further and further to the left, or to include an increasingly wide range of reds, or to contain more or less use of colours of low saturation. Any of these *may* be critically relevant but just generalising a trend would not show critical relevance;[8] it would not enable us to see their importance for one particular work or group of works. So why should we regard Wölfflin's generalisations as faring any better? How do we see the sequence marked by his concepts as penetrating our understanding of particular works and not simply as generalisations which cover the works without becoming integral to our understanding?

A particular form in which the problem shows itself is this: earlier works are not always related to later works in the same way. In the case of many major works, we have no idea of the immediate sources upon which the artist drew. But where we do know the sources, the roles they play in our understanding of the particular work may be very diverse. It is perhaps useful at this stage to distinguish some of the ways in which the work of earlier and later artists are related.

For instance, an architectural feature like Brunelleschi's augmented column (Plate 49), which includes a section of entablature which echoes and reduplicates the capital, had, as Burckhardt observed, numerous anticipations.[9] Although not as part of a free-standing colonnade, this feature had already occurred in antiquity where a section of entablature within a wall had projected over a column standing in front of the wall; it recurs in the façade of the Florentine Baptistry and it is also anticipated in the way fourteenth-century Florentine architects treated the piers of the Loggia dei Lanzi. But in appreciating this range of sources, we do not see Brunelleschi as offering a variation on an earlier theme; he was re-using a device. If we were to see it as a variation on an earlier theme, what would be the theme? The original classical column and entablature? or the column with the projecting entablature? or the form that this took on the Romanesque façade of the Florentine Baptistry? What concerns us is the way the device is used in the context of Brunelleschi's building; the way the cornice of the entablature block echoes the

49. Capital, Santo Spirito, Florence.

capital and makes the arch appear to spring in two stages, enhancing its eloquence in innumerable ways (Plates 50 and 51). Thus our sense of sources may enable us to articulate what is before us, without our seeing those sources as invoked or as the theme of a variation.

Secondly, a work may invoke an earlier work without presenting itself as a variation of it. Ghirlandaio's frescoes in Santa Trinita invoke the frescoes of the life of St Francis by Giotto (Plates 52 and 53) and in doing so enforce the theme of the Florentine heritage which runs discretely through the fresco cycle, with its views of Florence as the settings for episodes and numerous other details. We are not, surely, invited to see the frescoes as providing a *variation* on a theme of Giotto. Thirdly, there are cases where, clearly, we do see the work as a variation and *not* simply invoking or using an earlier motif, as in the broken pediments and undulating façade of Santa Maria della Pace (Plate 33).

Differences like these are effectively masked by Wölfflin's account of the change of style. Tracing a change of stylistic physiognomy over a period of time would not be an account of any artist drawing upon any previous artist's work; it would only be tracing a change in the look, to us, of the finished products, unless we had built into our understanding of the works concerned the purpose which artists had in transforming their sources.

iv. *The Cyclic Theory and the Generalisation Across the Visual Arts*

If the sequence is one which has a sense of purpose, that purpose is presumably of producing more compendious, more complex and more elusive relations both to the visible world and between the elements within the particular work. If we impart to Wölfflin's account of the transformation of style a sense of purpose of this kind, we can do this only because we attribute this purpose to the artists who bring about this change. But if we regard the artists themselves as possessing this aim, we must assume the aim present throughout the tradition—surely not only painterly artists have this aim. We must assume a general aim toward such enhanced complexity. But it would be implausible to regard that general aim as capable of fulfilment only in the history and with reference to the motifs which Wölfflin traces; these changes could not possibly

50. Santo Spirito, interior, Florence.

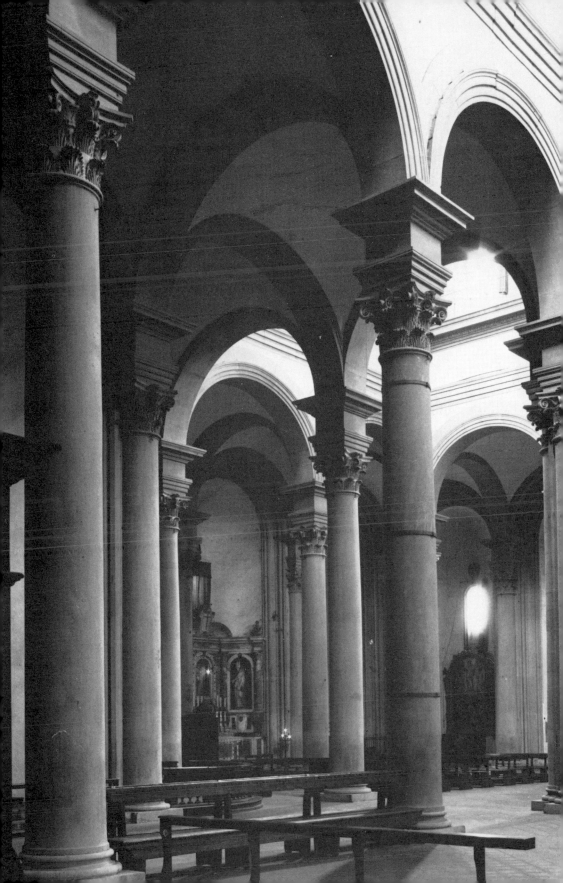

be seen as co-extensive with that general purpose. We need to distinguish that general purpose from the 'motifs' in which it is exhibited in Wölfflin's typology.

Once this distinction is introduced, two problems within Wölfflin's thought can be resolved. Had he made this distinction, he could have dispensed with his implausible cyclic view of stylistic development, in accordance with which a clear classic style is succeeded by an elusive baroque, after which there is a reversion to a simple style, and the cycle begins again. Once the general objective was distinguished from the particular motifs in which it was realised, he would have no reason to assume that a radical break or reversal need occur; for the way each artist called on the devices of previous art would be unlikely to fall into a single line of development, or to exhibit so very little variety at any one moment. Many other devices could be acknowledged as part of the thematic fabric which was being constantly re-worked. If we allowed for this diversity of motifs, we could also allow that when one mode of composition or one group of motifs was 'exhausted', others could be developed. Only if we assume that the process was tied to a few limited motifs would a radical break-down occur.

Once we have distinguished the general principle of modific-ation and the particular motifs in Wölfflin's theory, it also becomes easier to approach the question of how far we could accept his categories as covering painting, sculpture and architecture, how we could take seriously a scheme which sees the same principle in a landscape by van Goyen and a Baroque façade.[10]

In order to answer the question briefly, we might say that one quality of Renaissance architecture from Brunelleschi to Bramante was to present the viewer with clear architectural argument, making its ordering procedure manifest. Subsequently, once that procedure was well understood, its elaboration involved re-duplication, abbreviation and the reciprocally intercepting play of motifs. This, in fact, was very like the way in which the linear clarity of forms was disturbed by the shadows falling across edges and not along them, and the way spatial relations within painting became more elusive, and so on. The similarities between painting and architecture in the specific period from the Renaissance to Baroque, may be seen as deriving from the way each gained its motifs and procedures in the first period and then went through a course of sophisticating them.

51. Santo Spirito, columns seen from the aisle, Florence.

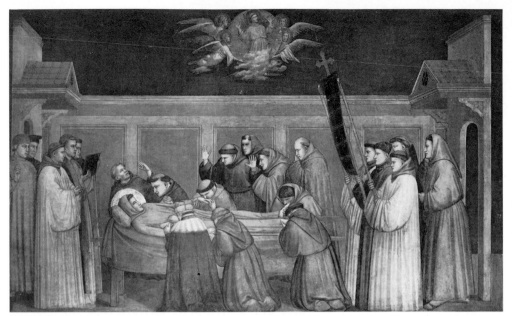

52. Giotto, *Death of St Francis*, *c.* 1320, Florence: Santa Croce.

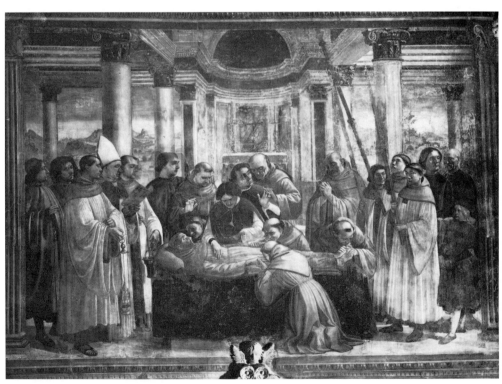

53. Ghirlandaio, *Death of St Francis*, 1483–6, Florence: Santa Trinita.

The correspondence between the two may not be susceptible to the strictness which Wölfflin attempted: his five distinct oppositions do not fit architecture very well, but the sense of transformation of motifs toward more elusive definition and broader effects still pick out a recognisable feature of both arts.

v. *Criticisms of Wölfflin's treatment of Architecture: Schmarsow and Frankl*

Wölfflin's treatment of architecture was the subject of a distinctive literature, and a brief account of this seems appropriate here. August Schmarsow, Wölfflin's earliest serious critic, was primarily a 'philological' historian, but he also wrote a considerable amount of critical history, in the sense used here. In the 1890s, he raised a number of questions about Wölfflin's treatment of architecture. His criticisms are directed at *Renaissance and Baroque* in the first instance (he later extended his criticism to the *Principles*) but the core of his argument remains the same.[11]

Schmarsow's criticisms focus on Wölfflin's notion of the painterly and are offered as part of a general theory of art, more particularly of how the main visual arts, architecture, sculpture and painting relate to each other. Each art is seen as a way to transform our visual confrontation with the world into something our minds find satisfying. In his account each of the main visual arts has a central characteristic or focus of concern. Architecture is primarily a matter of our sense of space—the space into which we move, the space which stretches out before us. The purest architecture—not in an evaluative sense of pure but just in the sense of being most clearly distinct from painting or sculpture— confronts us as external and defines the spaces into which we can move, or conceive ourselves as moving, with the sharp clarity of geometrical forms.[12]

As soon as we cease to regard forms as defining our avenues of movement and begin to empathise with them we are regarding those forms sculpturally. Sculpture is first of all a matter of erect vertical forms, an extension of our sense of the upright figure. As architecture was primarily a matter of defining avenues of movement in depth, so sculpture is primarily a matter of defining our posture in relation to the earth.[13]

What Schmarsow considered as the essential character of

painting was extensiveness. In his schematic conception the axis into depth was of the essence of architecture, the vertical axis of sculpture and painting's essential axis was horizontal, associated by Schmarsow with the picture plane. In Schmarsow's view, Hildebrand mistakenly associated the picture plane with sculpture.[14]

Having distinguished the three main visual arts Schmarsow goes on to make a second type of classification, of styles within the arts. His concepts of style are derived from his distinction between the arts, in that a style of, say, painting, may be sculptural or architectural—sculptural when the painting has a dominant vertical axis, where its overall character seems to be that of supporting forms or forces pressing vertically down—as in Michelangelo's *Last Judgement*[15] or Carracci's Farnese ceiling— architectural when it uses the sharp space defining edge to give a sense of the eternal and immutable as, says Schmarsow, in Raphael's *Disputà*.[16] For Schmarsow this capacity of each art to take on the character of the others shows the continuity between them. The 'realm of art' is seen as rather like a colour circle, with both its continuities and its acknowledged primary colours.

When Schmarsow distinguished different styles of architecture he regarded the Baroque—starting with Michelangelo's Laurentian Library staircase—as giving dominance to the vertical and so to the sculptural, just as he had seen Michelangelo's *Last Judgement* as sculptural painting. There was, in his view, a painterly architecture but, contrary to Wölfflin's account, it was present in one form in the Renaissance, for instance in the architecture of Brunelleschi's Santo Spirito, (Plate 50) with interiors which we assimilate to pictorial views, and Raphael's design for the Villa Madama; here the loose grouping of self-contained forms was integrated with its surroundings, it emphasised breadth and the plane rather than depth and recession.[17] Rococo architecture manifests painterliness in a different way. The edges of forms are dissolved and mirrors become a characteristic architectural feature (Plate 56), characteristic by virtue of the way they confuse spatial definition.[18]

Schmarsow's descriptions, which I shall not follow in further detail, do convey a sense of architectural experience different to that suggested by Wölfflin. The underlying weakness of Wölfflin's procedure was, in Schmarsow's view, that he failed simply to admit an adequate response to architecture and so denatured and

estranged it as part of imaginative life and he did this because he had failed to give his terms the conceptual clarity which must precede any critical description.[19] But Schmarsow's conceptual clarity, his tidy system of the major visual arts and their styles, each with its own dominant axis, now seems more like an object for intellectual archaeology than a secure *a priori* basis of criticism. It presents the grounds of its own critical relevance no more convincingly than Wölfflin's categories.

Schmarsow's criticism of Wölfflin, furthermore, does not challenge the isolation of visual concepts of style; it does not integrate form and a sense of function. Building largely on Schmarsow's typology Paul Frankl attempted this enlargement of viewpoint in his *Die Entwicklungsphasen der neueren Baukunst* (1914) of which the English translation was given the title *The Principles of Architectural History*, to suggest that it constituted a complement to Wölfflin's *Principles*.[20] Frankl provides a scheme for regarding the development of architectural history from the Renaissance to the nineteenth century. He treats the development from four points of view: first as the ordering of space, in the sense of spaces in which people orient themselves and through which they move. One such type of ordering is where one space is joined to another so forming a series—for instance, the way side chapels and central spaces are grouped, where each appears to offer a separate centre from which to orient ourselves. This he sees as characteristic of Renaissance architecture (Plate 50); this is contrasted to a relation of spaces where no one component seems thus independent but each seems to be a subdivision of a continuum—for instance, a series which seems to extend to infinity or goes round in an unbreakable circle as in Baroque interiors (Plate 54).

The second way of regarding the development is by looking at the physical masses and the way they represent forces; for example, the change from treating the forms of a building as an architectural skeleton, to 'the interpretation of all individual forms as components of a continuous skin, stretched or hung round the spatial form ... the play of forces on the continuous surface becomes more important than the musculature which is still present' (Plate 55).[21]

Thirdly there is his notion of 'visible form'; we may see many views but see them as views of the same building—which we relate to our underlying sense of the same building, or in diffuse Rococo

architecture we may, as it were, see an infinite number of partial images within a single view (Plate 56). What Frankl has provided is an elaboration of Schmarsow's three basic styles of architecture— the architecture of architectural spaces, of sculptural masses and of painterly effects—but he has turned them into three ways of regarding architecture.[22]

Finally, Frankl provides a fourth viewpoint: that which is concerned with function in the sense of social or religious intention.[23] His sense of function extends from the dominant concern for the well ordered household or the purpose of impressing visitors, to the details which involve the way we pass from one part of the building to another—for instance, from the box office to foyer to auditorium of a theatre—and it includes furnishing. Indeed it includes the whole life lived in and round the building and he regards the building as devitalised without it, a mere archaeological relic.

At this stage we must recall that our present purpose has been to see how Frankl's position serves as a criticism of, as well as a contrast to that of Wölfflin's view of architecture. The difficulty of Frankl's view regarding the relation of functional to formal development corresponds to the difficulty of Wölfflin's separation of the visual root of style. We can see Frankl caught up in this difficulty where he tries to bring together the two main strands; thus he writes— when contrasting Santo Spirito in Florence with the Gesù in Rome:

Only the Society of Jesus had a lasting effect on the people; it used art for specially religious ecclesiastical purposes. But once the architectural intention changed, the three formal elements had to be adjusted unconditionally.

And writing about the internal motivation for visual change:

He [the artist] begins to want that which he does not have and to work for that unattainable satisfaction by means not previously explored. By this I certainly do not mean that a kind of 'form fatigue' hurries on the new phase. Rather, it is the feeling that all the problems of the prevailing movement have been solved . . . The formal elements are changed by internal causes, then, and this change is sealed by external causes, by the new intention.[24]

But this is to remain with the visual root of style as autonomous yet in some pre-existent harmony with alterations in function and

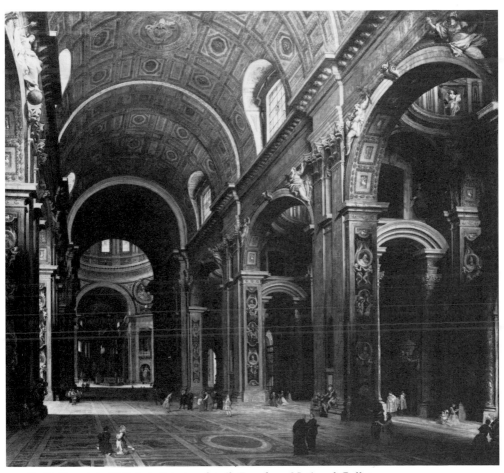

54. G. B. Pannini, *St Peter's Interior*, detail, London: National Gallery.

55. Zwinger, Pavilion
façade, Dresden.

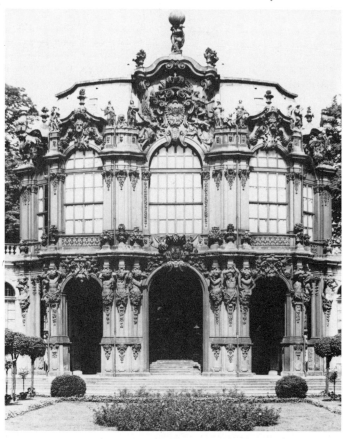

56. Residenz,
Spiegelkabinett, Würzburg.

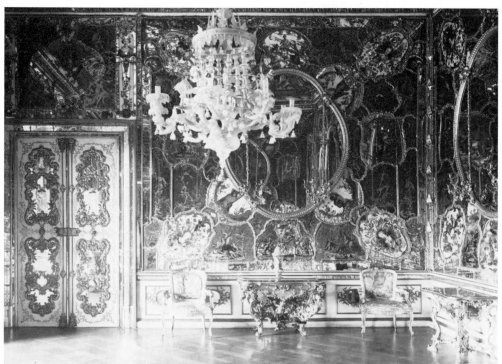

culture. This is open to the same objection as the two roots of style theory, as well as objections to the conception of a necessary unity within the age.

The interesting feature of both Schmarsow's and Frankl's theories is their extension of the phenomenological scope of architectural analysis, and of Frankl's introduction of function in a suggestive, if theoretically unintegrated, way.

vi. *Conclusion*

Wölfflin wrote about Dürer:

> When he is described as primarily a draughtsman, this does not mean that he drew more than he painted but that to him all natural phenomena transposed themselves into linear manifestations. He perceives the plasticity of the body for which he had a strong—sometimes exaggerated—feeling, in terms of linear currents shooting up and down. And even when these movements became calmer and ebbed away, their occurrence was still suggested by sparse, faint lines.[25]

We feel, says Wölfflin, the same underlying 'laws of formulation' whatever he is representing.

Taken together, Wölfflin's categories are, like Dürer's morphology, rules of formulation which we feel permeate the representation of the subject. Those concepts he dwells on in the *Principles* may be more fundamental than others, *Grundbegriffe*, in the sense of being the kind of factor which is relatively less variable: they align the painter's material to the world in a very general way. This exercise of his medium may be more complex than Wölfflin's categories suggest, but the kind of factor he defines is central to it whatever other complexities are involved.

It is finally worth observing that the concepts do not need to be seen as historically sequential and that there are occasions when opposed concepts can be applied to the same painting. In Rubens's *Deposition* (Plate 46) for instance, we might regard the compactness of the group of figures, and the way they interlock and fill the foreground, set off against the distant sky as relief-like and planimetric, while we observe the reaching forward of Joseph of Arimathaea on the left, as part of a movement within the painting running from back to front. And to take an example outside the historial range which Wölfflin himself had in mind, the distinction between closed and open form may serve to characterise a contrast

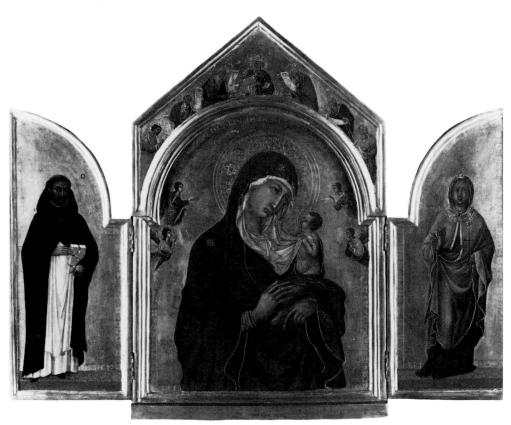

57. Duccio, *Majestà*, *c*. 1300–30, London: National Gallery.

within Duccio's tryptich in the London National Gallery (Plate 57), in which the saints who flank the Madonna stand on a firm platform, the front of which may be seen as coincident with the surface of the panel, and the Madonna is set in a space indeterminately related to the edge of the panel—either more fully in our world or more remote.

VIII

FROM SPRINGER TO WARBURG

THE HISTORIANS whose writings were examined in the previous chapters—Riegl and Wölfflin—were explicitly concerned with the construction of critical systems. This chapter is about two historians who were not. Anton Springer and Aby Warburg represent a continuation of the tradition of Rumohr, both in their concern with philological detail and their integration of the study of art within the complexities of social life.

i. *Springer's Rejection of Hegel*

Anton Springer was born in 1825. In his superb autobiography he describes himself as a Czech who became a German and a Catholic who became a Protestant. These moves were partly negative, precipitated by the police and clerical spies of the Austro-Hungarian empire, whose attention he engaged by being a polemical liberal journalist. As far as becoming a German was concerned, he had been in favour of German unification, but became disenchanted by the result. More central was his sense of German letters, a culture to which—he wrote at the end of his life—he hoped he had contributed.

But Springer was not only a Czech who became a German, but an idealist philosopher who became an art historian and a commentator on his own time who searched for the working context of past art. He defined his own theoretical position early, in his doctoral dissertation of 1848.[1] The dissertation is an attack on Hegel's philosophy of history, and involves the *Aesthetics* without making it focal. Springer later wrote in his autobiography: 'I wanted to demonstrate the artificiality of the system and make clear the internal contradictions of Hegel's *Philosophy of History* . . .'[2] The interest of Springer's thesis in the present context is not for its exposure of internal confusions within Hegel's thought, but for the way in which Springer defines his own position against Hegel's.

His first set of arguments is directed against Hegel's erection of a definitive interpretative viewpoint. He traces two ways in which

Hegel produces this; the first is by treating history itself as a *stage* in the development of Spirit. To this Springer objects that there are no human activities which do not take place within the framework of history. This is not, of course, to maintain that no products of history, such as human thought, outlive the context of their production. But the way in which past thought influences later social life is itself part of history.[3]

The second route by which, according to Springer, Hegel comes to define a vantage point outside history is by treating history as the history of the 'race', and the history of the race as manifest in two complementary ways, in religion and the state. Both religion and state are seen as having an ideal form. But this ideal form is not conceived as some remote abstraction, but the actual Prussian Protestant state of his own time. This, in Hegel's view, is the only properly constructed state, which means that all previous and other modern states are defective. On this Springer remarks:

That the modern state does indeed exist does not give the philosopher any right to lift it out of the sphere of history and place it in a negative and polemical relation to the developments of the past.[4]

In this way, too, Hegel had again isolated his own present viewpoint and set it against the flux of the past.

But Springer had another and more comprehensive ground for his attack on Hegel's treatment of history. In it Hegel had made the true interest of the individual identical with that of the state; the 'universal interest' which the state expresses is, for Hegel, the substance of each individual's interest. Furthermore, the state was reduced to its laws, without consideration of how those laws were enacted or administered, and correspondingly religion was reduced to abstract speculation about God, without the practices of cult or church.[5] Hegel had depopulated and dematerialised history by treating the individual, the state and religion as manifestation of the Idea. Finally he reduced the notion of human freedom to a caricature. According to Hegel's account, in ancient despotisms only one man, the ruler, was free; in subsequent oligarchies only some men were free, and then, only in the modern Protestant state were all men free. Springer regards this as an absurd trivialisation.[6] All men are limited in some respects and free in others, the mediaeval monk and the French revolutionary. The

content and scope of their freedom alters; people are not simply free or unfree *tout court*. In attacking Hegel's attempt to give history the appearance of 'necessity', Springer begins to articulate his alternative, playing ironically on Hegelian language:

Fact and accident exist [for Hegel] . . . only as disturbance, they must be suffered . . . as one cannot get rid of them they must conscientiously live out their pitiful existence in the antechamber of the system. And as in the final analysis the whole content is in movement, everything awkward and recalcitrant is cut away, and the dialectic defines itself as an infinite and absolute formalism. A quite different and essentially opposite picture confronts us in the movement of history Upon the firm foundation of material nature, the mind develops its processes; it is in individual human beings that ideas find their bearers, and in space and time their dimensions and goals. The play of accident appears in vivid colours within the framework of unchangeable necessity, and the limited, finite fact drags the aspiring idea into the reality of the present.[7]

ii. *Springer's Alternative Aesthetics*

Springer does not only reject the metaphysical high-handedness of Hegel's philosophy of history, but rejects it with particular reference to art. In so doing he indicates his own aesthetics:

Man as a natural being—and the immediacy of nature is his finitude—is subordinated and suppressed in religion and law, rather than having his life completely and eternally freed by them. Nature represents the limitation of Reason, and continues to exist in defiance of Reason's inviolability and unyielding high handedness. Throughout the realm of art we have a sense of the finite, but no longer as an alien power, as negation, as compelling and repressive. On the contrary, the finite appears in its free development as an open vessel of the infinite . . . Where dry religion teaches the unimportance of the mere individual, and warns men against pride and presumptuous self reliance, art values the tragic fate of individuals; in the comic the finite is given its due in opposition to the presumption of broad infinity; finally, humour, with divine courage, allows them to fuse, tying the unlimited and eternal to the small and transitory. What, for the faithful, cannot be bound together—heaven and earth—architecture constructs in finite space. The visual arts swathe in a holy veil that from which the pious recoil in anger. In drama the hero is revealed as the absolute source of his own destiny. It is art, indeed, which allows the personality that was silenced in the arena of law to radiate forth in its fullness. In similar ways the finite mind triumphs in philosophy, and only insofar as the world *exists* for it, only so far does the mind grasp it.[8]

The importance of the individual as against the unity of the state, of the individual and particular as opposed to the universality of principles, the insistence of the physical and sensuous as well as the intellectual elements in human nature, like the self-determination of the dramatic hero, all recall the themes—even the phrases—of Schiller's aesthetics, as for instance Springer's remark: 'It is indeed art which allows the personality to radiate forth in its fullness . . .' echoes the famous sentence in Schiller's *Kalias Briefe*: 'The rays of the great idea of self-determination stream back at us from certain appearances of nature, and this we term beauty.'[9] The affinity between them lies in their sense of art as permeated by human relations and social life, rather than providing merely images of thought.

The continuity with Schiller can be traced into the detail of Springer's mature work. In his paper 'Das Ende der Renaissance', for instance, he compares the figures of Castiglione and Aretino, the dignified and moral sense of the one and the venality of the other. He goes on to face the problem presented by Titian's close relation to Aretino, 'his shared bond of hedonism'. How are we to interpret the erotic painting of Titian in the light of the licentious company Titian kept? On Titian's paintings of Flora, of Venus, of women admiring themselves in mirrors (Plate 2), he wrote:

They bloom and exude a fragrance for themselves . . . The coarse appropriating hand which would pluck them remains unseen. Therein lies the difference between Titian and Aretino. In the case of Titian we see inflamed desire, but held back. Titian leaves to beauty a free and unconstrained independence . . .[10]

In the last letter of the *Aesthetic Education*, Schiller had written of man transforming sexual urgency by taking delight in appearance, 'from being a force impinging upon feeling, he must become a form confronting the mind; he must be willing to concede freedom because it is freedom he wishes to please'. Springer's sense of Titian—within his painting 'leaving to beauty a free and unconstrained independence'—is surely drawing upon that sense of restraint with which the *Aesthetic Education* finishes. The point would be trivial if it were taken to be that this restraint were imposed by the mere procedure of painting. But Springer's language makes clear that it is not by virtue of being a painting, but by being a painting of a particular kind, painting that directs itself to the subject's self involvement.

Springer had written general handbooks of art history early in his career, but regarded his first serious research as a study of the social life of thirteenth-century Paris.[11] In this he examined records to find in which streets different professions were practised, the relative wealth of parts of the city insofar as this was revealed by tax returns, the ordering of households, food and clothing, and the administration of schools.

In his autobiography, he remarks on the remoteness of the Romantic view of the Middle Ages from the historical facts:

In the Cluny Museum I saw the multiplicity of the genuine creations of the Middle Ages, collected and ordered, and came to know the enterprise and vigorous artistic purpose of even the so-called dark Middle Ages. I discovered that what was primarily to blame for having so misjudged it was the unfortunate and quite unjustified separation of the products of the applied arts from what was normally regarded as artistic creation.[12]

The interest in the applied arts was widespread in the 1850s, but Springer's particular interest had wider implications than those of, say, Semper. Thus, he directs attention to applied arts, for instance to sarcophagi, in considering the survival of classical models into mediaeval art, and in a paper on art in the French revolution,[13] he examines what happened to the luxury trade of the jewellers; he also describes how the popular wedding prints had removed St Nicholas and replaced him by a figure of Liberty in a Jacobin hat, a pike in one hand and fasces in the other, while the rest—saving the inscription—remained intact. The point was not to provide anecdotal detail, but to show the shallowness of the newly invented symbolism as against the traditionally embedded figures of popular cult.

There is a further sense in which Springer considers the interpenetration of art and social life and this is concerned with 'high art'. Springer compared the relation of the artist to the society in which he lived, to that of the tragic hero or the political leader. He takes the example of the French Revolution: all the ingredients were there, the notions of freedom and equality, the famine, the American War of Independence; but what was still needed was a gesture

which could become the currency of the Revolution. The drama began when the characters emerged who could translate the general feeling

into the rhetoric of passion, appearing before us to carry through the successive phases of the Revolution ... Mirabeau, the Girondins, Danton, Robespierre and then Napoleon were in the foreground. In their speeches and actions they clarified the urgencies of the people ... Having sprung from the dull instincts of the people, the Revolution made its way back through the passions and aesthetic pathos to the clarified consciousness of this people.[14]

Correspondingly the chance conjunction of the artist's mental powers, and the energy required to carry through a sustained work, are seen as catalytic. And the work or symbol produced by the artist reached forward into subsequent social life.[15]

For Springer the historian's position is always one of re-interpreting the past from his own limited position, just as the object of interpretation—in the case of art—is itself a re-interpretation of some earlier source. He remarks that it is pointless for us to try and elude the dominant sense we have of classical antique art. It has been developed through a process of education over the centuries and for us it is not something we can discard. His sense of the artist's relation to the past, as well as the historian's, is nowhere more marked than in his account of responses to antiquity.[16] At the simplest level Springer points out that a mediaeval artist, if he is to take up a classical motif, must transpose it into a new medium in order to make it live again in his own artistic practice.[17] At the level of high art, he writes of Raphael and his contemporaries that they would hardly have understood the recreation of antique forms as a self-sufficient project, merely satisfying antiquarian enthusiasm: 'They live rather in the present and take hold of the antique because it provides a superb means of expression for their own mood and movement.'[18] Springer's concern with re-interpretation includes a sense of the different kinds of function and value with which a past art may be invested. Thus in his paper 'Das Nachleben der Antike' he discusses the way in which images derived from antiquity were thought to have magical powers. He describes the magical belief in gems and regards it as going back to two sources, one to the time of Nero placing the power in the nature of the stone itself, the other placing the power not in the material but in the image engraved upon it: a stone with Pegasus or Bellerophon bestowing speed and courage, and Andromeda successful marriage. Springer resists a simple generalisation according to which superstition was

simply a mediaeval imposition on the classical source: 'The nature-myths do not stem from the dark mind of the Middle Ages. Belief divided it from antiquity, but superstition binds the two periods together.'[19] Thus, not only is the art of classical antiquity not an eternal ideal for all art, but it is, perhaps, not to be regarded without some ambivalence when seen in the context of its own time.

iii. *Warburg and Botticelli's Mythologies*

Springer was a younger contemporary of Schnaase and Semper. The art historian most similar to him in theoretical stance in the next generation—the generation which included Wölfflin and Riegl— was Aby Warburg. Warburg, like Springer, was consistently, even programmatically, concerned with historical particularity; with establishing the way in which paintings, sculpture and printed images functioned in their original situations.[20] He did not, in his mature work, set out to produce a general scheme of the development of history, nor to refine a set of interpretative concepts, although in his early student years there were a number of drafts for both of these projects.[21] Warburg in his published papers was concerned with precisely how images were used, what religious, political and psychological functions they served.

He was an art historian who worked by examining motifs within a work, rather than giving primary concern to its overall stylistic character. He analysed the way in which visual motifs were connected with social life outside art, and drew analogies between visual and literary elaborations of the same subject. But he also had a general view of art: he saw it as involved in a fight against external and internal compulsion, against the constraints of social convention and superstitious fear. Unlike Riegl and Wölfflin, however, he did not see the bid for freedom as leading to an independent zone or aspect of human activity, cut off from the urgencies and needs of ordinary life.

These three factors, the concern with motifs, with milieu, and with overcoming repression and magical belief, broadly speaking succeed each other as central to Warburg's thought.

In his dissertation on Botticelli's mythologies, Warburg's concentration on separate motifs is already fully in evidence. Warburg placed Botticelli's *Birth of Venus* and *Primavera* (Plate 58) within a literary context provided by the poetry of Poliziano who,

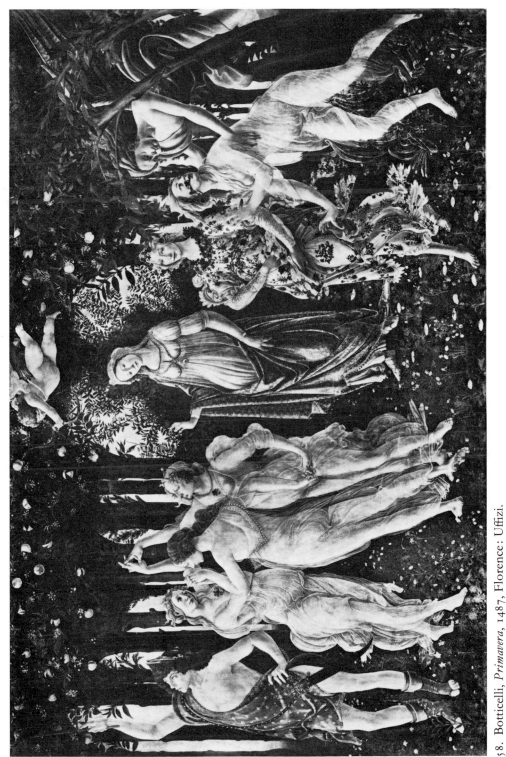

58. Botticelli, *Primavera*, 1487, Florence: Uffizi.

like Botticelli, was employed by the Medici.[22] Warburg con-
centrated on a feature which he had also observed elsewhere in late
quattrocento painting: the running female figure with the breeze
catching her hair and blowing her dress against her body. This was
a revival of a classical motif which, even before his work on the
Botticelli mythologies, Warburg had contrasted to the stiff
brocaded figures of quattrocento painting.[23] He analysed the
connotation of the motif for the quattrocento by using a literary
analogy; Poliziano had introduced descriptions of wind blown
drapery and hair with its suggestions of movement in his
adaptation of a Homeric Hymn describing the *Birth of Venus*.
Warburg also showed how these details were themselves derived
by Poliziano from expressions of movement in classical poetry,
particularly the poetry of Ovid.[24] What Warburg has done is not
merely to find a verbal analogy for a visual feature but to treat the
painting as if it were a text with an analysable vocabulary and use
of metaphor.

This interpretation of motifs had another model beside that of
the literary text and literary analysis: Semper's sense of ornament
and costume. Semper had regarded types of drapery as an index of
a culture when he contrasted free flowing drapery with the stiff
garb of barbarians.[25] When Warburg adapts this interpretation of
costume to painting, a problem emerges. Warburg observes how,
in two prints which show dancing figures (Plates 59 and 60), the
woman in the first version is in stiff Burgundian or Flemish
costume, and in the second has been liberated and is in flowing
drapery.[26] Here the sense of style applies ambiguously to mode of
dress and mode of representation and this conflation becomes
more complete in Warburg's remarks on a further print, of Paris
and Helen (Plate 61). For here their elaborate Burgundian
costumes are contrasted with the style of classical relief which
decorates the pavilion in which they stand.

The confusion between styles of costume and styles of
representation now seems complete, and Warburg's position
problematic. For the notion of a style of representation is normally
thought to be the artist's contribution to his work, rather than part
of the subject matter before it has entered a painting or piece of
sculpture. From what vantage point was it possible to disregard
this distinction between style of representation and style of the
object represented? The common ground between them is that

style of dress and style of representation are both ways of elaborating—giving expressiveness to—the human form; again we are led back to the model of Semper, who saw in clothes and ornament a way of illuminating the sense of human poise. But if we sustain this viewpoint, how can we integrate the motif of the human figure into the overall order of the painting? This is a problem which is of particular interest and to which we shall return.

But for the moment let us get back to his treatment of the Botticelli mythologies. By reference to passages, largely from Ovid, Warburg identifies and reflects upon the figures in the *Primavera*: Mercury leading the Graces on our left, Venus, the coy, crowned bride-figure in the centre, and reading from the viewer's extreme right, Zephyr pursuing the nymph Chloris; and Chloris, having undergone metamorphosis, depicted as the marvellous striding figure of Flora. Warburg shows that they are all gathered in the painting as the 'children of Venus'. Then, by the way he dovetails the quotations and introduces parallel material, he links the painting to Poliziano's use of the same passages from Ovid. Thus Zephyr's pursuit of Chloris/Flora in Botticelli's painting is shown to correspond to Ovid's description of Apollo's pursuit of Daphne, a passage which is taken up by Poliziano in his description of Apollo and Daphne, which in its turn is presented in his poem as the subject of a work of visual art, a relief.[27]

Under the guise of giving archaeological or philological explanations, Warburg sets up circuits which pass through the work; these are never mere solutions to iconographic or stylistic questions. It is not so much that we confront the work but, rather, that we are allowed to enter and leave it as part of the conduct of a wider life. The way Warburg moves from one item to another within the painting, making his analogies with Poliziano and Ovid, cannot be seen as aimed simply at establishing its subject matter. This is helped only marginally by the analogy between Botticelli's possible use of the Apollo-Daphne description from Ovid in his treatment of Zephyr and Chloris, and not at all by observing that Poliziano had used the same passage of Ovid in his description of Apollo and Daphne, and by remarking that this scene was described by Poliziano as if represented within a work of visual art. The point of Warburg's procedure is to set up analogies not only between the painting and certain texts but between

59. Detail of the Planet Venus from the first edition of the so-called Baldini Calendar, *c.* 1460–70.

60. Detail from the second edition of the so-called Baldini Calendar, *c.* 1460–70.

61. Florentine Picture Chronicle, Paris and Helen, *c.* 1460–70, London: British Museum.

62. Hugo van der Goes, Portinari Altarpiece, 1476–8, wing showing portrait of donor and Saints Anthony and Matthew, Florence, Uffizi.

different texts outside the painting. The painting becomes merely one element in a network.

Warburg has thus dissolved the self-containedness of the painting in two ways: he has isolated motifs from the fabric of the painted image and he has treated the picture as a whole as an element in a wider chain of works. His analysis both isolates elements within, and directs itself beyond the painting itself. Here again the difficulty already mentioned regarding the treatment of individual figures—dissociated from the painting of which it is part—recurs. The question—which for the present I shall not attempt to answer—is how Warburg conceived of the painting as something over and above its constituent motifs.

iv. *The Milieu of Merchants and the Sassetti Chapel*

The Botticelli papers were concerned with late quattrocento responsiveness to a classical motif which carries intimations of emotional release. The relation of visual to verbal evidence and the sense of freedom became much more complex in subsequent papers on the Florentine bourgeoisie published after 1900.

In 1902 Warburg published two papers which focus on the nature of donor portraits. One group of such portraits was of the Florentine merchants who worked in Flanders (Plate 62).[28] Their taste for Flemish art presented a problem. What was the attraction of this small-scale jewel-like art for the Florentines? Was it that it was easier to appreciate than the broad grandeur of Italian fresco painting? Warburg says of portrait painting that we must see it as the natural deposit of the interaction of sitter and subject; and with respect to van Eyck's painting of the Italian merchant Arnolfini and his bride, he suggests that the interest of the merchant who deals in luxurious materials may have overlapped with those of the painter whose cool observation registered the sumptuous play of light. But Warburg in effect dismissed this merely aesthetic response as inadequate. At the core of the Florentine merchants' interest in detailed Flemish portraits was a response not simply to the luxury but to the inwardness and the realism of Flemish art.

The merchants valued the Flemish painters' realism because their portraits had a function close to that of ex-voto images: and in that capacity, the level of likeness carried with it a magical force, linking the patron to the protecting divinity. The combination of inner devotion and naturalism of the art of Memlinc and Hugo van

der Goes was ideal for this religious function. The link between religious purpose and the interest in Flemish painting is underlined when, in Memlinc's *Last Judgement*, Warburg recognised, among the naked figures, Iacopo Tani, the most prominent member of the Florentine trading community in the Netherlands. That the ex-voto figure played a regular role in quattrocento Florentine life is documented by Warburg.[29] He points out that Florentine churches were filled with wax effigies which people dressed with their own clothing. Warburg sees the same motivation in the ex-voto effigies as in the donor portraits. And he sees a clear affinity to both in the representation of Francesco Sassetti, his family and associates, including Lorenzo de' Medici himself, in the fresco in Santa Trinita (Plate 63). At first their presence may appear a presumptuous intrusion thrusting the religious event depicted into a mere background scene, but when we see them as a more urbane version of the ex-voto figure their significance changes.[30]

In a subsequent paper, the research for which was precipitated by his puzzlement regarding this fresco cycle, Warburg showed that its very situation in the Church of Santa Trinita was evidence of religious seriousness. Warburg discovered that the same man who had had carved, for himself and his wife, fine versions of classical sarcophagi, decorated with reliefs, had been very concerned that his burial chapel should depict the life of his patron saint, St Francis. He had been so concerned that he had moved the site of his burial chapel from the Dominican church of Santa Maria Novella, where a Francis cycle was unacceptable, to Santa Trinita.[31]

Warburg saw a tension between the Christian and the classical symbolism of the chapel itself: between the biblical David and his sling over the entrance and the pagan centaurs with their slings, which were carved round the sarcophagi; between the classical lamentation carved on the sarcophagus, based on an antique death of Meleager, and the death of St Francis in the fresco cycle above. The duality was traced by Warburg with extraordinary persistence when he confronted two mottoes which Sassetti used; one suggesting the bold pagan self-reliance: *A mon pouvoir* (which appears on the ex libris of his copy of Aristotle's *Ethics*); the other suggesting a circumspect understanding of human limitations: *Mitia fata mihi*.[32] The intensity of Warburg's focus is enhanced by

63. Ghirlandaio, *Confirmation of the Rule of St Francis*, detail showing Francesco Sassetti, Lorenzo de' Medici, *et al.*, 1483–6, Florence: Santa Trinita.

other connections, at the centre of which was the symbol of the goddess *Fortuna*, at once a term signifying wealth and storm winds, and a symbol peculiarly pregnant for a merchant with major overseas investments. Sassetti's sense of the double meaning was clear in the text of a will he made before a journey to Lyons, just as it was for another merchant, Giovanni Rucellai, whose device was a ship with billowing sails and with the figure of Fortune as a mast. The tension surrounding the notion of fortune is brought out in a letter which Rucellai wrote to the neo-Platonist Ficino in which he asks Ficino whether it is possible to control one's fate. The wise man gave a carefully ambiguous answer.[33]

Warburg's study of the Sassetti chapel shows him as working in a curious way against the background of Burckhardt's vision of the Renaissance. The evidence tells firmly against Burckhardt's view of Renaissance man as defying superstition with wordly assurance, yet Warburg seems to accept something of this conception when he writes of the tension of his Florentine merchants as belonging to a transitional stage of history, moving away from mediaeval piety. For fifteenth-century Florentine burghers, worldliness and piety were co-existent. Warburg imagines a tension between them, and the tension as generating their energy.[34] But Warburg nowhere shows that these merchants felt these two sources of their culture as presenting a conflict. It seems as though a conflict about the interpretation of the Renaissance has been projected into the historical material itself.

Warburg's study of the Sassetti chapel and the related material is the central work on which consideration of him as an historian must turn. Even less than in his studies of the Botticelli mythologies do we seem concerned with confronting a single, formally cohesive work. The chapel itself is made up of so many components, the interior frescoes, the altarpiece, the relief sculpture round the sarcophagi and the external frescoes. What we have is indeed a work which defies aesthetic unification and even if it did not, the way Warburg moves into it from so many points of view would hardly be concerned with such formal unity, observing as he does the transformation from the wax votive offerings into the portraits of the frescoes, the convergence and contrast of pagan sources and Christian piety, the contrast of Sassetti's two mottoes and the correspondence of his concern with *Fortuna* and that of Rucellai. These moves suggest what it is like to

live in the society for which the chapel was built, but what
Ghirlandaio and Giuliano da San Gallo contributed to its interest
is never seriously considered by Warburg.

v. *Art and Superstition*

The relation of artistry to its material was focal for Warburg
himself in the next stage of his work. He deciphered the strange
fresco cycle in the Palazzo Schifanoia in Ferrara, which had twelve
vertical panels (Plate 64), as illustrating an astrological treatise.[35]
He showed that the division of each section of the wall into three
zones was to be explained by reference to the way each month was
reigned over by one divinity, placed at the top, while in the middle
register a sign of the Zodiac and symbols for each ten-day period,
and at the bottom were the appropriate activities for the children
of the respective divinities. But what was crucial for Warburg was
not the unriddling of the imagery but something humanly
disturbing about its presence. Hellenistic astrology, having been
safely countered by the early Church, returned after a thousand
years through the Arabs and Spain. In its literature it contained
descriptions of divinities which could be identified with specific
classical statues, thus the prescription for a Jupiter amulet was
derived from a description of the ancient statue of Zeus at
Olympia. So ancient gods came back in descriptions of how to
devise magical images, how to influence fortune. For Warburg
two correlative movements are involved in the Renaissance:
overcoming the bondage of superstition and recovering the
classical form of the Olympians. What is of particular interest is to
see how these two enterprises were connected.

At the start of the paper on the Schifanoia frescoes Warburg had
said something which might have been a mere rhetorical device:

The Roman world of form of the Italian High Renaissance announces to
us art historians the final and fortunate pursuit by artistic genius of
freedom from the mediaeval servitude of illustration . . .[36]

And Warburg, presenting his paper in Rome, offers a mock
apology for drawing his audience back to astrology, the enemy of
free creation. Like Burckhardt, he subscribed to a view that the
process of artistic creation stood in an antagonistic relation to
illustrative as well as magical functions. Thus he compares the
relative distinction of Cossa's contribution to the fresco cycle with

64. Francesco Cossa, *Month of April*, 1469–70, Ferrara: Palazzo Schifanoia.

that of lesser hands, saying that 'Cossa's absorbing sense of reality
. . . overcomes the unartistic element of the literary admixture . . .'
whereas 'the weaker artistic personality cannot infuse sufficient
vitality to overcome the dryness of the programme'.[37] The relation
between the artist and the material he is called on to handle is
emphasised when Warburg suggests that a dispute between
Pellegrino, the astrologer who devised the programme in the
Palazzo Schifanoia, and Cossa, the artist called on to carry it out,
may not have been merely over money, but over Pellegrino's
indifference to artistic quality.

But there is a second strand in Warburg's paper: not only of the
need for art to overcome servitude to illustration but to overcome
superstition. Cossa, said Warburg, had not found a way to escape
from the costume realism *alla Francese* into the light air of the
Venere aviatica of the Farnesina (Plate 65). Botticelli was to provide
an intermediary stage between Cossa and Raphael; Botticelli had to
release his goddess of beauty from the banality of mediaeval genre
realism and astrological illustrations, so that she could eventually
regain her Olympian freedom.

The recovery of Olympian freedom seems attached both to
overcoming superstition and reaching a new level of freedom in
artistic performance. And Warburg asks:

How far is the emergence of a stylistic shift in the representation of the
human form in Italian art to be seen as a . . . process of disengagement
from the surviving figurative ideas of the pagan culture of the eastern
Mediterranean? . . . Our wonder in front of . . . artistic genius can only
be strengthened if we recognise that genius is not only a matter of grace
but also of determined combative energy. The new grand style which
has been given to us by the artistic genius of Italy, grew in the social will
to recover Greek humanity from the orientalised Latin practices of the
Middle Ages. With the intention of restoring antiquity, 'good
Europeans' began their struggle for enlightenment, and they did so in an
age of the world-wide circulation of imagery which we all too mystically
call the Renaissance.[38]

High Renaissance art is assumed to participate in resolving the
tensions found in the mental life of the early Renaissance. The
artistic style, identified with the presentation of the human figure,
was part of that resolution.

But this may still seem to leave unrelated the two facets of
Renaissance culture, overcoming of superstition on the one hand

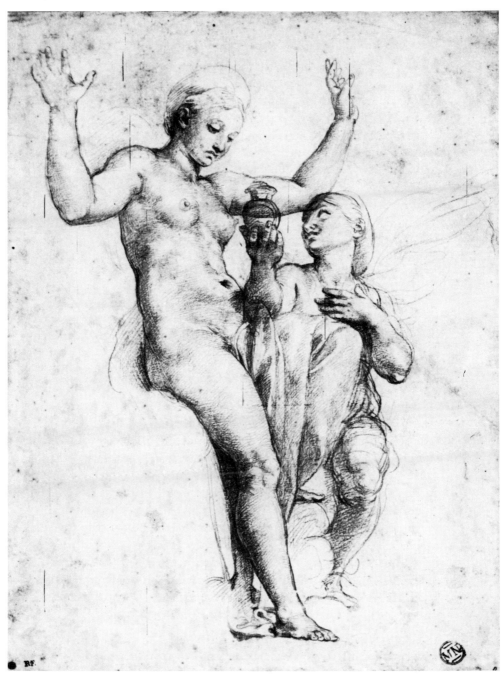

65. Raphael, *Venus and Psyche*, drawing for the decoration of the Farnesina, 1516–17, Paris: Louvre, Cabinet des Dessins.

and the development of visual formulation on the other. And we may feel the same problem present in Warburg's treatment of Dürer's *Melancholia I* (Plate 66):

The genuinely creative deed, which makes Dürer's *Melancholia I* a humanistic consolation in the fearful confrontation with Saturn, can only be grasped when one recognises that it is this magical mythology which is the essential object of the inspired artistic transformation. The sinister child-eating planetary demon, the outcome of whose struggle with the other planet rulers decides the destiny of the creatures influenced by them, becomes through Dürer's humanising metamorphosis the plastic embodiment of the intellectual craftsman.[39]

The question of how far Warburg saw the development of High Renaissance art—or that of Dürer—as a *visual* achievement, how far the visual artist contributed to this overcoming of superstition, is problematic. In a later note he writes:

The creation and the enjoyment of art demand the viable fusion between two psychological attitudes which are normally mutually exclusive. A passionate surrender of the self, leading to a complete identification with the present—and a cool and detached serenity which belongs to the categorising contemplation of things. The destiny of the artist can really be found at an equal distance between the chaos or suffering excitement and the balancing evaluation of the aesthetic attitude.[40]

Warburg's position seems to have overtones of both Nietzsche and Schiller.[41] The artist elaborates upon his material; this is the exercise of his freedom as artist. In order to elaborate upon it he must overcome intimidation. He must not be in awe of it, but surmount the urgencies, fears or seductions set up by the material. The artist's elaboration is a way of transforming the material, of giving a different force to it, as when the fluency of the classical figures displaces the stiff bourgeois drapery, or when the intensity of Dürer's drawing alters the significance of *Melancholia I*, displacing the force of superstitious fear by the way it is absorbed and reflected upon. Toward the end of his life, Warburg rehearsed the theme again in a notebook entry:

. . . if we want thoroughly to assess the relevance of the process of sublimation in its consequences for the stylistic development of Europe, we must agree to acknowledge the surviving divinities of antiquity as a religious force—in the shape of demons in charge of human destiny whose worship is systematically codified by astrology.

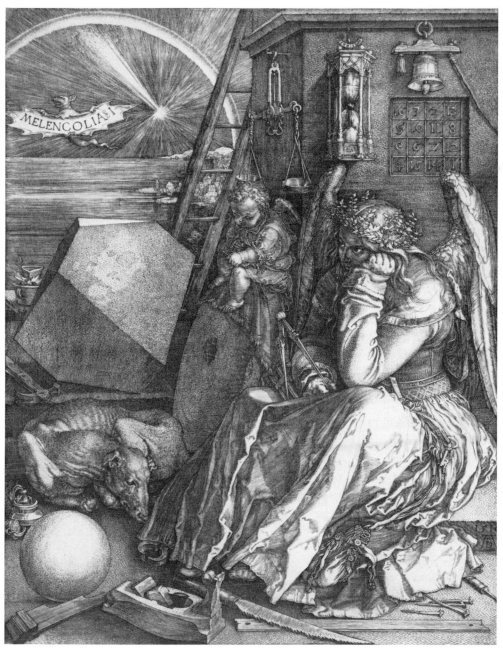

66. Dürer, *Melancholia I*, engraving, 1514, London: British Museum.

This insight will allow us to grasp the humanising import of the step by which Raphael transformed these sinister demons into the serene gods of Olympus who dwell in higher spheres where there is no longer any room for superstitious practices . . .[42]

Warburg, it is true, tells us little about the artist's handling, little about the prosody or what is distinctive about the artistry of painting or sculpture, beyond insisting on its presence.

vi. *The Role of Classical Art*

At this stage I shall try to dispose of two problems. First, the position which Warburg gave to classical antiquity. Did he make it a norm for all time, was he too caught in the nostalgic passion for the gods of Greece? The answer to this is, no. Early on in his writing, a touch of nostalgia was marked, but as he developed he recognised that the ancient world held its demons as well as its Olympians. He regarded the recovery of ancient forms as a central factor within the history of European art and thought. One way in which a particular stage of European sensibility could be plotted was by reference to how it used the reservoir of the classical past. It was not its *destiny* to recover that past, as if that past were its own true latent essence; nor was the style of classical art set up as the style for all art. It is not clear whether Warburg would have accepted Springer's point that the meanings which we had invested in the art of classical antiquity were ineradicably part of our culture both by virtue of centuries of education and the quality of the works concerned. But there seems nothing inconsistent with Warburg's position on this. It was simply a matter of fact that Europe had the past it did; it was equally a matter of fact that what people did in their art and thought depended upon the traditions on which they could draw. It was a matter of historical inquiry how they did so and it was a matter of the historian's sense of human psychology, his sensitivity to its urgencies and his involvement with them, which formed his sense of achievement or defeat, delight or distress:

We must not demand of antiquity that it should answer the question at pistol point whether it is classically serene or demoniacally frenzied, as if there were only these alternatives. It really depends on the subjective make-up of the late-born rather than on the objective character of the classical heritage whether we feel that it arouses us to passionate action

or induces the calm of serene wisdom. Every age has the renaissance of antiquity it deserves.[43]

The expressions of violent feeling found in antique art are seen as suspended in a collective memory, are recalled or remobilised later:

It is in the zone of orgiastic mass-seizures that we must look for the mint which stamps upon the memory the expressive movements of the extreme transports of emotion, as far as they can be translated into gesture language, with such intensity that these engrams of the experience of suffering passion survive as a heritage stored in the memory. They become exemplars, determining the outline traced by the artist's hand as soon as maximal values of expressive movement desire to come to light in the artist's creative handiwork.[44]

Here, as in virtually all other passages cited by Gombrich on Warburg's conception of memory, it is the *language*, the image stock, which appears as the suprapersonal memory and the 'expressions' come to light for the artist, who inherits this language, from within his own mind as he formulates his work. Furthermore, such 'expressions' can, like volatile metaphors, reverse their significance, a gesture of triumph becomes one of magnanimity, one of brutality becomes one of healing or lamentation.

Antiquity thus provides material for the European language of imagery, and in Classical art it provided a supreme example of that material brought under control. How much of the vocabulary or the control of any later artist or poet could achieve was a matter of his own mind or culture.

Warburg's discussion of motifs from classical antiquity used the term *Pathosformel*, a term anticipated by Springer's 'aesthetic pathos' (above p. 157). Sometimes Warburg seems to mean no more than an item of visual vocabulary, a way or representing a gesture or scene, sometimes it contains the sense of urgency controlled through ritual, but it could also be something which could be debased by facile use.[45] Quite as important an expression was *antikisierende Energiesymbol*, which he used of the centaur in the Sassetti chapel but also, and more interestingly of the figure of *Fortuna*. Thus, Warburg wrote about Francesco Sassetti's will, when as an old man of eighty he had set out from Florence to Lyons to resolve the affairs of the Medici bank there:

We still feel why, for Francesco Sassetti, in the crisis which he faced in 1488, it was the storm goddess *Fortuna* that, symptomatically, crossed the threshold of his consciousness, an index of his heightened state of tension.[46]

Earlier he had noted that the mental utility of this symbol was to mediate between self-reliance and reliance upon God.[47] Clearly the sense of *antikisierende Energiesymbol* is more complicated than that of primitive feelings being brought under control by being turned into gesture and expression; the symbol here is invested with complex attitudes and derives its energy from the urgency which conflicting attitudes set up and presupposes unconscious play upon articulate thought. He is closer to Freudian than empathy theory. He saw the force of a symbolic figure as the 'condensation' of a situation which we recognise as our own.

vii. *Warburg and Pictorial Behaviour*

This sense of a symbol as *both* an image of a situation which confronts us, and a gesture we make within that situation, coincides with Warburg's underlying sense of art as a mode of behaviour—of visual behaviour. And this leads us back to the role which Warburg assigns the human figure in his account of art; in particular the way in which the treatment of the human form may seem, in Warburg's account, to exhaust the scope of the visual artist, and give no sense of representational style—no sense of the range of painting or sculpture beyond the presentation of the human form. This would be a very limited view of painting. Earlier I suggested that both style of dress and style of representation could be regarded as ways of elaborating the human figure—of dramatising it. But the human figure is dramatised through social behaviour as well as through clothes and gestures; and that behaviour could include behaviour distinctive to painting. For instance, Warburg insisted on the social propriety of placing portraits in the foreground of the scene of the *Confirmation of the Rule of St Francis*.[48] It is, after all, more urbane behaviour than propping up a wax effigy of yourself. In this way, the mode of representation is clearly part of social behaviour. Similarly, the precise realism of a Memlinc donor portrait was felt to be relatively less grand and self-conscious than an Italian fresco figure, more intimate, more reserved. In both

cases the painting was part of the behaviour of its patron, part of the way the patron, in collaboration with his artist, projected himself socially.

To take this view of painting, to see it as emanating from urgencies transformed through the conventions of society (including the social conventions unique to art), is to see it as behaviour. It is charged with our purposes, our ways of projecting ourselves into our social environment as well as presenting ourselves before traditional gods. And to see it in this way is not to tie it, in a narrow sense, to the expressiveness of the human figure, but in a broad sense to the expressiveness of personality in its social life through the works which formed part of that life.

While Warburg was quite unlike the systematic historians in that he did not elevate the concepts he used and treat the historical material as of interest in exemplifying them, there is an involvement with his own thought, a sense in which he was elaborating a personal vision in the historical material. Gertrude Bing wrote of him that after ten years' work on archival material in Florence, he returned to Hamburg to write his *Buddenbrooks*. It was perhaps an indication of the particular kind of interrelatedness which Warburg achieved in his use of the historical material that it was appropriate for his associate, Fritz Saxl, to give an account of Warburg's work in a form which was less highly wrought, the form of a set of results for the use of current scholarship.[49]

IX

PANOFSKY

PANOFSKY'S first published book, which developed out of his doctoral thesis, was on Dürer's theory of art. It was concerned in part with the relation between formalised artistic theory and the artist's imaginative performance. Toward the end he quoted Goethe: 'The highest thing would be so to grasp things that everything factual was already theory.'[1] This quotation may serve as a motto for two convergent themes in Panofsky's work: the fusion of the subjective life of the mind with external reality, and of thought with perception—themes developed in a way which bring Panofsky closer to Hegel than Goethe.

In a series of papers between 1915 and 1927, Panofsky revived the Hegelian project of constructing an absolute viewpoint from which to regard the art of the past, a viewpoint from which the inner structure of all works of art could be made clear. The inner structure was assumed to be thought-like in ways which, broadly, correspond to those which Hegel had seen in art. But Panofsky's project was undertaken against a different background. The issue of the intelligibility of the art of the past had gained a temporary solution in late nineteenth-century psychologism, in the theory that there were certain innate principles of the mind which could guide our interpretation of works of art—as we found in the writing of Wölfflin and Riegl. But the presumption that our perception had such innate propriety and penetration was undermined in studies of social life at the turn of the century. What was required was some way of showing that we were not merely projecting; that our viewpoint did not simply invest the art of the past with our interests, see it in the light of our own values. To fight off the challenge of subjectivism and psychologism required some criterion of validity; in the study of social life, some way of establishing equivalent stringencies to those which governed natural science.

The way in which this problem is encountered in the history of art is seen by both Max Weber (in 1917) and Ernst Cassirer (in 1918) as twofold. On the one hand there was the need to escape

from mere subjectivism, but on the other the need to rise above a merely causal account of art. Weber expresses this, when talking about the history of music, by saying:

The empirical history of music can and must analyse these [technical] features of its development, without undertaking, on its own part, an *aesthetic* evaluation of the worth of musical art. Technical 'progress' has quite often led to achievements which, when evaluated aesthetically, were highly imperfect. The focus of *interest*, i.e. the *object* which is to be historically explained, is heteronomously given to the history of music by its aesthetic significance.[2]

That is, the work of art of which we give a causal explanation is not characterised as a work of art by that explanation, either by showing its place in a history of solutions to technical problems or its place in any other causal sequence.

Weber goes on to say of Wölfflin: 'In the field of painting, the elegant unpretentiousness of the formulation of the problem in Wölfflin's *Classic Art* is a quite outstanding example of the possibilities of empirical work.' Whatever reservations we may have about Weber's account of Wölfflin, his comments point to the problem which was to engage Panofsky—that of establishing a viewpoint which would not reduce art history to tracing the development of an art or the genesis of a particular work, but would show what it was to treat a work as a work of art.

Panofsky challenged, *inter alia*, Wölfflin's concepts in the *Principles*, not because he doubted their descriptive aptness, but because he queried their critical relevance—or, at least, held that this needed to be shown.[3] Wölfflin's concepts were dependent upon empirical observation of individual works and lacked any guarantee that such observations were critically pertinent. The problem was, as Panofsky conceived it, to turn those remarks about visible and historical objects into interpretative remarks about works of art. Panofsky attempted to construct such an authoritative viewpoint, one which would show how the various factors within a work of art cohered and the work took on the distinctive meaning it had *qua* work of art.

1. *The Systematic Strategy*

Panofsky gives the most striking formulation of his project at the beginning of his paper of 1920, 'Der Begriff des Kunstwollens':

It is the curse and the blessing of the systematic study of art
[*Kunstwissenschaft*] that it demands that the objects of its study must be
grasped with necessity and not merely historically. A purely historical
examination whether it goes first to content or to the history of form,
elucidates the phenomenal work of art only by reference to other
phenomena, it does not have any higher order knowledge on which to
ground itself: to trace back the particular inconographic representation,
derive a particular formal combination from a typological history, . . . is
not to fix it in its absolute place and meaning related to an Archimedean
point outside its own sphere of being, but it is to remain inside the total
complex of actual interconnected appearances. Even the longest
'developmental series' necessarily place the lines within the limits of the
purely historical complex.[4]

What does Panofsky understand here by necessity? What would
constitute a vantage point which was derivable from somewhere
outside the field of historical phenomena and which would lead to
a systematic understanding of a work of art or of the whole field of
works of art? To start with, why should we believe that there is
anything better to be had than the reconstruction of past material?
What beyond phenomena could we hope to find? Admittedly
we could avoid the more obvious clumsiness of separating
the components of a single work—symbols, patterns or
morphologies—and subjecting each to a separate history; and we
could avoid treating individual works as if they were of interest for
their place in a sequence, or as transmitting or transforming
symbols, motifs or morphologies. But what can we take Panofsky to
mean by an Archimedian point outside the field of the phenomena of
history?

Panofsky argues, broadly, that critical understanding requires
that we look for artistic intention—he takes the term *Kunstwollen*
from Riegl—but he rejects immediately the idea that we can
understand, say, Rembrandt's artistic intention simply by looking
at the painting, for our procedure would be narrowly circular. Nor
do we get a principle of interpretation from our own emotional or
empathic response for we have no way of checking its
appropriateness. Finally we cannot rely on artists' statements of
intention—Dürer theorised, Grünewald did not, Poussin did, but
not Fragonard; and even when artists do theorise their theory may
run counter to the thrust of their work (perhaps Panofsky had
artists like Reynolds in mind). Their theories themselves need

interpretative elucidation; they are just more phenomena.

What then could provide an absolute viewpoint from which we might elucidate a painting or building? Panofsky takes as a model for the kind of interpretation he wants the Kantian conception of what makes a judgement scientific. What makes a judgement about the world a scientific judgement, as opposed to a merely personal report, is its *causal* character, and this causal character or structure is not, in Kant's view, derived empirically but is injected into experience by the mind. It transforms that experience in a way which makes it amenable to scientific understanding. It is irrelevant to Panofsky's use of this parallel, that for Kant we had to inject the concept of cause into experience. What was important for Panofsky was that it was assumed to be a concept we did not derive *from* experience but one which we brought *to* experience in order to give it its intelligibility.

Panofsky takes (from Kant's *Prolegomena*) the example of the causal statement 'air is expandable' and he distinguishes various ways in which we might regard this utterance: we might consider the psychological condition of the speaker; we might look at its grammar; but neither of these would bring out its character as a scientific formulation. Not even regarding it as a report of personal experience would bring out its scientific character. Its scientific character depends upon our experience being attached to the causal form of our judgement. Only as a causal statement ('if I vary the pressure the air will expand or contract') does it enter the hard impersonal discourse of science, irrespective of the personal psychology of the speaker, historical circumstances of utterance, or grammatical specification. But what could correspond, in our understanding of art, to the concept of cause in science? The answer, put simply, was a conception of the *coherence of a work of art*. And the conception of the coherence of a work of art was conceived as the resolution of two complementary factors called subjectivity and objectivity. Panofsky's line of thought follows closely that of Cassirer.

In his commentary on Kant's *Critique of Judgement*, Cassirer had maintained:

(a) that a work of art, to be understood aesthetically, must be extracted from the causal account of how it came into being;[5]

(b) that the particular work of art can be seen to exemplify the general principles of the realm of art in the way that a particular

natural causal law is a special case of lawlikeness in general in science;[6]
(c) and that principle in the case of a work of art is a principle of coherence according to which we have some 'totality' of consciousness, perhaps some general cast of mind, from which all particular factors should be seen to follow.[7]
Cassirer describes the way we should see this underlying unity in the following way:

> In aesthetic feeling a totality of consciousness and its powers is discovered, which is prior to and is a basis for all analysis of consciousness into individual, reciprocally connected propensities. In each of these two modes of thought [natural laws and aesthetic experience] the whole with which it it concerned is so seen as not to appear as if put together of its parts, but as if it is itself the source of its parts and the grounds of its concrete determination.[8]

And this prior and underlying unity is understood as a relation of objectivity and subjectivity.[9] But what does this relation of the objectivity and subjectivity mean? For Cassirer it is the relation of the ordering mind to the material of experience, and in this sense, objectivity is what the mind provides and subjectivity what the outside world provides to the senses.

But then there is a second sense which could be given to the opposition of objectivity and subjectivity, derived from Riegl; according to this, the objective is what marks the object as outside the mind, and the subjective is what marks the mind's projection upon the object outside it. While Panofsky follows Cassirer in the search for a concept of coherence which will serve the understanding of art as the concept of cause serves the natural sciences, it is Riegl's sense of subjectivity and objectivity which he uses in elaborating his account of coherence. For Panofsky, following Riegl, objective art represents things as self-contained, firmly circumscribed as in Egyptian sculpture and relief; they elicit the minimal projection onto spatial cues and minimal emotional identification on the beholder's part. Subjective art, on the other hand is that which allows forms to merge, takes into account the viewer's conditions of perception and the inward emotional life of what is depicted. All works are seen to stand somewhere on a scale between these extremes.

Panofsky developed this thesis in the paper 'Über das Verhältnis

der Kunstgeschichte zur Kunsttheorie'. There he maintains that not only do works stand at a certain point of this range, but each critical aspect of each work is a resolution of these two demands, a resolution which is somewhere along a continuum between pure objectivity and pure subjectivity '. . . the systematic study of art establishes that within a particular artistic phenomenon, all artistic problems are resolved in one and the same sense. . .'[10] We thus have, underlying all the significant aspects of any work, its particular subjective-objective resolution; this will show up in any of the lower level manifestations like the relative separation or fusion of forms, their relative depth or flatness, colour and, presumably, their subject matter:

Strong 'polychromatic' treatment of colour, by virtue of being a corresponding resolution of the fundamental problem, is therefore the necessary correlate to separation of forms and to a flat and crystalline spatial composition while the 'colouristic', in particular the 'tonal', is just as necessarily linked to unified, deep and painterly composition of space and forms.[11]

And the difference or similarity between any two works will be a genuinely stylistic difference or similarity if it can be traced back to a higher stylistic principle.

We might (wrongly) understand Panofsky to mean that the way we use colour, the way we evoke space, and the way we join or merge forms in a painting will interact with each other; that each will change the overall character of the work and the effect of any other factor. The underlying unity within a particular work might have been thought of as the resultant of all these factors. But that is not the view Panofsky is holding. He is not merely saying that one aspect cannot be interpreted except in the light of the whole work of which it is a part. What he is saying is that all aspects of the work stand in a relation of co-ordination by virtue of sharing the general form-content solution. This produces serious difficulties. For how do we know precisely where, on that spectrum between subjectivity and objectivity, any particular work lies? And how can we know that our painting or relief does in fact cohere, that all factors are properly governed by one resolution of the objective-subjective opposition? And how can we regard the factors we isolate as having the subjective or objective force they are assumed

to have, independently of their context in the particular work? Would the strong use of local colour and the clear separation of forms ever be independent of each other?

This *a priori* conception produces insuperable difficulties, first of all because it assumes a set of fixed values or connotations for all elements in a work; secondly, it assumes a natural correspondence between those elements so that we can have no sense of their interaction within a work. To re-use an analogy from Schopenhauer, each factor is regarded as like a facet of cut glass, and each facet gives a view of the same flower placed behind it. We might understand this conception of coherence as a 'regulative idea', an ideal to which we try to approximate our understanding of a work of art. For instance, we might try to see how a very sharp definition of figures in a clearly defined space had a particular consonance with the subject matter of the nativity, of a specific selection of the moment in the nativity story, and so on. But even if we use this conception of coherence as a 'regulative idea' we do not have any possibility of talking about the interaction of factors.

But there is another problem about this conception of coherence. How does it relate to the mass and diversity of historical facts which appear—and appear to Panofsky—to be relevant to the individual work? Confronting this problem he distinguishes between establishing the phenomenal character of the work on the one hand and the task of interpretation on the other. Establishing or restoring the work can be compared to correcting and amending a verbal text as opposed to offering a philosophical analysis of what it says.[12] Similarly a work of art may be damaged or we may be unfamiliar with the meanings that the forms originally possessed, and thus we should be unable to subject it to proper systematic interpretation. We have to make sure of what Panofsky calls the phenomenal understanding of the appearance of a work; thus any change in our understanding of devices employed, or any reconstruction of the original state of the work, could be significant for its 'systematic' critical interpretation. But such emendation leaves us with the problem of establishing the *Kunstwollen* of the corrected text or phenomenal work, and this can only be derived by reference to the *a priori* system. The problem remains: how do we attach that phenomenal work to the *a priori* system, how do we connect the 'philological' and 'interpretative' tasks? How are facts uncovered by philological inquiry absorbed

in the scheme of interpretation? Take some straightforward examples: if it is part of the pre-interpretative stage that we see a given building as reconciling column and wall architecture, then what do we have to do in order to absorb that historical observation into the *Kunstwollen* of the objective-subjective scale? How do we attach the fusion of components in Dürer's *Melancholia I* or his *Sol Iustitia* (Plates 66 and 70) into this *a priori* scheme?

ii. *The Adaptive Strategy*

Let us, for the moment, leave aside Panofsky's project for constructing a systematic viewpoint and move on to a quite different way in which Panofsky sought to overcome cultural strangeness, to show how one culture could appropriate the art of another and appropriate it as art. This second approach to the problems of interpreting the art of an alien culture is to be found in two papers also written in the early 1920s, 'Albrecht Dürer and Classical Antiquity' and 'The First Page of Vasari's Libro'.[13]

In 'Albrecht Dürer and Classical Antiquity', Panofsky argues that Dürer came to understand classical art not by direct confrontation with it, but by the mediation of Italian Renaissance re-interpretation, which was more readily intelligible to him. The crucial point of his argument was that the understanding of historically distant art is not simply a matter of confronting it; it involves a process of assimilation and re-interpretation which extends outwards from what is familiar. (The point is hardly original but takes on a distinctive interest in the context of Panofsky's thought.)

There is an interesting 'complementary' example of this process of mediation, which may look at first sight in conflict with it, in 'The First Page of Vasari's Libro'. Panofsky argues that the way in which Vasari recognised the distinctive style of earlier art—and framed a supposed Cimabue drawing in a Gothic-styled mount— was a feat of historical understanding and sensitivity which was possible because, from the vantage point of High Renaissance art, the alienness of Gothic could be recognised and it could be appreciated as having its own family of forms or style. Panofsky enforced the argument by reference to the Renaissance possession of the notion of *concinnitas*, of reciprocal appropriateness or integration. (Putting weight on the term seems unnecessary.

Whether someone has such a *term* or not, a sense of distinct styles presupposes some such concept.) Both in 'Dürer and Antiquity' and 'Vasari's Libro' these arguments are about artists becoming sensitive to art different from their own, and both are about the need to interpret that alien art by reference to their own.

But this, surely, does not provide an Archimedean point from outside the field of historical phenomena, a principle drawn from a higher source. Well, in a sense it does. It provides a point outside the field of phenomena that are being studied, phenomena which, *ex hypothesi*, are removed from the historian's own position in time and place, and it provides a general principle for all such interpretation: that historical interpretation is always a matter of establishing both continuity and discontinuity with the products of one's own culture—which may be more or less adequate to the task.

The two approaches to trans-cultural interpretation, the systematic approach of the theoretical *Kunstwollen* papers and the adaptive approach in 'Dürer and Antiquity' and 'Vasari's Libro' may be seen to converge in what is perhaps Panofsky's most difficult and contentious paper, 'Die Perspektive als "symbolische Form"'.[14]

iii. *The Perspective Paper*

What is the perspective paper about? What does it set out to show? The simple answer is that it takes the perspective construction developed in the Renaissance and argues, firstly, that it has no unique authority as a way of organising the depiction of spatial relations, that it is simply part of one particular culture and has the same status as other modes of spatial depiction developed within other cultures. Secondly, the spatial order between components in a painting is the natural correlate of contemporaneous cosmology and modes of perception. But having made the perspective construction of the Renaissance culturally relative, Panofsky goes on to use it as providing an absolute viewpoint for interpreting other constructions.

Panofsky's paper develops out of a distinction made by Guido Hauck in 1879.[15] Hauck examined the implications for painting of two different ways in which we measure relative visual size in perception. The first way—which he called *collinearity*—applied to

our perception of what was focal and in such focal perception we saw straight lines as straight. The kind of drawing construction which corresponded to this kind of perception was the construction which dropped a perpendicular through the visual cone as in the Renaissance perspective construction. But there was another way in which we perceive relative visual size (which Hauck called *conformity*—as opposed to *collinearity*); and that second kind of perception was of features which were peripheral to our field of vision; it covered non-focal vision. In non-focal or peripheral vision our perception of relative size corresponded to the relative size of the angle made when we draw lines from the edge of the object to the eye. This had the effect of making straight lines appear curved, and the further away they were from the focus of vision, the more curved they appeared. In Hauck's view, in our ordinary perception we constantly altered focus and strove for a consistent vision; with our expectation that straight lines would appear straight, and because of our constant re-adjustment of focus on what interested us, collinearity dominated our perception. (These observations on *collinearity* and *conformity* were related in Hauck's theory to the curvature and muscles of the eye, but for present purposes this mechanical physiology is irrelevant.)

Panofsky 'historicised' Hauck's distinction; he made the difference between the two modes of visual perception into a matter of a difference of culture. He made the mode of perception which assessed relative size by reference to the visual angle part of the culture of antiquity, and the assessment of relative size by reference to the cross section of the visual pyramid, part of the culture of the Renaissance. In this way he assumed that in antiquity objectively straight lines were seen as curved and in the Renaissance they were seen as straight.

What evidence did he have for doing this? First of all he assumed that in classical antiquity no-one had thought of dropping a perpendicular through the visual cone and that therefore their geometry ('the purest expression of their sense of space') implied a lack of the sense of homogeneous infinite space which emerged with the Renaissance perspective construction and Cartesian conception of *substance étendue*. But as Pirenne has argued,[16] Euclidian optics implies an infinite and homogeneous space in the same way as the Renaissance perspective constructions. There is nothing in Euclidian optics to *exclude*

dropping the perpendicular of the projection plane between the eye and an object (as Panofsky admits). So on this evidence at least Panofsky cannot hold that the ancients had a different conception of space, only that they did not drop a perpendicular through the visual cone to construct representations. (That the cross-section of the visual cone is never considered by Euclid is explained by Pirenne simply by the fact that Euclid was concerned with natural vision and not with depiction.)

Panofsky's second piece of evidence for associating collinearity with the Renaissance and conformity with antiquity, is that the form of painting in antiquity corresponds to its kind of geometry; but his only grounds for saying this is the absence of the Renaissance perspective construction from either. There is then a third piece of 'evidence', but its relevance is never established. It is the presence of refinements of curvature in Greek buildings. *Entasis* is said to compensate for the curvature in perception, but in Panofsky's account there is no reason why there should have been such compensation if they saw all straight lines as already curved, and Panofsky ultimately admits—in the middle of footnote twelve of the perspective paper—that it is no more than evidence for the Greek interest in curvature as such.

The two substantial points linking pictorial construction and cosmological or geometric conceptions of space depended upon relating each to the Renaissance perspective construction, and showing the absence of that construction in both. And it is in this way, first of all, that the Renaissance perspective construction lies both within the range of historical constructions and is also a trans-historical reference point.

But the Renaissance perspective construction also has a much richer and far reaching implication for Panofsky as a pivotal point of historical interpretation. He sees a correspondence between the Renaissance perspective construction, with its capacity to relate the viewpoint of the observer and the object viewed, and Kantian epistemology. For Kantian epistemology does not regard objects as independent of our minds, nor merely as projections from our minds, but treats the mind and the world, subjectivity and objectivity, as joint conditions of experience. That is, Panofsky comes to understand the Renaissance perspective construction through its affinity with that neo-Kantian conception of knowledge, then having matched his neo-Kantian viewpoint with

the Renaissance perspective construction, he has used it as a foil against which to consider other constructions and attached un-Kantian connotations to them.

Towards the end of the paper the implications of this become explicit. Panofsky writes that in the Renaissance:

the subjective visual impression was so far rationalised that it could form the foundation for the construction of a world of experience, which was—in a modern sense—infinite, (one could compare the function of Renaissance perspective specifically with critical philosophy, that of hellenistic-Roman perspective with scepticism), a transformation of psychological space into mathematical space; in other words, an objectification of the subjective.[17]

And what 'objectification of the subjective' means here, presumably, is the absorption of the fluctuations of subjective visual experience by conceptual thought; that is, becoming self-aware of the interplay of the mind and the objects of its perception. Perspective, like the critical philosophy of Kant, holds both the viewer and the viewed within its conception.[18] And from this critical vantage point any particular work or style may be seen to diminish the level of 'objectivity' or 'subjectivity', and after the discovery of perspective, to do this with a new kind of control. Panofsky has adapted his neo-Kantian philosophical scheme, given it application to a feature of Renaissance art (its spatial construction), and then, by contrasts, to other art. This is the most deep-seated and most sustained example of the 'adaptive' strategy, but it is also a way of giving at least a limited application to his own neo-Kantian *a priori* scheme of interpretation. The perspective construction is not only a mediating term between his theory of the mind and Renaissance painting, but also becomes associated with other aspects of depiction.

iv. *The Theory of Human Proportions*

Panofsky's paper 'The History of the Theory of Human Proportions' of 1921 is closely related to the perspective paper, and also shows a convergence of the adaptive and systematic strategies of interpretation.[19] Here Panofsky isolates an element of artistic procedure, theories of human proportion, which he sees as susceptible to more precise analysis than the full complexity of

artistic style. And he makes a further reservation: theories of proportion may be at any one time elaborated and treated as theories beyond the limits of practical application, for their own sake. Here Panofsky is presenting us with a set of conceptualised procedures, historically discrete, ranging from ancient Egypt to the Renaissance. He assumes that they do not comprehend the scope and richness of the works that embody them, just as they may also extend beyond the realm of practice, lying on the side of thought rather than visual realisation. But he also assumes that the central features of the theories are revelatory of the central attitudes of the works which employ them.

How much of the programme of the *Kunstwollen* papers remains in the paper on proportion? First of all, the *a priori* theory, the Archimedean point upon which the discussion pivots is provided by a distinction between objective proportions, those belonging to the depicted object irrespective of how it is represented, and technical proportions, those which involve the way the object is transformed in the work of art. And he sees a range of different relations in which those two kinds of proportion can stand. At one end of the range he places Egyptian art. This presents its object, the human figure, in a way which disregards the subjective life of the figure (subjective life here being identified with a figure's inwardly motivated movement or expression); it also disregards the position from which the represented figure is thought to be viewed (e.g. frontal and profile views are combined in a standard formula); and it disregards the (subjective) position from which the represention is viewed. In classical Greece, on the other hand, the subjective life of the figure is expressed in movement, and the position from which the figure is represented, as well as the position of the viewer of the representation were accounted for (with such refinements as diminishing the depth of lap of a seated figure represented above eye level to prevent the lower and upper part of the body appearing discontinuous). But this only becomes systematically realised in the Renaissance, where the subjective adjustments are articulated in a theory: that of the perspective construction. Thus, although more subjective factors are included as the series develops, they are also 'objectified' by being accounted for by the increasing complexity of the theory which takes into account the relation of object to viewer.

So far we have looked at Panofsky's theories and procedures with one question in mind: how did he conceive of the absolute viewpoint from which the history of past art was to be interpreted? To this question we have traced two rather different answers—different but not unrelated. The first was the way in which Panofsky sought to establish a system of concepts with necessary application to works of visual art and through which they were interpreted—the concepts of objectivity and subjectivity and the ways in which they were manifested. This project appeared to be flawed and unproductive because it had no criteria for deciding on the relative objective or subjective value to be given to any feature of a work, and no means of connecting the *a priori* scheme to the complexity of historical facts.

The second way of erecting a critical viewpoint was to take a position outside the field of historical material actually under consideration, but not outside history altogether, and then to show how an artist or historian—like Dürer or Vasari—might recover, or relate himself to, the work of an earlier age. Finally we saw the fusion of these two procedures when, in the perspective paper, Panofsky's own neo-Kantian viewpoint became identified with the Renaissance perspective construction (the latter serving as a metaphor of the former), and in the paper on proportion, where both spatial order and the treatment of the human figure were described in ways which gave metaphorical extension to the subject-object dichotomy of the *a priori* system.

A parallel procedure is present in Panofsky's *Idea*, a book which should perhaps be seen as both a reflection upon his own thought and upon the past. In the book he traces the relation, in the history of art theory, between the 'ideas' of the intellect and the 'imitations' of sensory experience. The history of this relation between thought and image is treated as constitutive of the history of art on the one hand, and of the development of epistemology on the other, and so linking the two. Like the theories of proportion, it makes art available—if only partially—to conceptualisation. Finally, in Panofsky's account, it is in Riegl's art theory, which he sees as corresponding to Kant's epistemology, that the opposition between idea and image is understood as incapable of resolution. Thus the art theory with which Panofsky himself operates is seen as connected to earlier theories of art which in turn mediate between it and the history of art itself.[20] In this way Panofsky has

linked art to an absolute viewpoint, the concern with rationality as such, and this makes the art of the past available in so far as it can be seen as participating in that rationality.

v. *The Relation of Images and Concepts*

Let us now leave to one side the problems of the historian adapting his own viewpoint to that of the works from past or alien cultures and concentrate on the ways in which Panofsky conceives of visual images as exhibiting rationality; that is, ways in which Panofsky conceives of the relations between images and concepts. It is convenient to divide those relations into two broad and overlapping categories: the first is that in which the visual form is presented to us as an *exemplification* of a concept; in the second the construction of the visual form is seen as guided by a theory which is like that of philosophical or theological thought.

The first category, 'exemplification'—the visible representation of what falls under the concept—includes what Panofsky called a 'visual type'. A 'visual type' is an image which attaches a literary content to a visual form; for instance, there is a visual type of the 'choice of Hercules' in which he is shown placed between two goddesses or allegorical figures, one persuading him to follow a virtuous and difficult life, and one persuading him to follow a life of ease and luxury. It is a characteristic of visual types that they are adapted through the history of their use. For instance, the motif of the choice of Hercules absorbs an element from the dream of Scipio—hence Hercules is shown sleeping, with the goddesses of virtue and luxury standing either side of him, and not seated listening to their arguments (as the description of the event in Xenophon would suggest).[21] But the visual types are not merely illustrations; in central cases they present not simply a narrative text but *instantiate* a general idea. Thus, in exemplification we use concepts in the ordinary sense—we recognise something in the image, but we also come to understand the concept more fully by looking at the image; we come to enrich or transform our grasp of the concept by reflecting upon its embodiment. And such embodiment may be an exemplification but it may also be a personification, or a combination of both.

It is an essential feature of such exemplification and personification, for Panofsky, that it can serve our understanding of

the concept it exemplifies or represents. At its most modest, the image may simply give a concrete instance without seriously enhancing our understanding of the concept. A more intimate relation between concept and visual form occurs where the image involves an exercise of the concept, as geometrical concepts are exercised in our attention to geometrical figures: that is, where the image serves as a model upon which we perform a conceptual demonstration. But the use of figures for such demonstrations in geometry are marginal to the kind of relation between concept and image which is involved in the visual arts. For we exhaust the interest of the geometrical figure when we have mastered the relevant concepts with its help; no visual delicacy or suggestion beyond what is included in the geometric proposition is of interest.

The demonstration and exemplification really central to art are those which not only act back upon our understanding of the concept, but give the concept new interest, an interest explored in the instantiation. For instance, in the small panel by Raphael, which Panofsky regards as depicting Hercules at the crossroads (Plate 67), the traditional motif on which he assumes it was based showed the moral opposition between the severe goddess of virtue and the painted goddess of sensual luxury; but in Raphael's image the ethical conflict is, on Panofsky's view, made less stark, a certain relativism is introduced; stern virtue is set opposite a figure which no longer represents mere sensual indulgence. Panofsky suggests that alternative positive values are presented by the way it is painted.[22]

Dürer's *Melancholia I* (Plate 66) exemplifies and personifies its theme in very complex ways.[23] The fusion of symbolic elements was eventually discovered to correspond to a particular mode of melancholy described by the German humanist, Agrippa of Nettelsheim, who was adapting ideas from, *inter alios*, Ficino. He divided creative melancholy into three stages of a scale, *imagination* which operates in the sensory world and is operative in mechanical arts particularly architecture and painting, secondly *reason*, knowledge of the natural or social world, and finally *mind*, knowledge of divine matters. So Dürer's *Melancholia I* is firmly attached to a speculative programme. Further, Panofsky and Saxl saw in this account of Melancholy, one in which Dürer would have recognised his own condition: 'For there is a falsehood in our

67. Raphael, *The Choice of Hercules* (?), *c.* 1500, London: National Gallery.

knowledge, and darkness is so firmly planted in us that even our groping fails.'[24] The density of symbolism like the strain of grasping the truncated polyhedron, itself illuminates and transforms the concept of creative melancholy.

Panofsky described a comparable transformation (Plates 68, 69 and 70) with reference to the print of *Christ in Judgement*:

Sol Iustitia, then, Christ as Sun God and Supreme Judge is the title which does justice to the iconographic attributes as well as the mood of Dürer's engraving. For what greater tribute could we pay to the power of the small print than to identify its content with a concept which fuses the grandeur of the Apocalyptic judge with the strength of the mightiest force in nature.[25]

Panofsky's conception of the transformation of types has been subjected to several critical attacks. Thus Renate Heidt writes that Dürer's *Melancholia I* is seen by Saxl and Panofsky in their original study of 1923 as an extension of their consideration of Ficino:

They regard the image with the consciousness of its dependence on Ficino, and project into their perception of it the feelings that they derive from their interpretation of Ficino. Thus their study of historical sources becomes not a corrective or confirmation of the impression derived from artistic experience, but the premiss of that experience.[26]

Heidt's argument must be read as implying that because the study of the engraving emerged out of the study of humanist texts, it is seen simply as illustrating them. What for Heidt is missing, it seems, is a recognition of the centrality of vision to the experience of the print.

There is then a second line of criticism (advanced by Dittmann)[27]. According to this, what is lacking in Panofsky's account is that sense of the *Weltanschauung* which Panofsky himself had elsewhere made essential to the interpretation of art, his notion of the unconscious presupposition in his essay of 1932,[28] and his notion of iconology, where he derived the 'essential tendency of the human mind' of a work of art from its links with its surrounding culture. This criticism of Panofsky is, similarly, that he has left out of his account the essential core of the work, now identified with underlying unconscious attitude. The criticism follows that of Otto Pächt in his review of Panofsky's *Early Netherlandish Painting*.[29] Artistic intention appears to Pächt to have

68. Dürer, *Apollo and Diana*, drawing, 1501–3, London: British Museum.

69. Dürer, *Resurrection*
(*The Small Passion*),
woodcut, 1509–11.

70. Dürer, *Sol Iustitia*,
engraving, 1498–9,
London: British Museum.

been reduced by Panofsky to the symbolism that the artist employs. When Panofsky says that van Eyck had a complete programme, iconography has been promoted to a total account of the work. The content of the work is turned into theological or philosophical thought.[30]

Let us first look at the common ground of these two criticisms: they are both attacks on Panofsky for reducing the interest or nature of works of art to that of vehicles for a programme— although they differ in what they believe has been missed out (Heidt the visual style, Pächt and Dittmann the unconscious expressive core). But Panofsky's sense of symbolism here is *not* that of the carrier of signs, but the visual and 'expressive' exemplification of concepts. The symbol can only function by instantiating or embodying, by *presenting* and not merely by being readable.

These critics, surely, fail to see the role of visual presentation within this mode of symbolism. In Panofsky's account of the work of van Eyck in *Early Netherlandish Painting* (the object of Pächt's criticism), Panofsky characterises the tradition in which van Eyck worked as one of reconciling the demands of early symbolism with a new demand for visual realism and consistency:

There could be no direct transition from St Bonaventura's definition of a picture as that which 'instructs, arouses pious emotions and awakens memories' to Zola's definition of a picture as 'un coin de la nature vu à travers un tempérament'. A way had to be found to reconcile the new naturalism with a thousand years of Christian tradition; and this attempt resulted in what may be termed concealed or disguised symbolism as opposed to open obvious symbolism . . . In early Flemish painting the method of disguised symbolism was applied to each and every object, man made or natural. It was employed as a general principle instead of only occasionally just as was the method of naturalism. In fact the two methods are genuine correlates. *The more the painters rejoiced in the discovery and reproduction of the visible world, the more intensely did they feel the need to saturate all its elements with meaning. Conversely, the harder they strove to express new subtleties and complexities of thought and imagination, the more did they explore new areas of reality.*[31] (my italics)

For instance, in the van Eyck *Annunciation* (Plate 71) the event takes place in the doorway of a church which is Romanesque on one side and Gothic on the other, but the representation of the church is highly realistic; it sustains a sense of visual coherence despite the

anomaly. Panofsky calls this 'disguised symbolism', but that is not just a covert way of using symbols. It is a way of permeating the natural visible world with meaning and, correspondingly, embodying religious meaning in that visible world. This 'sanctification of the visible world' is a kind of incarnation through the art of painting. 'It has been justly said of the *Annunciation* in the Merode altarpiece that God, no longer present in a visible figure, seems to be diffused in all the visible objects.' Panofsky sees the gradual crystallisation of disguised symbolism into a perfectly consistent system[32] in a way which is parallel to, and evocative of, Hegel's conception of art and religion in which the object of consciousness, the world, takes on the form of Spirit,[33] but Panofsky gives to this notion a specificity which Hegel never reached.

We come now to that second category of relation between concepts and images within Panofsky's thought, the category in which the *production* of the visual image is seen as analogous to, or informed by, a procedure of reflection. This second relation is given its most telling formulations in the papers, already discussed, on theories of proportion and perspective, but one further essay, *Gothic Architecture and Scholasticism*,[34] raises a different and wider issue.

In 'The History of the Theory of Human Proportions' (1921), Panofsky regarded theories of proportion, which have been used in constructing representations of the human figure, as conceptually definable. They can be stated in unequivocal terms. Such theories may be more elaborate than any actual artistic procedure on the one hand, and on the other will never exhaust the richness of an artistic style which employs them. Nevertheless Panofsky sees the overlap between a proportion system and style as picking out something central to that style, as paradigmatic of the cast of mind which the style involves.

In *Gothic Architecture and Scholasticism* a more tentative relation between theological thought and architecture is set up. It has as its background a loose analogy between the shift from the revival of Platonic to the revival of Aristotelian philosophy on the one hand, and the shift from Romanesque to Gothic sculpture on the other. In a dying echo of Hegel, the Aristotelian view of the mind inanimating the body is opposed to the Platonic view of mind as outside matter. This opposition is seen reflected in the difference

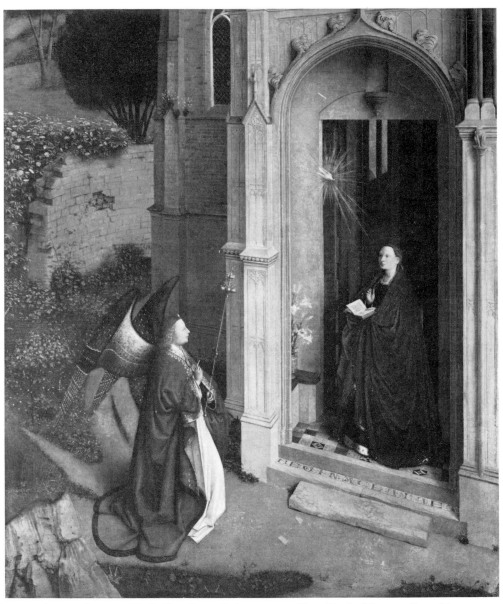

71. Hubert or Jan van Eyck (?), *Annunciation*, *c.* 1430, New York: Metropolitan Museum.

between (Aristotelian) Gothic and (Platonic) Romanesque sculpture.[35] But at the core of the book is the thesis which claims that, whatever suspicions we may have in general about such parallelism we can, in the period from 1130 to 1270 and within a hundred mile radius of Paris, see the development of Gothic architecture within the immediate environment of the development of scholasticism. The characteristics of scholasticism which Panofsky picks out are its dialectical procedure of reconciling conflicting biblical views or opposed theological positions, and the deliberate systematicity, marking the procedure of argument by the form of the exposition, with main sections, sub-sections, and subsequent sub-divisions. By virtue of such sytematicity, it is always possible, in principle, to see where you are in the total order of argument.

Panofsky sees Gothic architecture as similarly reconciling conflicting elements and manifesting systematicity; the discordant or conflicting factors are reconciled as the various parts of the church, nave, aisles, apsidal chapels are drawn into a single order of homologous parts; this he sees as corresponding to the way in which various sections of a *summa* are made equivalent to each other and have the same dialectical structure. Within each part of the church we find that the pier supports with their residual arch and wall structure are by stages simplified, and then clustered columns are articulated so that they become continuous with the vaulting system (Plates 72 and 73). In the final stage of this development not only is each component of the clustered column relatable to its corresponding rib in the vaulting and *vice versa*, but the ribs (and colonettes) are themselves ordered in a hierarchy of main divisions and sub-divisions of the vault. Panofsky's detailed survey of this development fits both the conception of integration, overcoming conflict (here stylistic or morphological) and also the conception of making order manifest. As a further example of integration, Panofsky cites the inclusion of the rose-window in the Gothic arch (Plates 74 and 75) and as another an example of making meaning manifest in the form, he cites the way the exterior of Gothic cathedrals increasingly make manifest their interior structure (Plates 73 and 75).

But how does Panofsky link the theological thought and architectural practice of his chosen area? He assumed here that the mental habit of public disputation, and the status of the masters of building as learned men, facilitated the transmission of the mental

habits of scholasticism. But if that causal explanation appears to us rather slight in relation to the degree of correspondence between the architecture and the scholastic *summa*, then the onus is perhaps on us to find some other explanation for the correspondence.

Let us accept that both scholasticism and Gothic architecture exhibit a progressive integration, resolving morphological conflict and achieving enhanced compendiousness in the manifestation of order; we might explain this by saying that such ideals are as much part of rational discourse as they are of art. Panofsky's consistent concern with this analogy here seems to need no special historical explanation, and to be genuinely illuminating without one.

In his theoretical papers Panofsky had been concerned to set up an *a priori* system of interpretation which would locate a particular mind-world relation within any particular work. This mind-world relation was seen both as the source of the work's internal co-ordination, and also as unifying it with surrounding culture. It becomes expressed in the Introduction to *Studies in Iconology* as an 'essential tendency of the human mind'. This continuity between different activities within the same culture appears to have two rather different kinds of rationale. The first, which is the less interesting, is the concept of a coherent philosophical outlook within a single period. It appears in the theoretical papers in a schematic way, as an ideal entity, something extra, something beyond the historically elucidated concept or motif, something beyond what can be captured in theories of proportion or visual types, implying the injunction to continue the search for parallels. The trouble with this is that the more specific Panofsky's parallels between thought and image become, the more redundant become notions like 'the essential tendency of the human mind'. It is anyhow far too vague as a heuristic principle for the purpose of linking the visual features of works with their age.

But there is a second way in which the notion of cultural coherence functions in Panofsky's thought—not now in the search for the rationality of art, but in the concern with retrieval of past mental life for the present. The theory is expressed in *Beschreibung und Inhaltsdeutung* (1932); it posits an unconscious attitude which a work betrays rather than a meaning which it displays.[36] It is a meaning of which the artist himself cannot be aware, it lies outside the limits of his possible self-consciousness.

72. Laon Cathedral, interior.

While this sense appears fully only in the 1932 paper and with specific acknowledgement to Ralph Mannheim, there is an intimation that Panofsky had in mind a sense of the limits of self-awareness in the earlier theoretical papers, for instance, when Panofsky wrote, as early as 1920, that Polygnotus could not have wanted to paint a landscape because it was outside his immanent mental world to conceive of it.[37] In defining this underlying factor as the limits of possible self-consciousness, Panofsky can perhaps be understood as pointing to the gap between the historian and the subject of his study—the artist of the past; marking the limits of the artist's possible self-consciousness is a way of showing how the artist's pre-suppositions differ from those of the historian, and so showing the mental adjustment the historian has to make. In this way it offers a partial theory of the adaptive strategy of historical retrieval which we discussed earlier.

But here a reservation must be made. To pick out the conditions under which an artist works is not in itself to pick out the nature of his work. It is a matter of critical judgement whether an artist has responded to, say, the achievement of another art contemporaneously practised in his own city or whether he has turned current religious issues into a matter of positive visible interest. Determining the border between working *with*, and merely working *within*, the contextual factors is an inescapable critical demand.

There could, within the range of historians considered in this book, be no greater gap than that between Warburg on the one hand and Panofsky on the other; it is as great as that between Rumohr and Hegel, to whom their respective intellectual ancestry is to be traced. That their interests overlapped, that Panofsky had worked in the ambience of Warburg and that some of his early work was published by the Warburg Library should not obscure the difference. In no writer was the conception of art as like knowledge so elaborately developed as by Panofsky; in no writer had art been so integrated into the sense of social behaviour as by Warburg. Compare Warburg's account of *Melancholia I* with his sense of the artist overcoming fear and superstition, and Panofsky's account which sees in it the melancholy of 'those who cannot extend their thoughts beyond the limits of space'.[38] The commitment to the ideal of art as the mind's pursuit of freedom, could hardly have been realised in more different ways.

73. Rheims Cathedral, interior.

74. Amiens Cathedral, West Front.

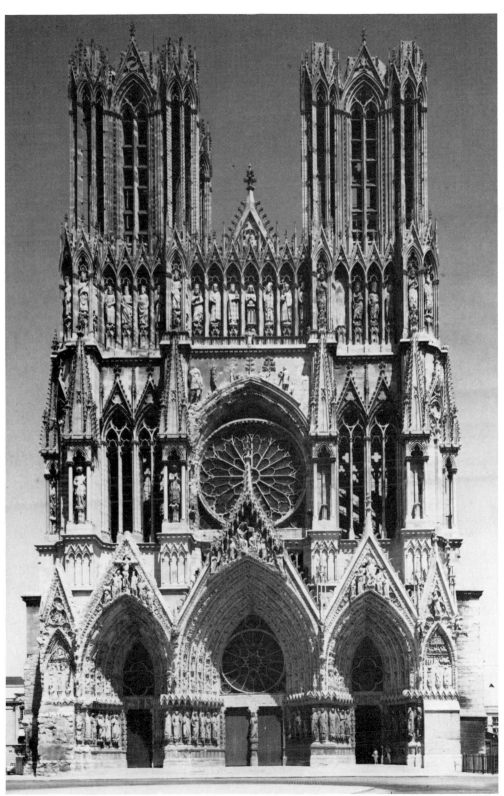

75. Rheims Cathedral, West Front.

The two conceptions of art are not altogether unconnected. The notion of human rationality and human poise are both aspects of a single ideal which we surely recognise, and we cannot readily indicate it except by saying it is where aspirations of knowledge and behaviour converge. Warburg saw in classical art an achievement of understanding and will which overcame superstitious fears and magical practices, and Panofsky talks at one point of the impossibility of conceiving our world except as the interpenetration of action and thought. But our present discussion cannot be continued into arguments about how we relate virtue and knowledge. Nor could we be asked to choose between relating works of art on the one hand to discursive thought—including theology and metaphysics—and on the other to social behaviour—including religious devotion and responsiveness to other people. For there seems no general choice to be made, only particular connections to be traced in both directions.

X

THE TRADITION REVIEWED

THE SYSTEMATIC historians like Riegl and Semper have been criticised on the grounds that the particularity of the individual work and the detailed study of its historical context was sacrificed to another objective, to treating particular works as exemplifying their interpretative concepts—as instances of a stylistic phase or category.[1]

But how justified was this attack? What were the constraints imposed by constructing such systems? How far did they curtail attention to individual works? In answering these questions, we shall also come to relate the systematic and unsystematic historians, so the argument may stand as an evaluation of the modes of critical history as a whole.

i. *The Problems of Systematic Interpretation*

There is an initial distinction to be drawn between different claims which writers may be making for their systems. The extreme claim is that the system offers a sufficient set of concepts for the critical understanding of a work. And the claim may be strengthened further by holding that the concepts of the system provide the *exclusive* terms in which works can be understood. The concepts on offer thus become necessary as well as sufficient. The rigidity of this position is clearly unacceptable, because in this way the interest of a work is seen as exhausted by applying the concepts of the system. We have encountered this claim only once, in the second position adopted by Hegel, his absorption of the art of the past within his completed 'Philosophy of Spirit'.

The normal claim for the systems of critical interpretation is that the set of concepts it offers is necessary, that it provides a network or armature for critical understanding while not claiming to be exhaustive of such understanding. The systems are offered in a way that acknowledges interests which are not circumscribed by the systems' own concepts. Thus Wölfflin offers his concepts of linear and painterly and the related pairs, assuming that questions

of subject matter are also critically relevant. Panofsky offers his *a priori* scheme of the objective—subjective spectrum, while assuming that the results of detailed historical inquiry will be relatable to the structure it provides. The difficulty is that in both cases, the necessary condition of interpretation—the conceptual network or armature—produces a distinct mode of interest which forms no bond with other interests.

Here there is a qualification to be made. It is not that the individual concepts of Wölfflin's or Panofsky's systems cannot be integrated or used in richer critical descriptions, as we saw in re-using Wölfflinian concepts in discussing Duccio's triptych. But when we regard the set of concepts as offering a critical viewpoint, they circumscribe and elevate the qualities they describe, and separate those qualities from others which are not included in that description. So what are offered as necessary conditions of the interest of a painting or building turn out in practice to be disconnected from other interests. It might be thought possible to resist this objection, for it might be held that in holding certain characteristics essential to something as a work of art, we were not saying that our interest was exhausted by the fact that they were present, but we were interested in *how* they were present, in the particular determinations that those necessary characteristics took on.

But the concepts of the visual forms like the 'painterly' had been offered as independent of the interest of subject matter, and what was missing was any account of how we might connect the mode of representation and the interest of the subject matter, or the relation of Panofsky's subjective–objective spectrum to the variety of qualities in actual works.

ii. *The Separation of Functions and Features*

How serious and general a criticism is this? and how far does it lead us to disvalue the critical systems to which it applies? First, we should observe that a critical system like that of Semper does not appear open to this objection, and a comparison of Semper's system with those of Riegl, Wölfflin and Panofsky underlines the kind of revision we need to make to the latter three. Semper's position allows a set of general principles—marking, masking and metaphor—to function over a potentially infinite range of visual

motifs generated by function, materials and skills. The problem of too exclusive a critical view arises when the concepts of the system claim to isolate and circumscribe the properties of critical interest. If a systematic project operates at two levels, one defining the nature of critical interest (like Semper's evaluation through marking, masking and metaphor), and the other developing concepts which can fulfil that interest (like his types of motif), the fatal isolation or reduction of critically relevant properties is avoided.

If we look back to our examination of Riegl, Wölfflin and Panofsky, we find in each case we were forced to introduce distinctions between, for instance, a general ideal of coherence toward which artists were assumed to aim, and the particular models and motifs through which this coherence was achieved; or between a general theory of development, and the particular motifs that figured in that development; or between the general notion of artistic intention, and the particular materials through which it was realised. The critical systems had to be split into general purposes or functions and the particular materials which were drawn upon in their fulfilment.

Having this two-tier division, between what we might term the level of *feature* and the level of *function*, we are in a better position to summarise the critical potential of the systematic historians. Their analogies generated fresh and compendious descriptive concepts. At the higher level there was the search not for an analogy of *features* but for what we may term *functional equivalence*: as Riegl sought out what it was in Rembrandt's painting which corresponded to the more readily grasped mode of coherence in Raphael, or Hegel sought a manifestation of self-awareness in Egyptian and Christian art which would be the counterparts of the body's expression of the mind that he saw in Greek sculpture.

It might seem as though Panofsky, in proposing his *a priori* scheme, was himself attempting to make just the division we have been led to propose, that he sought to distinguish between empirical concepts like those of Wölfflin, and what I have termed functional concepts which indicated a viewpoint from which the empirical material should be surveyed. There is no doubt that Panofsky introduced his notion of the *Kunstwollen* in analogy with Kant's notion of causation with some such intention. And one reason his project misfired was that he attempted to draw detailed

descriptive content out of his high level functional concept; he tried to derive a detailed system of phenomenological possibilities from the notion of artistic purpose.

The relation between, on the one hand, general functional concepts and on the other, motifs, must be left free, just as the notion of seat cannot be tied to specifications of material, shape, colour or technique of carpentry, through which the objects which fall under it may be realised, and in the way that the notion of generosity or responsibility cannot tell one what is required in a particular situation.[2]

At this point it becomes appropriate to look at a related objection to the critical historians, particularly Riegl and Wölfflin, that of Julius von Schlosser.[3] In a paper of 1935 he argued that a history of art could not be written by the compilation of a mass of contextual history, unless you had some criterion of what within that mass of information was relevant to artistic performance. On the other hand artistic achievement could not be registered by a formalist abstraction of aesthetic characteristics, onto which a historical pattern of problems and solutions was projected. This was unacceptable because the achievement of one artist was not the solution of a problem set by a predecessor any more than it was a matter of his influence on his successors. The history of the internal spiritual achievement of the artist was not something we could inspect; it transcended the current language of art and produced something personal and *sui generis*.

But Schlosser's insistence on separating the language of art from distinguished artistic performance, led him—with Croce— to regard that performance as transcending what could be historically studied. In this way Schlosser had no model by which to relate the history of the language of art to the works which were created in the language. This is an issue to which—in a moment—I shall return.

Schlosser's view that visual motifs and their history cannot be identified with what truly constitutes art, but might rather be seen to stand to the real achievements of art as the history of language to the creative achievement of the poet may be related to an argument that we cannot identify morphologies or motifs with what I have termed the functional concept of art. Each of these criticisms perhaps implies the other; for there would be no notion of art over and above the motifs and morphologies, if we did not

conceive of the artist as doing something with those motifs, and something which—in its general character—could be done with other motifs. Correspondingly we should have no notion of such artistic performance without higher level functional concepts implied by our idea of art.

iii. *On the Multiplicity of Viewpoints*

But it might be argued that if we make a revision in the critical systems which we have proposed, if we re-articulate them so as to distinguish between the functional concepts and the motifs which serve or fulfil those functions, we have left our central problem unresolved. For the functional concepts, in their turn, dictate a point of view, a mode of interest which cannot be comprehensive.

But the fact that a position is partial, that it is not comprehensive, is a necessary virtue. If it is to be a position in any useful sense at all, it must make some features salient rather than others, engage with the work in one way rather than another. We value the position for the importance and richness it leads us to perceive, for the resources of the mind that it leads us to employ.

This view might be resisted on two different grounds. First, it may be objected that it allows a degree of relativism which makes interpretation capricious. If quite different critical viewpoints and concepts may be adopted, interpretation becomes a matter of selecting a point of view, without any check or constraint. But this notion of the unconstrained adoption of points of view is an illusion. For the only way in which critical viewpoints and concepts can become intelligible is through their exercise upon the complex objects which form the occasion and purpose of their construction. The meaning of terms like painterly or tactile, of *textile art* as Semper uses the term, or *Kunstwollen*, as Riegl uses it or as Panofsky uses it, even notions like tradition and coherence are, in different authors, tied to examples on the one hand and the interest with which those examples are regarded on the other. By attempting to use them, we are not depriving ourselves of the capacity to turn and criticise them. We can perfectly well test out a viewpoint and reconstruct it, bring out the latent ambiguities of its assumptions or the inadequacy of its scope. What is needed is that we should be able both to grasp the point of the enterprise and to observe the objects with which it is concerned.

But the possibility of different critical viewpoints may be challenged out of what is virtually the opposite concern, not because there are no checks on it in the art and the historical material on which they are directed, but because the admission of a multiplicity of viewpoints rids any of them of authority or conviction. Assuming that they are not incompatible, they may well be incommensurable, hence we could not integrate them into one comprehensive critical view.[4] For this reason, if we regard these or any other systems in this way, they can never become *our* critical viewpoint. But then no system of thought, no systematic viewpoint could be regarded as identical with our thought or viewpoint. To make such an identification would be incompatible with the mind retaining its freedom. Our relation to any viewpoint, systematic or not, must be open in our own doubts and revisions.

Having considered the modes of interpretation in this rather general way, let us finally return to the two fundamental issues raised by the critical historians—the retrieval of past art for the present and the relation of art to the mind's freedom—and relate them to more recent discussion.

iv. *The Retrieval of the Past*

Let us return to an example which was used in the first chapter (Plate 3). If we now assume that we find it unavoidable that in our responsiveness to the *Coup de Lance* we use, however loosely, some concepts derived from psycho-analysis—some such notions as the release of aggression with the displacement of guilt, or that we see the level of emotion offset or transformed by its formal complexity, are we not reconstructing the work as part of our own mental life and doing so in a way which disregards what Rubens or his contemporaries might possibly have seen in it?

Three views of this situation seem to offer themselves. One is that we might say we understand the original meaning or intention of the painting, and then give it an added significance within our own mental life. This view, which is broadly that of E. D. Hirsch, Jr,[5] seems unacceptable because our modern sensibility is in there from the start. The painting is constituted for us by exercise of our sensibility and there is no way in which the painting for us can be freed from our present position unless we turn it into a mere archaeological object, disengaged from any but scholastic concerns.

The second view is that revision is inevitable and indeed the only course and objective of interpretation. The gap between author and modern spectator is absolute and also invisible: we cannot stand outside ourselves and observe the relation. Insofar as we really engage with a past work we must re-make it for ourselves.

This view assumes that I could not *both* exercise my modern concepts and sensibility and *also* be aware that I am doing so. But this assumption is surely false. What I have to accept is a third view: that within my engagement with Rubens' painting, I cannot exactly demark what he might have assented to in my account and what he might have deemed alien. But this reproduces the fundamental indeterminacy which marks all our knowledge, and is not distinctive of our relation to the past or to art. I cannot look at anything and know where my mind's contribution to its qualities ends and the qualities that belong to it in itself begin, because there is no such point. There are only the qualities it manifests from a particular viewpoint and the only corrective is from other particular viewpoints. But I can always reconsider my own assumptions, change the analogies in the light of which I regard a work, or try out the critical notions offered by others.

v. *The Mind's Autonomy*

Let us turn finally to the second central topic of the critical historians, that of the relation of art to the mind's freedom. This has been seen as exhibited in art by the way in which the work of the artist involves the rationality of experiment and self criticism, particularly in the transformation of styles of representation. E. H. Gombrich in *Art and Illusion* and a number of related papers provides an account of the development of representation different from those discussed here because it is based on the psychology of recognition and how the skills of invoking it are learned.[6]

The sense of art as exhibiting rationality in developing the skills of representation, and the co-ordination of representation and design, introduces a new set of concerns into the analysis of painting while retaining the problem solution pattern of much earlier art history.[7] But there is a further way in which more recent writing on art provides a radical shift of perspective from that of the critical

historians so far discussed. It relates to the separation of the interest of art from its surrounding culture. One major change in our understanding of art has followed upon the Wittgenstinian sense of language as a form of life.[8] In this view, language is seen as irreducible to the context of its emergence; language emerges within and transforms our social transactions, its content is not some state of affairs in the world but that state of affairs permeated by the life of speech. By analogy, art may be seen both to emerge out of the context of our other activities, and to be irreducible to them and to transform them. In this way an independence can be attributed to art without resort to a theory of two roots of style, or the separation of formulation and function. Something of this is anticipated by Semper, Springer and Warburg, but in general the critical historians oscillated uneasily between, on the one hand, the assimilation of art within some generalised notion of culture, and on the other the autonomous formal interest—with more or less spiritual overtones. This sense of art as a form of life—as *sui generis*—yet socially embedded relieves a problem which was recurrent.

But the sense of art as a 'form of life' on analogy with language raises two questions: in what way is the form of life manifested in literature related to that manifested in the language on which that literature draws? And how can that model be extended to the visual arts, in which there is no obvious equivalent to ordinary language? Schlosser's view had been that real literature transcended the ordinary use of language and even the pedestrian uses of literary forms; correspondingly, that great painting or sculpture transcended routine painting procedures. But he was unable to say anything very clear about the transcendence. However, we might at least clarify that transcendence by regarding it in this way: we see the procedures of language refined and recast in literature so that its formulations become richly self-informative. Similarly the procedures of painting can be refined so that its formulations draw us further back through its inflexions and paths of analogy. So it seems natural to say that distinguished visual art and literature are inextricably embedded in, as well as irreducible to, ordinary visual and linguistic performance, just as lower level linguistic and visual performance are themselves embedded in, and irreducible to, the contexts of life out of which they arise. The real art of painting or sculpture or literature transcend routine speech and routine

painting and routine carving without that transcendence being unrelated to the common run of speaking, painting and carving, or unrelated to the yet wider context in which these activities have their roles.

This does not make the transcendence of art in general any less astonishing—perhaps it makes it doubly so—but neither does it make art inaccessible to discussion, either in general or in the detail of particular works. This analogy of art and language suggests that the criticism of works of art should be concerned with the way they transform and evaluate the world, of which language and image making are already an integral part.

It is sometimes thought that the literature which has been the subject of the present book provided methodologies of art history. It should have become clear that this is a thorough misunderstanding. For what would it provide methods for doing which it did not itself do? This is not to say that it did not provide concepts and analogies which could be absorbed in detailed studies of particular works, studies which were archaeological as well. On the other hand nor is critical history—in the sense in which it has been our concern here—an altogether self-contained or independent way of viewing past art. To isolate it as I have done is to direct attention to one thrust within the very complex and irregular movements of thought which art itself sets up and which, in the nature of things, could not be gathered into a single system or perspective.

NOTES

WHERE references are given in a shortened form further details of publication are to be found in the bibliography, including details of translations.

Where works cited were originally published in German, reference to a German edition is given first, followed by reference to an English translation, where there is one.

Bibliographical information on a particular writer is included in the first notes corresponding to the extended discussion of him in the text.

NOTES TO CHAPTER I

1. 'Wenn man von einem trefflichen Kunstwerke sprechen will, so ist es fast nötig, von der ganzen Kunst zu reden: denn es enthält sie ganz, und jeder kann, soviel in seinen Kräften steht, auch das Allgemeine aus einem solchen besondern Fall entwickeln; deswegen sei hier auch etwas Allgemeines vorausgeschickt'. Goethe, 'Über Laokoon', *Werke, Hamburger Ausgabe*, Hamburg, 1957, Vol. XII, P 56. English translation in *Goethe on Art*, ed. and tr. John Gage, London, 1980, p. 78.

For a consideration of Goethe as a commentator on the visual arts, the remarks of Rumohr are particularly interesting in our present context. After remarking on Goethe's involvements with the visual arts he notes '... it is not to be denied that his historical knowledge and technical insight were neither very varied nor coherent; that he never, during his long life achieved a firm viewpoint for regarding art... I myself miss, in Goethe's occasional flights of enthusiasm for apparently quite conflicting manifestations, any general viewpoint which would assign components their proper place and value.'

[Andrerseits ist freilich auch nicht zu läugnen, dass seine historischen Kenntnisse und technischen Einsichten weder sehr mannichfaltig, noch selbst zusammenhängend waren ... Ich selbst hingegen vermisse zwar in Goethe's gelegentlichen Aufwallungen für scheinbar einander ganz entgegengesetzte Erscheinungen jenen allgemeinen Standpunct, welcher alles Untergeordnete an seiner Stelle und in seinem rechten Werthe zu sehen gestaltet.] C. F. von Rumohr, *Drei Reisen nach Italien*, Leipzig, 1832, pp. 18f.

Insights, derived from Goethe, occur frequently in the work of the critical historians, but transposed into a quite different mode of discussion.

2. 'Denn wenn die künstlerische Form vom Religiösen abhängt, wie kann uns Christen (eine andere als die eigentümliche-christliche Form, die des Mittelalters, wie kann uns) die heidnische Form zusagen?' Karl Schnaase, *Niederländische Briefe*, Stuttgart and Tübingen, 1834, p. 377.

3. J. G. Herder, *Sämtliche Werke*, ed. Suphan, Berlin, 1877–1913, Vol. VIII, pp. 476f. For an account of Herder's views of historical understanding, see particularly Isaiah Berlin, *Vico and Herder*, London, 1976 and the Introduction to *J. G. Herder on Social and Political Culture*, tr. and ed. with Introduction by F. M. Barnard, Cambridge, 1969. For Herder and Goethe on Egyptian art see Siegfried Morenz, *Die Begegnung Europas mit Aegypten*, Berlin, 1968, pp. 154ff.

4. Herder, *Sämtliche Werke*, Vol. V, pp. 503–5 (tr. Barnard, op. cit., p. 182f.).

5. *Ibid.*, Vol. XVI, p. 77; and Vol. VIII, p. 450.

6. C. F. von Rumohr, *Italienische Forschungen* (1827–32), ed. J. von Schlosser, Frankfurt-am-Main, 1920, p. 7.

7. Kant, *Critique of Judgement*, §§17–18 and 46.

8. I take this notion of a genuine alternative here from Bernard Williams, 'The Truth of Relativism', *Proceedings of the Aristotelian Society* (1974–5), N.S., Vol. LXXV, pp. 215–28. Reprinted in B. Williams, *Moral Luck*, Cambridge, 1981. For recent discussions of scientific trans-cultural understanding see Bryan R. Wilson, ed., *Rationality*, Oxford, 1970. Of particular relevance here is Alasdair MacIntyre, 'The Idea of a Social Science', originally published in *Aristotelian Society Supplementary Volume*, XLI, 1967. This is a response to P. Winch, *Idea of a Social Science*, London, 1958, relevant sections of which are published in this anthology. The problem of the trans-cultural intelligibility of art is not precisely equivalent to that of the trans-cultural criteria of rationality, but in two respects they converge: firstly in that those who approach an alien culture must retain their own sense of art or rationality, and secondly that they must be prepared to learn. But here the case of art may seem to have a further problem; for while we may be able to stipulate minimum features for rationality (see Steven Lukes, 'Some Problems about Rationality' in Wilson, *op. cit.*, pp. 208ff.), can we stipulate such conditions for art? For the assumptions which were in fact made by our writers, and to which I shall adhere, see Chap. I, p. 15.

For earlier and more general discussions of historical relativism

see Maurice Mandelbaum, *The Problem of Historical Knowledge: An Answer to Relativism* (1938), new ed., New York, 1967. On the problem of relativism and the understanding of art, see Richard Wollheim, *Art and its Objects*, second ed., Cambridge, 1980, §39, pp. 87ff., and Supplementary Essay IV, pp. 185ff., and E. D. Hirsch Jr, *Validity in Interpretation*, New Haven and London, 1976, and *The Aims of Interpretation*, Chicago and London, 1976, Chap. III.

9. G. Brotherston, *Images of the New World: The American Continent Portrayed in Native Texts*, London, 1978, pp. 82f. I am indebted to John Gazeley for suggesting this analogy.

10. See T. Puttfarken, 'David's *Brutus* and theories of pictorial unity in France', *Art History*, Vol. IV, No. 3, Sept. 1981, pp. 291–304, and forthcoming book, *Roger de Piles and the Unity of Painting*.

11. L. B. Alberti, *On Painting and On Sculpture*, ed. and tr. C. Grayson, London, 1972, particularly *On Painting*, Book II, pp. 73ff. on which see M. Baxandall, *Giotto and the Orators*, Oxford, 1971, Chap. III.

12. Aristotle, *Poetics*, 1450–51.

13. Schiller, 'Kallias Briefe', *Schiller's Briefe*, ed. F. Jonas, Stuttgart, Leipzig, etc., 1892–6, Vol. III, pp. 238 and 278ff, and *Letters on the Aesthetic Education of Man*, ed. and tr. E. M. Wilkinson and L. A. Willoughby, Oxford, 1967. Letter XXII, on which see M. Podro, *Manifold in Perception*, Oxford, 1972, pp. 41f. and 53ff.

14. On the classical sources see Helen North, *Sophrosyne: Self-Knowledge and Self-Restraint in Greek Literature*, New York, 1966. For Freud see *The Ego and the Id*, Standard ed., London, 1953, Vol. XIX, and the *New Introductory Lectures*, Lecture XXXI, *ed. cit.*, Vol. XVI.

15. For Kant see Chap. I, §iii.

16. 'Das allgemeine und absolute Bedürfnis, aus dem die Kunst (nach ihrer formellen Seite) quillt, findet seinen Ursprung darin, dass der Mensch *denkendes* Bewusstsein ist, d.h. dass er, was er ist und was überhaupt ist, aus sich selbst *für sich* macht . . . Der Mensch tut dies, um als freies Subjekt auch der Aussenwelt ihre spröde Fremdheit zu nehmen und in der Gestalt der Dinge nur eine äussere Realität seiner selbst zu geniessen.'
Hegel, *Aesthetik; Werke*, Vol. XIII, p. 50f. (tr. pp. 30f.).

17. 'Umgeben von einer Welt voller Wunder und Kräfte, deren Gesetz der Mensch ahnt, das er fassen möchte, aber nimmer enträthselt, das nur in einzelnen abgerissenen Akkorden zu ihm dringt und sein Gemüth in stets unbefriedigter Spannung erhält, zaubert sich die fehlende Vollkommenheit im Spiel hervor, bildet er sich eine Welt im Kleinen, worin das Kosmische Gesetz in engster Beschränkenheit, aber in sich selbst abgeschlossen, und in dieser Beziehung vollkommen, hervortritt; in diesem Spiel befriedigt er seinen kosmogonischen Instinkt.'

Gottfried Semper, *Der Stil*, (1860–3) Munich, 1878–9, Vol. I, p. xxi.

18. 'Alles Leben ist eine unablässige Auseinandersetzung des einzelnen Ich mit der umgebenden Welt, des Subjekts mit dem Objekt. Der Kulturmensch findet eine rein passive Rolle gegenüber der Welt der Objekte, durch die er in jeder Weise bedingt ist, unerträglich und trachtet sein Verhältnis zu ihr selbständig und eigenwillig dadurch zu regeln, dass er hinter ihr eine andere Welt sucht, die er dann mittelst der Kunst (im weitesten Sinn des Wortes) als seine freie Schöpfung neben die ohne seine Zutun bewirkte natürliche Welt setzt.'
Alois Riegl, *Holländisches Gruppenporträt*, Vienna, 1902, pp. 280.

19. For Burckhardt see *Weltgeschichtliche Betrachtungen, Gesamtausgabe*, Vol. VII, pp. 78f., tr. M. D. Hottinger, London, 1943, p. 91: 'Here lay man's first experience of release from religious terror. The sculptures of the gods meant salvation from the monstrous idol; the hymn purified the soul.'

On Warburg see Chap. VIII, §v. On the visual roots of style in Schnaase see Chap. III, §iv; in Wölfflin, Chap. VII, §ii. This view of the role of art was even expressed by an historian, Franz Kugler, whose practice was almost purely archaeological and who could hardly be regarded as a critical historian in any sense used here. He wrote: 'The source of art lies in the need of mankind to bind his thought to a stable location, and then to provide a form for this localisation of his thought, for this monument which would be the expression of that thought . . . For in general it is its highest aim to invest the appearances of the material world with spiritual import, to impart perpetuity to the transient and invest in the objects of the world a sense of the eternal. . .' ('Der Ursprung der Kunst liegt in dem Bedürfniss des Menschen, seinen Gedanken an eine feste Stätte zu knüpfen und dieser Gedächtnisstätte, diesem 'Denkmal' eine Form zu geben, welche der Ausdruck des Gedankens sei. . . . und überall ist es ihr höchstes Ziel, in den Erscheinungen der Körperwelt den geistigen Inhalt, in dem Vergänglichen das Dauernde, in dem Irdischen das Ewige zu vergegenwärtigen . . .' Franz Kugler, *Handbuch der Kunstgeschichte*, 2nd ed., Stuttgart, 1848, p. 3.)

20. J. J. Winckelmann, *Geschichte der Kunst des Altertums*, Dresden, 1764, pp. 82ff.

21. 'The rational being counts himself, *qua* intelligence, as belonging to the intelligible world, and only as an efficient cause belonging to it does he call his causality a will. On the other side, however, he is conscious of himself as part of the world of sense in which his actions are found as mere appearances of causality. . .'

Kant, *Foundations of the Metaphysic of Morals*, tr. Lewis White Beck, Indianapolis, 1959, p. 72.

'. . . one and the same acting being as appearance (even to its own inner sense) has a causality in the sensuous world always in accord with the mechanism of nature; while with respect to the same event, so far as the acting person regards himself as noumenon (as pure intelligence, existing without temporal determination), he can contain a determining ground of that causality according to natural laws, and this determining ground of natural causality itself is free from every natural law.'

Kant, *Critique of Practical Reason*, tr. Lewis White Beck, Indianapolis, 1956, p. 118.

22. This account of Kant's 'Critique of Aesthetic Judgement' modifies that given in greater detail in M. Podro, *Manifold in Perception*, Chap. II. For some revisions of this and a much fuller study see Paul Guyer, *Kant and the Claims of Taste*, Cambridge, Mass., and London, 1979, and Jens Kulenkampff, *Kants Logik des aesthetischen Urteils*, Frankfurt-am-Main, 1978.

23. Kant, *Critique of Judgement*, §8.

24. On this see particularly Kulenkampff, *op. cit.*

25. Kant, *Critique of Judgement*, §58, and *First Introduction to the Critique of Judgement*, §VIII.

26. Kant, *Critique of Judgement*, §52.

27. Schiller, *Letters on the Aesthetic Education of Man, ed. cit.* This conception of the disruption of human wholeness was much more extensive than the specialisation of the intellect. That was only one example of the increased diversification of human tasks and skills each of which so absorbed the people who performed them that their overall human personality was left to atrophy. With regard to the development of thought itself, culminating in the new philosophy of Kant, Schiller held that, whatever advantage it could bring it left us a prey to unbalanced and narrow judgement.

Letters VI, para. 13; XIII, para. 2, n. 2.

28. 'Um die flüchtige Erscheinung zu haschen, muss er sie in die Fesseln der Regel schlagen, ihren schönen Körper in Begriffe zerfleischen und in einem dürftigen Wortgerippe ihren lebendigen Geist aufbewahren. Ist es ein Wunder, wenn sich das natürliche Gefühl in einem solchen Abbild nicht wiederfindet?'

Schiller, *Aesthetic Education*, Letter I, para. 4.

29. 'Wenn der Schulverstand, immer vor Irrtum bange, seine Worte wie seine Begriffe an das Kreuz der Grammatik und Logik schlägt, hart und steif ist, um ja nicht unbestimmt zu sein. . .'

Schiller, *Ueber naive und sentimentalische Dichtung, Säkular-Ausgabe*, Vol.

XII, p. 175; English ed. *On Naive and Sentimental Poetry and On the Sublime*. tr. Julius A. Elias, New York, 1966, p. 98.

30. 'Der gesetzlose Sprung der Freude wird zum Tanz, die ungestalte Geste zu einer anmutigen harmonischen Gebärdensprache; die verworrenen Laute der Empfindung entfalten sich, fangen an, dem Takt zu gehorchen und sich zum Gesange zu biegen.' Schiller, *Aesthetic Education*, Letter XXVII, para. 6.

31. *Ibid.*, para. 7.

32. Nietzsche, *Birth of Tragedy*, §5.

NOTES TO CHAPTER II

1. The German edition of Hegel's works cited is: Hegel, *Werke, Theorie-Werkausgabe*, ed. Eva Modenhauer and Karl Markus Michel, 20 vols., Frankfurt-am-Main, 1970. The translation of Hegel's *Aesthetics* cited is: Hegel. *Aesthetics; Lectures on Fine Art*, tr. T. M. Knox, 2 vols, Oxford, 1975.

 Bibliographies on Hegel's *Aesthetics* are given in W. E. Steinkraus and Kenneth L. Schmitz, eds., *Art and Logic in Hegel's Philosophy*, Hegel Society of America, New Jersey and Sussex, 1980; and Wolfhart Henckmann, 'Bibliographie zur Aesthetik Hegels. Ein Versuch', *Hegel-Studien*, Bonn, 1969, Vol. V, pp. 379–427.

 For an account of mainly German responses to Hegel in this century see Werner Koepsel, *Die Rezeption der Hegelschen Aesthetik im 20. Jahrhundert*, Bonn, 1975. A recent background essay appears in Hegel's *Introduction to Aesthetics*, tr. T. M. Knox, with an Interpretative Essay by Charles Karelis, Oxford, 1979. The 'Prefatory Essay' by Bernard Bosanquet to his translation, *The Introduction to Hegel's Philosophy of Fine Art*, London, 1905, and the translation itself remain very valuable.

 For general introductions to Hegel's thought in English see: Alasdair MacIntyre, ed., *Hegel. A Collection of Critical Essays*, New York, 1972; new ed., Notre Dame and London, 1976. G. R. G. Mure, *An Introduction to Hegel*, Oxford, 1940. Charles Taylor, *Hegel*, Cambridge, 1975.

2. 'Sowenig des Apelles und Sophocles Werke, wenn Raphael und Shakespeare sie gekannt hätten, diesen als blosse Vorübungen für sich hätten erscheinen können, sondern als eine verwandte Kraft des Geistes, sowenig kann die Vernunft in früheren Gestaltungen ihrer selbst nur nützliche Vorübungen für sich erblicken. . .' Hegel, *Werke*, Vol. II, p. 19; *The Difference between Fichte's and Schelling's System of Philosophy*, tr. H. S. Harris and Walter Cerf, Albany, 1977, p. 89.

3. 'Denn der Geist sucht . . . sinnliche Gegenwart, die zwar sinnlich bleiben, aber ebensosehr von dem Gerüste seiner blossen Materialität befreit werden soll.'
 Hegel, *Aesthetik*; *Werke*, Vol. XIII, p. 60 (tr. p. 38).
4. *Ibid.*, *Werke*, Vol. XIII, p. 51 (tr. p. 31). See Chap. I, note 13.
5. *Ibid.*, *Werke*, Vol. XIII, p. 14 (tr. p. 2).
6. For an English introduction to Fichte see the Preface by Heath and Lachs to their translation of Fichte's *Wissenschaftslehre*; G. Fichte, *The Science of Knowledge*, ed. and tr. P. Heath and J. Lachs, New York, 1970, and Fichte's own First and Second Introductions published in that edition.
7. Schiller, *Aesthetic Education*, Letter IX, para. 5.
8. '. . . sie [diese sinnlichen Gestalten und Töne] von allen Tiefen des Bewusstseins einen Anklang und Wiederklang im Geiste hervorzurufen mächtig sind. In dieser Weise ist das Sinnliche in der Kunst *vergeistigt*, da das *Geistige* in ihr als versinnlicht erscheint.'
 Hegel, *Aesthetik*; *Werke*, Vol. XIII, p. 61 (tr. p. 39).
9. '[In dieser Weise] stellen uns die Pyramiden das einfache Bild der symbolischen Kunst selber vor Augen; sie sind ungeheure Kristalle, welche ein Inneres in sich bergen . . . —Deshalb bleibt die Gestalt für solch ein Inneres eine dem bestimmten Inhalt desselben ebensosehr noch ganz äussere Form und Umhüllung.'
 Ibid., *Werke*, Vol. XIII, pp. 459f. (tr. p. 356).
10. *Ibid.*, *Werke*, Vol. XIII, p. 461 (tr. p. 358).
11. '. . . die Physiologie müsste es zu einem ihrer Hauptsätze machen, dass die Lebendigkeit notwendig in ihrer Entwicklung zur Gestalt des Menschen fortzugehen habe als der einzig für den Geist angemessenen sinnlichen Erscheinung.'
 Ibid., *Werke*, Vol. XIII, p. 110 (tr. p. 78).
12. *Ibid.*, *Werke*, Vol. XIII, p. 103 (tr. p. 72).
13. 'Dies Vermindern der drei Dimensionen zur Ebene liegt in dem Prinzip des Innerlichwerdens, das sich am Räumlichen als Innerlichkeit nur dadurch hervortun kann, dass es die Totalität der Äusserlichkeit nicht bestehen lässt, sondern sie beschränkt . . . In der Malerei [tritt nun das Entgegengesetzte ein, denn] ihr Inhalt ist die geistige Innerlichkeit, die nur im Äusseren kann zum Vorschein kommen, als aus demselben in sich hineingehend.'
 Hegel, *Aesthetik*; *Werke*, Vol. XV, pp. 26f. (tr. p. 805).
14. 'Ebenso zweckmässig ist die Darstellung der Leidensgeschichte, der Verspottung, Dornenkrönung, des Ecce Homo, der Kreuztragung . . . Denn hier ist es eben die Göttlichkeit im Gegenteil ihres Triumphes . . .'
 Hegel, *Aesthetik*; *Werke*, Vol. XV, p. 50 (tr. p. 832).

15. '... dass das Werk, als das Subjektive darstellend, nun auch seiner ganzen Darstellungsweise nach die Bestimmung herauskehrt, wesentlich nur für das Subjekt, für den Beschauer und nicht selbständig für sich dazusein. Der Zuschauer ist gleichsam von Anfang an mit dabei, mit eingerechnet, und das Kunstwerk nur für diesen festen Punkt des Subjekts.'
 Hegel, *Aesthetik*; *Werke*, Vol. XV, p. 28 (tr. p. 806).

16. See for Riegl Chap. V, p. 83, and for Panofsky Chap. IX, p. 190.

17. 'Denn der Begriff erlaubt es der äusseren Existenz in dem Schönen nicht, für sich selber eigenen Gesetzen zu folgen, sondern bestimmt aus sich seine erscheinende Gliederung und Gestalt, die als Zusammenstimmung des Begriffs mit sich selber in seinem Dasein eben das Wesen des Schönen ausmacht.'
 Hegel, *Aesthetik*; *Werke*, Vol. XIII, p. 152 (tr. p. 112).
 It is this second viewpoint which is particularly vulnerable to the accusations (a) that Hegel reduces art to an expression of the mind at the time; and (b) that it presupposes the inevitable march of history in which spirit overcomes matter. For this attack in an early form see Anton Springer on Hegel, discussed here in Chap. VIII, §i, and E. H. Gombrich, *In Search of Cultural History*, Oxford, 1969, and 'André Malraux and the Crisis of Expressionism', in his *Meditations on a Hobby-Horse, and Other Essays on the Theory of Art*, London, 1963.

18. On Rumohr see J. von Schlosser, Introduction to *Italienische Forschungen, ed. cit.*; W. Waetzoldt, *Deutsche Kunsthistoriker*, Vol. I, pp. 292-318; Rüdiger Klessman, *The Berlin Gallery*, London, 1979, pp. 40ff.

19. Rumohr, *Italienische Forschungen*, p. 7. For the criticism of Lessing's view see his *Ueber die antike Gruppe Castor und Pollux oder von dem Begriff der Idealität in Kunstwerken*, Hamburg, 1812.

20. '... doch liebt man darin einige Andeutungen einer höheren Weisheit fallen zu lassen, und verhüllt sich mindestens in der Allgemeinheit des Wörtchens Idee, dessen schwankender sinnlich geistiger Sinn allerdings jeder wilden Behauptung eine Ausflucht offen lässt, mithin aller Unentschiedenheit oder Undeutlichkeit willkommen ist.'
 Rumohr, *Italienische Forschungen*, p. 14.

21. Hegel, *Aesthetik*; *Werke*, Vol. XIII, pp, 145f. (tr. pp. 106f.).

22. Rumohr, *Italienische Forschungen*, p. 96. There is perhaps an echo here of Goethe's remarks on sensuous beauty and that of the treatment of the subject. 'When the subject has been successfully discovered or invented, the treatment of it follows, and this may be divided into spiritual, sensible and mechanical.' Goethe, 'Einleitung in die Propyläen', *Werke*, Vol. XII, pp. 46f. (tr. p. 9).

But here again, the contrast between Goethe and Rumohr is as striking as the affinity. Goethe pivots his account on the seriousness of the subject matter, provided it is suitable for the sensuous medium of representation, while Rumohr, like Aristotle, is insisting on the way the artist's handling may transform subjects which are initially unbeautiful.

23, 'Allein die künstleirische Auffassung sittlicher Verhältnisse ist . . . nach den inneren Forderungen, oder nach der äusseren Stellung des Talentes, bald ernst, bald heiter, und gleich fähig, die Tiefen alles Daseins zu durchmessen, als, auf der Oberfläche weilend, Zufälliges hervorzuheben und menschliche Gebrechlichkeiten zu necken.'
Rumohr, *Italienische Forschungen*, p. 13.

24. '. . . die Kunst überhaupt (muss) . . . nach denselben Gesetzen sich bewegen, in ihrer Wertbestimmung demselben Masse unterliegen, als jede gleich freie Tätigkeit des Geistes. Also wird dasselbe, so in vielen andern Verhältnissen unser Urteil über den Werth, oder Unwerth menschlicher Leistungen bestimmt, uns auch da leiten müssen, wo bei Kunstwerken über das Verdienst, oder Unverdienst der Auffassung zu entscheiden ist. Kraft, Nachdruck, Schwung oder Güte und Milde, oder auch Scharfsinnigkeit und deutliches Bewusstsein des eigenen Wollens werden, wie überhaupt im Leben, so auch in der Kunst einen begründeten Anspruch auf Billigung besitzen.'
Ibid., p. 18.

25. *Ibid.*, pp. 252–6.

26. *Ibid.*, p. 226.

NOTES TO CHAPTER III

1. A biography of Schnaase by Wilhelm Lübke appears at the beginning of Karl Schnaase, *Geschichte der bildenden Künste im 15. Jahrhundert*, Stuttgart, 1879. For critical discussion of Schnaase see W. Waetzoldt, *Deutsche Kunsthistoriker*, Vol. II, pp. 70ff. and Ernst Heidrich, 'Karl Schnaase und Jakob Burckhardt', *Beiträge zur Geschichte und Methode der Kunstgeschichte*, Basel, 1917.

2. 'Da aber jede Periode die Totalität des menschlichen Wesens enthält, und da mithin in jeder sich alle spiegeln, so konnte es nicht fehlen, dass das ganze Gebiet der Kunstgeschichte mehr oder weniger berührt wurde . . .'
Schnaase, *Niederländische Briefe*, pp. iv f.

3. '. . . erst dann versteht man die Kunst in ihrer Geschichte, wenn man nicht bloss für die glücklichsten Momente, sondern auch für die verbindenden Stufen den Sinn eröffnet hat . . . die wahre Frucht

ist aber die vollständigere Uebersicht des Ganzen, die bisher durch
das fehlende Mittelglied unterbrochen wurde.'
Ibid., p. 266.

4. 'Unsere Väter, vor einem halben Jahrhundert, gingen noch an den
Werken der vor-Raphaelischen Zeit, an den ältern Italienern und
Niederländern, wie an den gothischen Domen kalt und unberührt
vorüber, die uns durch die Rückwirkung der wiedergewonnenen
Antike wieder vollkommen verständlich geworden sind, und uns
eben so tief und tiefer ergreifen, als die alte Kunst selbst. Dieser
geschichtliche Gang der Dinge, besonders auch die Erfahrung der
letzten Zeit, gibt uns sehr deutlich Aufschlüsse über das Wesen der
Schönheit.

Das Verständniss der Antike öffnet uns den Sinn für das
Mittelalter; die Kunst des Mittelalters aber führte auf ihrer höchsten
Spitze zur glühenden Verehrung der alten Kunst. Sie rufen sich also
gegenseitig hervor, und kehren wieder zu sich zurück, bilden also
eine in sich abgeschlossene kreisähnliche Gestalt. Die Besorgniss
vor einer unbegränzten Zahl von Kunstgeschlechtern verschwindet
daher, und wir sehen eine innere Einheit des Schönen, ohne dass
dasselbe auf eine bestimmte Erscheinung zu beschränken wäre.'
Ibid., p. 397.

5. 'Ich beginne schon in jeder Vergangenheit neben ihrer Gegenwart
ihre Zukunft mitzuempfinden. So führt die genaue und klare
historische Betrachtung auch zu der höhern aesthetischen, . . .
welche in der Schönheit jeder einzelnen Zeit den Zusammenhang
mit den übrigen empfindet . . .'
Ibid., pp. 418f.

6. '. . . die antike Architektur (war) weniger fähig, auch ein schönes
Inneres zu schaffen, da sie für die einzelnen Glieder, wenigstens für
die bedeutendern, nur die selbständigen und harten Formen, den
Kreis oder die gerade Linie kannte. Es war daher nicht bloss die
religiöse und häusliche Sitte der Alten Welt, welche das Innere ihrer
Gebäude unbedeutend machte, sondern auch ihr Formensinn.'
Ibid., p. 192.

7. 'Schon oben bemerkte ich, dass die Schönheit des Innern
Anforderungen mache, welche der Aeussern entgegen wären, und
dass, weil Uebereinstimmung beider Theile ein unerlässliches
Erforderniss ist, daraus verschiedene Style entständen, in welchen
bald das Eine, bald das Andere vorherrsche. Jetzt können wir
wahrnehmen, dass diese nicht eine zufällige Schwäche der
Architekten, sondern dass es der notwendige Gegensatz ist, in
welchem sich diese Kunst in ihrer historischen Entwickelung
unablässig bewegt.

Die griechische Architektur hatte nur Formen für die äussere Gestalt; für das Innere fehlten sie so ganz, dass man bei grössern Tempeln, wo der innere Raum etwas bedeutender werden sollte, ihn, ohne Bedachung, wie einen offenen Hof liess. In späterer Zeit, bei römischer Anwendung, ändert sich diess; die Formen wurden schlanker, weicher, mannigfaltiger und zogen sich allmählich in das Innere hinein.'

Ibid., p. 212.

8. 'So war der letzte Ueberrest jenes Widerstrebens vertilgt; das Ganze bestand zwar aus einzelnen, deutlich erkennbaren, aber so gleichförmigen Gliedern, dass nichts die Einheit und die vollkommene Durchführung des perspektivischen Systems störte.'

Ibid., p. 215.

9. *Ibid.*, p. 212.

10. *Ibid.*, p. 192.

11. 'Von der Erfindung der Kuppel geht dann eine Umgestaltung aller architektonischen Details aus. Das gerade Gebälk wird immer seltner, zieht sich zuerst zu einem Aufsatze über dem Kapital zusammen, verschwindet dann völlig. Die Kapitäle, nun die unmittelbaren Träger des Bogens, müssen die zarte Linie des korinthischen Kelches, die leichte Blattzierde aufgeben, und erhalten statt dessen die statisch richtige aber spröde Gestalt des von unten nach oben ausladenden, aus dem Kreis des Säulenstammes in das Viereck des Bogenansatzes überleitenden Würfels.'

Schnaase, *Geschichte der bildenden Künste*, Vol. III, p. 297.

12. Riegl, *Künstlerische Grammatik*, pp. 212ff.

13. Schnaase, *Niederländische Briefe*, p.v.

14. *Ibid.*, p. 93.

15. 'Die Geschichte bildet eine fortlaufende Reihe, in der auf jeder Stufe die Natur und der Geist in immer reinerm Einklange erscheinen . . . Kunst und Religion stehen beide auf der geistigsten Höhe der Menschheit, aber sie verhalten sich hier wie Körper und Geist im Menschen selbst. Sie ergänzen sich, aber sie stehen im Gegensatze; herrscht das eine zu sehr vor, so leidet das andere, aber erst, wenn sie vereint in höchster Steigerung sind, ist das höchste Leben erreicht.'

Ibid., p. 378.

16. *Ibid.*, p. 378.

17. 'Darin stehen dann die Gestalten vereinzelt, kaum gegen einander gerichtet, meistens ganz im Profil oder ganz von vorne gezeigt. Die Gruppen sind, wenn es bloss auf äussere Handlung ankommt, wohlgeordnet, oft sogar sehr zierlich und leicht . . . Nie aber finden wir eine Gruppe in dem geistigen Sinne, dass uns durch Stellung

und Haltung der Gestalten schon ihre Beziehung auf einander, der Wechselverkehr der Rede und des Gefühls, die innige Verbindung häuslicher Geselligkeit klar würde, durch welche die Einzelnen aufhören getrennt zu sein, und zwischen und um ihnen das Ganze sich als das zusammenhängende, geistige Wesen der Familie zeigt.'
 Ibid., p. 96f.

18. *Ibid.*, p. 177.

19. *Ibid.*, p. 179.

20. 'Die Theile erhielten statt der unmittelbaren Geltung eine mittelbare; sie wirken nicht mehr äusserlich und im Sinne der breiten vielgeteilten Fläche, sondern innerlich durch ihre Verbindung in der geistigen Einheit der Perspectiv-Linie. Es waren darin die Grundzüge der christliche Form des Lebens in der Kunst gegeben; für die individuelle Kunst deutet sie auf die Malerei, in der auch die Dinge nicht mehr plastisch neben einander, sondern zu einer höheren Einheit verbunden gelten.'
 Ibid., p. 384.

21. *Ibid.*, p. 385.

22. Goethe, 'Einleitung in die Propyläen', *Werke*, Vol. XII, p. 49 (tr. p. 11).

NOTES TO CHAPTER IV

1. Semper, *Vorläufige Bemerkungen über gemalte Architektur und Plastik*, Ancona, 1834. For Semper's intellectual biography see Hans Semper, *Gottfried Semper. Ein Bild seines Lebens und Wirkens*, Berlin, 1880. For a study of Semper as architect see C. Lipsius, *Gottfried Semper in seiner Bedeutung als Architekt*, Berlin, 1880. The most informative study of the sources of Semper's thought, in particular his relation to Schinkel, is L. Ettlinger, *Gottfried Semper und die Antike*, Halle, 1937. For a bibliography and excellent summary of discussions of Semper see Adrian von Buttlar, 'Gottfried Semper als Theoretiker' in the Kunstwissenschaftliche Studientexte reprint of G. Semper, *Der Stil*, Mittenwald, 1977.

2. '[Was für Wunder uns aus dieser Empfindung erwachsen! Ihr verdanken wir's, dass] unsere Hauptstädte als wahre Extraits de mille fleurs, als Quintessenzen aller Länder und Jahrhunderte emporblühen, so dass wir, in angenehmer Täuschung, am Ende selber vergessen, welchem Jahrhunderte wir angehören.'
 Semper, *Vorläufige Bemerkungen*, p. viii.

3. 'Die Lehre von den Urmotiven und den aus ihnen abgeleiteten

früheren Formen mag den ersten kunstgeschichtlichen Teil der Stillehre bilden.

Ohne Zweifel befriedigt es das Gefühl, wenn bei einem Werke, sei es auch noch so weit von seiner Entstehungsquelle entfernt, das Urmotiv als Grundton seiner Komposition durchgeht, und es ist gewiss bei künstlerischem Wirken Klarheit und Frische in der Auffassung desselben sehr wünschenswert, denn man gewinnt dadurch einen Anhalt gegen Willkür und Bedeutungslosigkeit und sogar positive Anleitung im Erfinden. Das Neue wird an das Alte geknüpft, ohne Kopie zu sein, und von der Abhängigkeit leerer Modeeinflüsse befreit.'

Semper, *Wissenschaft, Industrie und Kunst* (1851), ed. H. M. Wingler, Mainz, 1966, p. 35.

4. 'Die Reihung ist ein Gliedern der einfachen und deshalb noch aesthetisch indifferenten Bandform und wohl das ursprünglichste Kunstprodukt, die erste thatsächliche Kundgebung des Schönheitssinnes, der bestrebt ist, den Ausdruck der Einheit durch Vielheiten zu bewerkstelligen . . .'

Semper, *Der Stil*, Vol. I, p. 13.

5. *Ibid.*, pp. 17f.

6. 'Der Blätterkranz ist vielleicht die früheste Reihung, er behielt als Corona in den Künsten aller Zeiten sein altes Vorrecht als Symbol der Bekrönung, der Begrenzung nach Oben, und, im gegensätzlichen Sinne, zugleich als Symbol der Begrenzung nach Unten, in welcher Anwendung der Blätterkranz die Spitzen der Blätter nach Unten richtet.'

Ibid., pp. 13f.

7. 'Wie das Flechtwerk das Ursprüngliche war, so behielt es auch später, als die leichten Mattenwände in feste Erdziegel— Backstein—oder Steinquadermauern sich umgestalten, der Wirklichkeit oder bloss der Idee nach, die ganze Wichtigkeit ihrer früheren Bedeutung, das eigentliche Wesen der Wand.

Es bleibt der Teppich die Wand, die sichtbare Raumbegrenzung. Die dahinter befindlichen, oft sehr starken Mauern wurden wegen anderer, das Räumliche nicht betreffender Zwecke notwendig, als zur Sicherheit zum Tragen, zur grösseren Dauer und dergleichen . . . und selbst, wo die Aufführung fester Mauern erforderlich wurde, bildeten sie nur das innere nicht sichtbare Gerüste, versteckt hinter den wahren und legitimen Repräsentanten der Wand, den buntgewirkten Teppichen.'

Semper, *Die Vier Elemente der Baukunst. Ein Beitrag zur Vergleichenden Baukunde*, Brunswick, 1851, p.57f.

8. Semper, *Der Stil*, Vol. I, pp. 104 and 124.

9. '. . . die Seide (ist) noch nicht stilistisch verwerthet, man erkannte in ihr nur erst einen Stoff, der einige Eigenschaften der früher gewohnten Stoffe in erhöhtem Grade besitzt, ohne schon darauf gekommen zu sein, die ihm besonders eigentümlichen Qualitäten . . . als Grundlage eines neuen Stils zu betrachten und daraus ein neues Prinzip der Seiden—Kunstweberei zu begründen.'
 Semper, *Der Stil*, Vol. I, p. 150.

10. Semper, *Ueber die formelle Gesetzmässigkeit des Schmuckes und dessen Bedeutung als Kunstsymbol*, Zürich, 1856, pp. 6 and 16. cf. Semper, *Der Stil,* Vol. I, pp. 12 and 415.

11. 'Erst ist das Unterscheidende der bildenden Künste, nicht in Begriffen, sondern in Anschauungen aufzufassen, und das anschaulich Aufgefasste so darzustellen, das solches ohne alle Zuziehung von Tätigkeiten des Verstandes unmittelbar durch die Anschauung von anderen erfasst werden kann.'
 Passage quoted by Hans Semper, *op. cit.* p. 12.

12. 'Die stufenweise Verminderung der Mächtigkeit der Strukturelemente von unten nach oben, die an den besseren im Quaderstil ausgeführten Kunststrukturen überall wahrgenommen wird, entspricht daher zugleich dem Schönheitsgesetze und dem dynamischen.'
 Semper, *Der Stil*, Vol. II, p. 351.

13. *Ibid.*, Vol. I, pp. 216f, note 3.

14. *Ibid.*, p. xvi.

15. 'Jedes Kunstschaffen einerseits, jeder Kunstgenuss anderseits, setzt eine gewisse Faschingslaune voraus, um mich modern auszudrücken—der Karnevalskerzendunst ist die wahre Atmosphäre der Kunst. Vernichtung der Realität, des Stofflichen, ist notwendig, wo die Form als bedeutungsvolles Symbol als selbständige Schöpfung des Menschen hervortreten soll.'
 Ibid., pp. 216f, note 3.

16. A. Riegl, *Stilfragen*, Berlin, 1893, pp. 6ff. and *Historische Grammatik der bildenden Künste*, ed. K. M. Swoboda and O. Pächt, Graz and Cologne, 1966, pp. 217 and 255.

17. Waetzoldt, *Deutsche Kunsthistoriker*, Vol. II, p. 134.

18. H. Quitzsch, *Die aesthetische Anschauung Gottfried Sempers*, Berlin, 1962, p. 46.

19. 'Die Kunst hat ihre besondere Sprache, bestehend in formellen Typen und Symbolen, die sich mit dem Gange der Kulturgeschichte auf das mannigfachste umbildeten, so dass in der Weise, sich durch sie verständlich zu machen, fast so grosse Verschiedenheit herrscht, wie diess auf dem eigentlichen Sprachgebiete der Fall ist. Wie nun die neueste Sprachforschung bestrebt ist, die verwandtschaftlichen

Beziehungen der menschlichen Idiome zu einander nachzuweisen,
die einzelnen Wörter auf ihrem Gange der Umbildung in dem Laufe
der Jahrhunderte rückwärts zu verfolgen und sie auf einen oder
mehrere Punkte zurückzuführen, woselbst sie in gemeinsamen
Urformen einander begegnen, . . . eben so lässt sich ein analoges
Bestreben auf dem Felde der Kunstforschung rechtfertigen.'
Semper, *Der Stil*, Vol. I, p. 1.

20. *Ibid.*, Vol. I, p. 387.
21. *Ibid.*, Vol. I, p. 421.
22. *Ibid.*, Vol. I, p. 325.
23. *Ibid.*, Vol. I, p. 362.
24. Semper, *Wissenschaft, Industrie und Kunst*, p. 36.
25. Semper, *Die vier Elemente der Baukunst*, p. 52.
26. Semper, *Practical Art in Metals, with a more comprehensive plan for a
 museum and classification of objects*, 1854, Victoria and Albert Museum
 MS. 86, ff. 64.
27. Adolf Göller, *Die Entstehung der architektonischen Stilformen*,
 Stuttgart, 1888, pp. 146f.
28. *Ibid*, p. 113.
29. 'Alles Formschöne lässt sich als ein theils gleichzeitiges, theils
 aufeinanderfolgendes Vorstellen vieler solcher Gesetze nachweisen;
 je mehr derselben ein Gebilde dem Auge vereinigt darbietet, desto
 reicher ist es, und der erste und wichtigste Grund unseres
 Wohlgefallens an bedeutungslosen schönen Formen liegt nun eben
 darin, dass in ihnen das Bewusstsein eine besonders grosse Zahl
 solcher Formgesetze zugleich erfasst.'
 Ibid, p. 14.
30. See J. F. Herbart, *Psychólogie als Wissenschaft,* §§30, 31, 39, 57, 94, and
 152 and Introd. to Part II. *Sämtliche Werke*, Vols. V and VI; *Lehrbuch
 zur Einleitung in die Philosophie*, §§74, 77, 89, *ibid,* Vol IV; and
 Allgemeine practische Philosophie, Introd. §I, *ibid.*, Vol. II. For an
 exposition of Herbart's position see M. Podro, *Manifold in Perception*,
 Chap. V.
31. Göller, *Die Entstehung der architektonischen Stilformen*, p. 18.
32. *Ibid.*, p. 165.
33. 'Wie in der Musik die vollkommene Harmonie den Griechen zur
 fehlerlosen Schönheit wesentlich erschien, indem sie sogar Terzen
 unbrauchbar fanden, wie dagegen spätere Zeiten das Bedürfniss
 fühlten, auch die unvollkommenen Accorde und endlich sogar
 wirklich Dissonanzen herbeizuholen, so war und ging es auch bei
 den Ordnungen.'
 Ibid, p. 113.
34. Wölfflin, *Renaissance und Barock*, pp. 58f. (tr. p. 73).

35. 'Das Auge will Schwierigkeit überwinden. Man soll ihm lösbare Aufgaben stellen, ja; aber die ganze Kunstgeschichte ist ein Beweis, dass die 'Klarheit' von heute morgen langweilig ist und dass die bildende Kunst auf partielle Verdunkelungen der Form, momentane Irreführungen des Auges so wenig verzichten kann wie die Musik auf die Dissonanzen, Trugschlüsse und diegleichen.'
Wölfflin, Review of H. Cornelius, *Elementargesetze der bildenden Kunst, Repertorium für Kunstwissenschaft*, Vol. XXXII, 1909, p. 336.

36. 'Just as with food and music novel and extraordinary things delight us for various reasons but especially because they are different from the old ones we are used to, so with everything the mind takes great delight in abundance.'
Alberti, *On Painting*, ed. cit., p. 79.

NOTES TO INTRODUCTION TO PART II

1. Goethe, 'Einleitung in die Propyläen', *Werke*, Vol. XII, p. 49 (tr. p. 12), 'Relief von Phigalia', *ibid.*, p. 170 (tr. p. 11), and 'Leonardos Abendmahl', *ibid.*' pp. 164ff. (tr. pp. 166ff.).

2. Burckhardt, *Erinnerungen aus Rubens, Gesamtausgabe*, Vol. XIII, p. 435 (tr. p. 68).

3. 'Ganz mächtig und tragisch aber verbindet sich die starke Bewegung mit einem der grossen Momente der Passion, und hier hat Rubens in einzig originaler Weise das Erschütternde bis auf die volle Höhe gesteigert: es ist die grosse Kreuztragung des Museums von Brüssel, . . . Die Komposition ist auf vier Stadien bekannt: . . . und jedesmal wird die Erzählung einfacher, mächtiger und furchtbarer; der Beschauer wird in langes Mitdulden hineingezogen, indem der Zug einen steilen und engen Bergweg hinangetrieben wird, vom Rücken gesehen, jedoch so, dass die Hauptgestalten sich nach vorn umwenden; in der Mitte, um den hinsinkenden Christus herum, bilden erst in der letzten, reichsten Redaktion die heil. Veronika und die Frauen von Jerusalem mit ihren Kindern, samt dem einen das Kreuz unterstützenden Schergen jene beinahe symmetrische Lichtmasse . . . Auch dem Grässlichen konnte sich Rubens so wenig unbedingt entziehen, als einst im 15. Jahrhundert seine berühmten niederländischen Vorgänger, wenn sie die Martern von Heiligen malen mussten.'
Ibid., p. 448 (tr. p. 82).

4 M. Dvořák, *Kunstgeschichte als Geistesgeschichte*, Munich, 1924, pp. 3–40.

5. See below Chap. VI, §iii.

6. Burckhardt, 'Das Porträt', *Beiträge zur Kunstgeschichte von Italien*, p. 196.
7. Burckhardt, *Weltgeschichtliche Betrachtungen, Gesamtausgabe*, Vol. VII, pp. 78f. (tr. p. 91).
8. Hildebrand, *Das Problem der Form*, p. ix.
9. 'In der Tat steht der moderne nordische Mensch Kunstwerken wie der Schule von Athen . . . so völlig unvorbereitet gegenüber, dass die Verlegenheit natürlich ist. Man kann es nicht verübeln, wenn jemand im Stillen fragt, warum Raphael nicht lieber einen römischen Blumenmarkt gemalt habe oder die muntere Szene, wie die Bauern auf Piazza Montanara sich rasieren lassen am Sontag Morgen. Aufgaben sind hier gelöst worden, die mit der modernen Kunstliebhaberei in gar keinem Zusammenhang stehen . . .' Wölfflin, *Klassische Kunst*, p. 2 (tr. p. xvi).
10. Riegl, *Spätrömische Kunstindustrie,* pp. 10f. and 114; *Holländisches Gruppenporträt*, pp. 192–4. The major work of Franz Wickhoff in which he treats the impressionistic effect of late antique works is *Die Wiener Genesis*, Vienna, 1895, English ed. *Roman Art*, tr. Mrs Authur Strong, New York and London, 1900.
11. K. Fiedler, *Schriften über Kunst*, Vol. I, pp. 135ff.
12. Warburg, *Gesammelte Schriften*, p. 96; Riegl, *Spätrömische Kunstindustrie*, p. 19.

NOTES TO CHAPTER V

1. For an account of Riegl's career see J. von Schlosser, *Die Wiener Schule der Kunstgeschichte*, Innsbruck, 1934, pp. 181ff. and Hans Tietze, 'Alois Riegl', *Neue Oesterreichische Biographie*, Section I, Vol. 8, 1935. For a critical account of Riegl on the art of late antiquity see A. Schmarsow, *Grundbegriffe der Kunstwissenschaft*, Leipzig and Berlin, 1905; on Riegl's *Stilfragen* see E. H. Gombrich, *The Sense of Order*, Oxford, 1979, pp. 181–8. An interpretation of Riegl's views is given by H. Sedlmayr, 'Die Quintessenz der Lehren Riegls', in the Introduction to Alois Riegl, *Gesammelte Aufsätze*, Augsburg and Vienna, 1929. This would, to the present writer, seem to exaggerate all that is least interesting in Riegl. For an analysis of Riegl which makes a genuine attempt to follow through the detail of his critical procedure, see Margaret Iversen, 'Alois Riegl's Historiography', Ph.D., University of Essex, 1980.

Lorenz Dittmann, *op. cit.*, gives an extensive account of Riegl's thought, with particular emphasis on *Stilfragen* and the paper 'Eine neue Kunstgeschichte'; see also H. Zerner, 'Alois Riegl: Art, Value and Historicism', *Daedalus*, Vol. 105, No. I, Winter, 1976, and Otto Pächt, 'Alois Riegl', *Burlington Magazine*, 1963, Vol. 105.

2. Riegl, *Stilfragen*, Berlin, 1893, pp. 1ff. and 61ff.

3. 'Ihre sinnliche Wahrnehmung zeigte ihnen die Aussendinge verworren und unklar untereinander vermengt; mittles der bildenden Kunst griffen sie einzelne Individuen heraus und stellten sie in ihrer klaren abgeschlossenen Einheit hin. Die bildende Kunst des gesamten Altertums hat somit ihr letztes Ziel darin gesucht, die Aussendinge in ihrer klaren stofflichen Individualität weiterzugeben und dabei gegenüber der sinnfälligen Erscheinung der Aussendinge in der Natur alles zu vermeiden und zu unterdrücken, was den unmittelbar überzeugenden Eindruck der stofflichen Individualität trüben und abschwächen konnte.' Riegl, *Spätrömische Kunstindustrie* (1901), Vienna, 1927, p. 26.

4. 'Zu allererst trachtete man die individuelle Einheit der Dinge auf dem Wege der reinen sinnlichen Wahrnehmung unter möglichstem Ausschluss jeglicher aus der Erfahrung stammenden Vorstellung zu erfassen. Denn solange es Voraussetzung war, dass die Aussendinge wirklich von uns unabhängige Objekte sind, musste jede Zuhilfenahme des subjektiven Bewusstseins, als die Einheit des betrachteten Objekts störend, instinktiv vermieden werden.' *Ibid.*, p. 27.

5. 'Aber das Auge vollzieht die Operation der Vervielfältigung der Einzelwahrnehmungen weit rascher als der Tastsinn, und daher ist es auch das Auge, dem wir unsere Vorstellung von Höhe und Breite der Dinge hauptsächlich verdanken.' *Ibid.*, p. 29.

6. 'Dagegen muss die antike Kunst die Existenz der dritten Dimension—der Tiefe—, die wir für die Raumdimension im engeren Sinne anzusehen pflegen, von Anbeginn grundsätzlich verleugnet haben.' *Ibid.*, p. 29. This implication of Riegl's position was objected to by Schmarsow in *Grundbegriffe der Kunstwissenchaft*, Leipzig and Berlin. 1905, pp. 15ff. For a general account of Schmarsow's position see Chap. VII, pp. 143ff.

7. *Ibid.*, pp. 102–5.

8. *Ibid.*, p. 93.

9. *Ibid.*, p. 93; cf. Panofsky, 'Die Perspektive als "symbolische Form"', *Aufsätze*, p. 113.

10. *Ibid.*, pp. 32f. and 122f. This conception of three stages of art is perhaps an adaptation of August Schmarsow's typology: see Chap. VII, §v.

11. Riegl, *Holländisches Gruppenporträt*, pp. 188f., note, and p. 192.

12. Riegl, *Spätrömische Kunstindustrie*, pp. 24f.

13. *Ibid.*, pp. 44ff.

14. *Ibid.*, pp. 46ff.
15. 'Noch immer handelt es sich in letzter Linie um die abgeschlossene Darstellung eines stofflichen Individuums. Aber dieses wird jetzt nicht mehr einfach in die Ebene hingestellt und mit dieser verbunden, sondern es soll sich in seiner vollen Dreidimensionalität aus der Grundebene loslösen. Infolgedessen wird zwischen die Grundebene und das Individuum eine Reihe kleinerer Individuen eingeschoben, die das grössere wirksamer aus der Ebene heraustreiben.'
 Ibid., p. 49.
16. *Ibid.*, p. 51.
17. *Ibid.*, pp. 51–4.
18. *Ibid.*, p. 56.
19. See above, Chap. III, p. 36.
20. Riegl, *Spätrömische Kunstindustrie*, p. 59.
21. Riegl, *Holländisches Gruppenporträt*, p. 41.
22. *Ibid.*, pp. 14ff., 133, and cf. above Chap. II, §ii.
23. *Ibid.*, p. 42.
24. *Ibid.*, pp. 55f.
25. *Ibid.*, p. 171.
26. *Ibid.*, pp. 181ff.
27. On the repainting of the Tulp Anatomy see A. Bredius, *Rembrandt, the Complete Edition of the Paintings*, revised by H. Gerson, London, 1971, pp. 582f., and W. S. Heckscher, *Rembrandt's Anatomy of Dr Tulp*, New York, 1958.
28. Riegl, *Holländisches Gruppenporträt*, p. 193.
29. 'Die Verbindung mit dem Beschauer ist in diesem Bilde eben nicht mehr wie früher durch die blosse Aufmerksamkeit auf Distanz, sondern durch eine in bestimmter Richtung individualisierte Aufmerksamkeit hergestellt. Die in gerader Richtung gegen den Beschauer herausgestreckte Hand des Kapitäns lässt keinen Zweifel darüber, dass im nächsten Augenblicke diese ganze seinem Befehle folgende Truppe sich nach dem betrachtenden Subjekt heraus bewegen werde.'
 Ibid., p. 199.
30. *Ibid.*, pp. 14f.
31. *Ibid.*, pp. 135f.
32. *Ibid.*, p. 213.

NOTES TO CHAPTER VI

1. For discussion of Wölfflin see Dittmann, *Stil, Symbol, Struktur*, Munich, 1967. J. Gantner, *Schönheit und Grenzen der klassischen Form.*

Burckhardt, Croce, Wölfflin, Vienna, 1949. E. H. Gombrich, 'Norm and Form', *Norm and Form: Studies in the Art of the Renaissance*, pp. 89–98. A. Hauser, *Philosophy of Art History*, pp. 119–276. B. Croce, 'Un Tentativo Eclettico nella Storia delle Arti Figurative', *Nuovi Saggi di Estetica*, Bari, 1920, p. 251. E. Wind, *Art and Anarchy*, pp. 21ff. and 126ff. Panofsky, 'Das Problem des Stils in der bildenden Kunst', *Aufsätze*, pp. 23–31. For a bibliography of Wölfflin's own writings see Wölfflin, *Kleine Schriften*, ed. J. Gantner, pp. 265–71.

2. 'Notwendig muss die historische Wissenschaft im Sinne einer psychologischen Entwicklungsgeschichte sich ausbilden. Was man mit philologischen Methoden machen kann, ist durch die Archäologie gezeigt. Wer die Art archäologischer Arbeit mit jener andern Auffassungsgabe verbinden kann, der wird sicher vieles leisten. Aus der Philosophie werde ich einen Strom neuer Ideen in die Geschichte einführen können, aber erst muss ich des historischen Stoffes Herr sein und zwar ganz Herr. An der Kunst des Barock will ich das erste Exempel geben . . .'
 J. Gantner, ed., *Jacob Burckhardt und Heinrich Wölfflin. Briefwechsel und andere Dokumente ihrer Begegnung*, 1882–97, Basel, 1948, p. 36.

3. 'Was ist für die Formphantasie des Künstlers das Bestimmende? Man sagt: Das, was den Inhalt der Zeit ausmacht. Für die Gotischen Jahrhunderte nennt man Feudalismus, die Scholastik, den Spiritualismus u.s.w. Aber welches soll der Weg sein, der von der Zelle des scholastischen Philosophen in die Bauhütte des Architekten führt?'
 Wölfflin, *Renaissance und Barock*, Munich, 1888, p. 62; English ed., *Renaissance and Baroque*, tr. K. Simon, London, 1964, pp. 76f.

4. Wölfflin, 'Prolegomena zu einer Psychologie der Architektur', *Kleine Schriften*, pp. 13–47.

5. 'Der Barock verlangt eine breite, schwere Massenhaftigkeit. Die schlanken Proportionen verschwinden. Die Gebäude fangen an, lastender zu werden, ja hie und da droht die Form unter dem Drucke zu erliegen.'
 Wölfflin, *Renaissance und Barock*, p. 30 (tr. p. 44).

6. 'Pointiert könnte man sagen: Die strenge Architektur wirkt durch das, was sie ist, durch ihre körperliche Wirklichkeit, die malerische Architektur dagegen durch das, was sie scheint, durch den Eindruck der Bewegung. Dabei sei aber von vorherein bemerkt, dass von einem ausschliessenden Gegensatz niemals die Rede sein kann.'
 Ibid., p. 16 (tr. p. 30).

7. 'Der zeichnerische Stil bedient sich der Feder oder des harten Stiftes, der malerische gebraucht die Kohle, den weichen Röthel oder gar

den breiten Tuschpinsel. Dort ist alles Linie, alles begrenzt und scharf umrissen, der Hauptausdruck liegt im Kontur; hier Massen, breit, verschwimmend, der Kontur nur flüchtig angedeutet . . .'
Ibid., p. 17 (tr. pp. 3of.).

8. Wölfflin, 'Prolegomena', *Kleine Schriften*, pp. 46f.
9. Wölfflin, *Renaissance und Barock*, p. 63 (tr. p. 78).
10. Wölfflin, 'Die antiken Triumphbogen in Italien', *Kleine Schriften*, pp. 51–71.
11. 'Das wesentliche liegt darin, wie der Bogen mit dem Säulenbau verbunden wird, wie die Stützenstellung, wie die Bogenöffnung behandelt wird, wie die geschlossene Fläche zu der durchbrochenen sich verhält und in welche Proportion die krönenden Glieder der Attica und der Triumphstatue zum eigentlichen Torbau gesetzt werden.'
Ibid., p. 53.
12. Hildebrand, *Das Problem der Form in der bildenden Kunst* (1893). For Wölfflin's review see *Kleine Schriften*, pp. 84–9. On Hildebrand, see M. Podro, *Manifold in Perception*, Chap. VI, and Henning Bock, *Adolf Hildebrand, Gesammelte Schriften zur Kunst*, Cologne and Opladen, 1966.
13. See particularly Fiedler, *Ueber den Ursprung der künstlerischen Tätigkeit* (1887), Schriften über Kunst, Vol. I, pp. 187ff. On Fiedler see Gottfried Boehm's Introduction to the reprint edition *Schriften zur Kunst*, Munich, 1971, and M. Podro, *Manifold in Perception*, Chap. VIII.
14. 'In der Darstellung der Figuren fand die griechische Kunst nach längerem Suchen zwischen Profil und Vorderansicht diejenige schöne Mitte, welche bei der lebendigsten Profilbewegung doch den Körper in seiner Fülle zu zeigen und namentlich den Oberleib auf das Wohltuendste zu entwickeln wusste.'
Burckhardt, *Cicerone, Gesamtausgabe*, Vol. III, p. 472.
15. Wölfflin, *Klassische Kunst* (1899), 4th ed., Munich, 1908; English ed., *Classic Art*, tr. P. and L. Murray, London, 1953.
16. 'Der Täufer tritt nicht erst hinzu, er steht da, ganz ruhig. Die Brust ist uns zugewendet, nicht dem Täufling. Nur der energisch seitwärts gedrehte Kopf geht mit der Richtung des Armes, der weitausgestreckt die Schale über den Scheitel Christi hält. Kein besorgtes Nachgehen und Sich-Vorbeugen; lässig zurückhaltend wird die Handlung vorgenommen . . .'
Wölfflin, *Klassische Kunst*, p. 195 (tr. p. 209).
17. 'Was für eine grosse Empfindung lebt in dem Teppichentwurf zur Krönung der Maria, was für ein Schwung in der Gebärde des Gebens und Empfangens! Es gehört eine starke Persönlichkeit

dazu, um diese mächtigen Ausdrucksmotive in der Gewalt zu behalten.'
Ibid., p. 196 (tr. p. 210).

18. '. . . der Mensch selbst nach seiner Körperlichkeit ist ein anderer geworden und eben in der neuen Empfindung seines Körpers und in der neuen Art, ihn zu tragen und zu bewegen, steckt der eigentliche Kern eines Stiles . . . Das Gehen der Frauen ist ein anderes geworden. Statt des steifen Trippelns ein getragenes Wandeln: das Tempo hat sich verlangsamt zu einem andante maestoso.'
Ibid., p. 217 (tr. p. 231).

19. 'Es sind die eigentlich künstlerischen Prinzipien: die Klärung des Sichtbaren und die Vereinfachung der Erscheinung einerseits und dann das Verlangen nach immer inhaltreicheren Anschauungskomplexen anderseits. Das Auge will mehr bekommen, weil seine Fähigkeit des Aufnehmens bedeutend erhöht ist, zugleich aber vereinfacht und klärt sich das Bild, insofern die Dinge augengerechter gemacht sind.'
Ibid., p. 238 (tr. p. 251).

20. Burckhardt, *Die Zeit Constantins des Grossen* (1852), *Gesamtausgabe*, Vol. II, pp. 210ff.; English ed., *The Age of Constantine the Great*, tr. Moses Hadas, London, 1949, pp. 215–43.

21. 'Nun eröffnet sich das 16. Jahrhundert mit einigen Werken der hohen Idealität und der Grösse durch Vereinfachung. Das Wunderbild des Fra Bartolomeo . . . an rührender Schönheit in so wenigem vielleicht allen überlegen . . .'
Burckhardt, 'Das Altarbild', *Beiträge zur Kunstgeschichte von Italien* (1898), *Gesamtausgable*, Vol. XII. p. 126.

22. 'Zunächst hätte er die ganze vergangene Geschichte von Brabant und sonstigem Niederland realistisch in genau ermitteltem Kostüm darstellen sollen, auch die alten Schlachten, Volkstumulte, Feste u. dgl.—Dies alles aber nicht um der malerischen Wünschbarkeit willen, sondern im Sinne des Patriotismus und sogar des Fortschrittes . . . Allein Rubens hat nun eben nicht den Zumutungen einer herrschenden neuern Meinung gehorcht, sondern ganz frei den Auftrag einer fremden Fürstin angenommen, welchen er ebenso gut hätte abweisen können. Dieser Auftrag aber gefiel ihm, und weit die meisten der betreffenden Szenen offenbaren es sogleich und deutlich, dass und weshalb ihm derselbe gefiel, denn er hatte dieselben wesentlich angeben und erfinden können.'
Burckhardt, *Erinnerungen aus Rubens, Gesamtausgabe*, Vol. XIII, pp. 477f. (tr. pp. 114f.).

23. 'Wie weit das letztere ein neues Postulat des Künstlers oder des Dargestellten und seiner sozialen Schicht, wie weit es eine

gemeinsame Aeusserung beider ist, entscheidet der einzelne Fall.'
Burckhardt, 'Das Altarbild', *Beiträge zur Kunstgeschichte von Italien,
Gesamtausgabe*, Vol. XII, p. 243.

NOTES TO CHAPTER VII

1. Wölfflin, *Kunstgeschichtliche Grundbegriffe* (1915), 8th ed., Munich,
 1943, p. 249; English ed., *Principles of Art History*, tr. M. D.
 Hottinger, London, 1932, pp. 230f.
2. 'Linear sehen heisst dann, dass Sinn und Schönheit der Dinge
 zunächst im Umriss gesucht wird—auch Binnenformen haben ihren
 Umriss—dass das Auge den Grenzen entlang geführt und auf ein
 Abtasten der Ränder hingeleitet wird . . .'
 Ibid., p. 20 (tr. p. 18).
3. *Ibid.*, p. 80 (tr. p. 73).
4. 'Das Rechteck des Bildausschnittes erscheint in seinen Linien der
 Figur nicht mehr verwandt. Die Abstände der Figur vom Rahmen
 zählen nicht mehr als konstitutive Bildwerte. Der Körper, auch
 wenn er frontal gegeben ist, nimmt diese Frontalität nicht von der
 Bildfläche her. Die reinen Richtungsgegensätze sind aufgehoben
 und im Körper spricht das Tektonische nur noch verhehlt und wie
 aus der Tiefe.'
 Ibid., pp. 151f. (tr. p. 140).
5. 'Wenn ein grosses Individuum wie Tizian in seinem letzten Stil
 völlig neue Möglichkeiten verkörpert, . . . [dann sind] diese neuen
 Stilmöglichkeiten . . . für ihn doch nur in Sicht gekommen, weil er so
 viel alte Möglichkeiten bereits hinter sich gebracht hatte. Keine noch
 so bedeutende Menschlichkeit hätte zugereicht, ihn diese Formen
 fassen zu lassen, wenn er nicht vorher den Weg zurückgelegt hätte,
 der eben die notwendigen Vorstationen enthielt.'
 Ibid., p. 248 (tr. p. 230).
6. 'Die Entwicklung wird sich aber nur da vollziehen, wo die Formen
 lange genug von Hand zu Hand gegangen sind oder, besser gesagt,
 wo die Phantasie lebhaft genug sich mit den Formen beschäftig hat,
 um die barocken Möglichkeiten herauszulocken.'
 Ibid., p. 250 (tr. p. 232).
7. 'Wer die Welt als Historiker zu betrachten gewohnt ist, der kennt
 das tiefe Glücksgefühl, wenn sich für den Blick, auch nur
 streckenweise, die Dinge klar nach Ursprung und Verlauf
 darstellen, wenn das Daseiende den Schein des Zufälligen verloren
 hat und als ein Gewordenes, ein notwendig Gewordenes verstanden
 werden kann.'
 Wölfflin, 'Das Erklären von Kunstwerken', *Kleine Schriften*, p. 169.

8. Panofsky was to criticise Wölfflin because his theory did not show that his descriptive concepts yielded pertinent interpretation (see Chap. IX, p. 179); Panofsky in his first attack on Wölfflin thought that this could be done by relating them simply to the spirit of the age, 'Das Problem des Stils in der bildenden Kunst' (1915), *Aufsätze*, Berlin, 1964.

9. Burckhardt, *Die Kunst der Renaissance in Italien* (1867), *Gesamtausgabe*, Vol. VI, p. 49.

10. See Paul and Svetlana Alpers, 'Ut Pictura Noesis?' *New Literary History*, Vol. III, No. 3, Spring 1972, pp. 437ff.

11. A. Schmarsow, *Beiträge zur Aesthetik der bildenden Künste*, 3 vols. Leipzig, 1896–9. Schmarsow sustained his attack on Wölfflin for extending his account of painting to architecture and sculpture in 'Kunstwissenschaft und Kulturphilosophie mit gemeinsamen Grundbegriffen', *Zeitschrift für Aesthetik und allgemeine Kunstwissenschaft*, 1918, Vol. XIII, p. 174f. Schmarsow gives a general account of his own career in J. Jahn, ed., *Die Kunstwissenschaft in Selbstdarstellungen*, Leipzig, 1924.

12. Schmarsow, *Beiträge zur Aesthetik der bildenden Künste*, Vol. I, pp. 12f., 20ff. and 34, Vol. II, pp. 7f.

13. *Ibid.*, Vol. I, pp. 27–33.

14. *Ibid.*, Vol. I, pp. 38ff.; Vol. III, pp. 1–56.

15. *Ibid.*, Vol. II, pp. 67–84.

16. *Ibid.*, Vol. II, p. 13.

17. *Ibid.*, Vol. II, pp. 31–7.

18. *Ibid.*, Vol. II, pp. 354–9.

19. *Ibid.*, Vol. I, p. 15.

20. P. Frankl, *Die Entwicklungsphasen der neueren Baukunst*, Leipzig and Berlin, 1914; English ed., *The Principles of Architectural History*, tr. James F. O'Goman, Cambridge, Mass., 1968.

21. Frankl, *Die Entwicklungsphasen*, p. 117 (tr. pp. 129f.).

22. *Ibid.*, p. 138 (tr. p. 155).

23. *Ibid.*, p. 142 (tr. p. 157).

24. 'Erst das Fähnlein Jesu hat nachhaltig auf die Gemüter gewirkt und die Kunst in die spezifisch religiöse, kirchliche Richtung gedrängt. War aber die Baugesinnung einmal verändert, so mussten die drei formalen Elemente bedingungslos sich anpassen ... man fängt an, ... das höher zu schätzen, was man nicht hat, und die unerreichbare Befriedigung auf einem anderen Wege zu erhoffen als bisher. Ich meine also duchaus nicht, dass eine 'Formermüdung' in die neue Bahn drängt, sondern das Gefühl, dass die bisherige Richtung erledigt ist ...

Es gibt also innere Gründe, welche die formalen Elemente zur

Abkehr bringen, und äussere Gründe, welche den Umschwung durch die Neueinstellung der Gesinnung besiegeln.'
Ibid., pp. 179–81 (tr. pp. 189f.).

15. 'Wenn man sagt, er sei Zeichner gewesen, so heisst das nicht, dass er mehr gezeichnet als gemalt habe, sondern dass alle Phänomene der Natur sich ihm in Linienschauspiele umgesetzt haben. Die Plastik der Körper, die er lebhaft bis zum Uebertriebenen empfindet, wird ihm zu auf—und abschiessenden Linienströmen, und wenn sich die Bewegung beruhigt und ins Flächere mündet, so sind es, tröpfelnd und leise, noch immer Linienelemente, die den Vorgang wider-spiegeln.'
Wölfflin, *Dürer* (1905), 5th ed., Munich, 1926, p. 351 (tr. p. 257).

NOTES TO CHAPTER VIII

1. Springer, *Die Hegel'sche Geschichtsanschauung*, Tübigen, 1848.
2. Springer, *Aus meinem Leben*, Berlin, 1892, p. 115.
3. Springer, *Die Hegel'sche Geschichtsanschauung*, p. 16.
4. *Ibid.*, p. 18.
5. *Ibid.*, pp. 5ff. and 34.
6. *Ibid.*, pp. 36f.
7. 'Die That und der Zufall existiren in dieser Sphäre nur als Trübungen, die man wohl wegen der unerbittlichen Erfahrung dulden muss, aber ihnen dafür die blosse Duldung recht fühlbar macht. Wegjagen kann man sie nicht, dagegen müssen sie im Vorzimmer des Systems ihre Erbärmlichkeit sich zu Gewissen führen. Und indem endlich der ganze Inhalt in der Bewegung aufgeht, alles Spröde und Zähe desselben weggeschnitten wird, bestimmt sich die Dialektik als unendlicher, absoluter Formalismus. Ein ganz anderes, wesentlich entgegengesetztes Bild tritt uns in der Bewegung der Geschichte entgegen. Wohl wechselt, um nur vorläufig das Wesen derselben zu beleuchten, die Anschauung der Menschheit, wohl treten mit ungehemmter Kraft Negation und Vermittlung auf, eine reich gegliederte Kette herrschender Ideen schaffend; aber dieses dialektische Gewebe ist weder absolut noch formell, weder maasslos noch grundlos. An dem ruhenden Grunde der Natur entwickelt sich die Bewegung des Geistes, am mensch-lichen Individuum findet die Idee ihren Träger, am Raume und in der Zeit ihr Maass und Ziel. Das Spiel des Zufalls scheint in bunter Färbung in die unwandelbare Notwendigkeit hinein. Die abge-grenzte, endliche That zieht die himmelanstrebende Idee zur gegenwärtigen Wirklichkeit herab.'
Ibid., p. 9.

8. 'Der Mensch als Naturwesen—und diese unmittelbare Natür-
lichkeit macht seine Endlichkeit aus—wird demnach in der Religion
und im Rechte nur unterworfen und unterjocht, nicht nachhaltig
und vollständig befreit. Die Natürlichkeit bildet die Schranke gegen
die Vernunft, beharrt im Trotze der Selbstständigkeit und
unaufgelöster Eigenmächtigkeit. Die Endlichkeit tritt in der Kunst
gleichfalls in weitestem Umfange auf, aber nicht mehr als feindselige
Macht, als Negation, nicht als Gegenstand der Unterjochung und
Bezwingung: sondern sie erscheint in freier Entfaltung als das offene
Gefäss des Unendlichen. . . . Während die Religion die trockene
Nichtigkeit des Einzelnen lehrt, und vor Ueberhebung, ver-
messenem Selbstvertrauen warnt, preist die Kunst das tragische
Geschick des Individuums; im Komischen wird die Endlichkeit in
ihr Recht gegenüber den Anmassungen des gespreizten Unendlichen
gesetzt; der Humor endlich lässt mit göttlichem Muthe das Eine in
das Andere übergehen, kettet das Unbegrenzte und Ewige an das
Kleine und Vergängliche. Was für den Glauben Himmel und Erde zu
fassen nicht vermögen, bannt die Architektur in den endlichen
Raum; die bildenden Künste umgeben mit dem Heiligenschleier,
wovon der fromme Sinn unmuthig zurückbebt, im Drama offenbart
sich der Held als die absolute Quelle seines Schicksals. So ist es auch
die Kunst, welche die im Rechtsleben verstümmelte Persönlichkeit in
ganzer Fülle strahlen lässt. In ähnlicher Weise triumphirt der endliche
Geist in der Philosophie, sofern hier die Welt für ihn existirt, nur so
weit er sie begreift.'
 Ibid., pp. 50–1.

9. 'Die grosse Idee der Selbst-bestimmung strahlt uns aus gewissen
Erscheinungen der Natur zurück, und diese nennen wir Schönheit.'
 Schiller, *Briefe*, Vol. III, *ed. cit.*, p. 256.

10. 'Sei blühen und duften fröhlich für sich selbst, sie atmen Liebe und
Genuss. Die grobe Hand, welche sie selbstsüchtig pflückt, bleibt
unsichtbar. Darin liegt der Unterschied zwischen Tizian und
Aretino. Bei diesem sehen wir überall die heisse Begehrlichkeit sich
vordrängen, Tizian verleiht der Schönheit ein freies unabhängiges
Selbstrecht.'
 Springer, 'Das Ende der Renaissance', *Bilder aus der neueren
 Kunstgeschichte*, Vol. I, p. 367.

11. Springer, *Paris im dreizehnten Jahrhundert*, Leipzig, 1858; the earlier
books were *Handbuch der Kunstgeschichte*, Stuttgart, 1855, and *Die
bildenden Künste in ihrer weltgeschichtlichen Entwicklung*, Prague, 1857.
See *Aus meinem Leben*, p. 223.

12. 'Im Museum Cluny sah ich die mannigfachsten Schöpfungen echter
mittelalterlicher Kunst gesammelt und geordnet, lernte die

Rührigkeit und die eifrige Kunstpflege auch des sogenannten finstern Mittelalters kennen und entdeckte, dass an dem falschen Urteile die unselige, gar nicht berechtigte Trennung der kunstgewerblichen Leistungen von künstlerischen Schöpfungen die Hauptschuld trage.'
Springer, *Aus meinem Leben*, p. 146.

13. Springer, 'Die Kunst während der Französischen Revolution', *Bilder aus der neueren Kunstgeschichte*, Vol. II, pp. 267ff.

14. 'Es fehlte ihnen das Formgepräge, um als Revolutionsmünze zu kursiren. Da beginnt das Drama und eine lange Reihe ästhetischer Charaktere taucht auf, welche das allgemeine Gefühl in die Sprache der Leidenschaft übersetzen, als Träger der einzelnen Revolutionsphasen uns entgegen treten . . . Mirabeau, die Girondisten, Danton, Robespierre und Napoleon bilden den Vordergrund. An ihren Reden und Thaten erstarkte und klärte sich die Volksmeinung, . . . Aus dem dumpfen Volkssinn entsprungen nahm sie ihren Weg durch die Leidenschaft, und das ästhetische Pathos zum geklärten Volksbewusstsein zurück.'
Springer, *Die Hegel'sche Geschichtsanschauung*, pp. 46f.

15. *Ibid.*, p. 48.

16. Springer, 'Das Nachleben der Antike im Mittelalter', *Bilder aus der neueren Kunstgeschichte*, Vol. I, pp. 28f.

17. *Ibid.*, Vol. I, p. 9.

18. 'Sie leben vielmehr in der Gegenwart und weil für die Stimmungen und Strömungen der letzteren die Antike ein vortreffliches Ausdrucksmittel darbietet, greifen sie zu dieser.'
Ibid., Vol. I, p. 218.

19. 'Diese Naturmythen entstammen keineswegs dem dunkelen Geiste des Mittelalters. Der Glaube hatte das letztere vom klassischen Alterthume getrennt, der Aberglauben vereint wieder die beiden Perioden.'
Ibid., Vol. I, p. 20.

20. For studies of Warburg see G. Bing, 'A. M. Warburg', *Journal of the Warburg and Courtauld Institutes*, Vol. XXVIII, 1965. F. Saxl, 'Rinascimento dell'Antichità. Studien zu den Arbeiten A. Warburgs', *Repertorium für Kunstwissenschaft*, Vol. XLIII, 1922, pp. 220–72. E. H. Gombrich, *Aby Warburg, An Intellectual Biography*, The Warburg Institute, London, 1970. This contains the best bibliography of Warburg's works and of the literature about him. An extensive bibliography related to Warburg's work, and the republication of articles on Warburg appear in D. Wuttke, ed., *Aby Warburg. Ausgewählte Schriften und Würdigungen*, Baden-Baden, 1979.

21. Gombrich, *Warburg*, pp. 36 and 46ff.

22. Warburg, 'Sandro Botticellis "Geburt der Venus" und "Frühling"' (1893), *Gesammelte Schriften*, 2 vols., Leipzig and Berlin, 1932 (pagination is continuous throughout the 2 vols.).
23. Gombrich, *Warburg*, pp. 47ff.
24. Warburg, *Gesammelte Schriften*, pp. 7ff.
25. Semper, *Der Stil*, Vol. I, p. 200 and see Chap. IV, p. 48.
26. Warburg, *Gesammelte Schriften*, p. 86.
27. *Ibid.*, pp. 33f.
28. Warburg, 'Flandrische Kunst und florentinische Frührenaissance' (1902), *Gesammelte Schriften*, pp. 187f.
29. Warburg, 'Bildkunst und florentinisches Bürgertum' (1902), *Gesammelte Schriften*, pp. 116ff.
30. *Ibid.*, pp. 97ff.
31. Warburg, 'Francesco Sassettis letztwillige Verfügung' (1907), *Gesammelte Schriften*, pp. 129ff. For recent discussion of the sources, and some doubt on the detail of Warburg's interpretation, see Eve Borsook and Johannes Offerhaus, *Francesco Sassetti and Ghirlandaio at Santa Trinita, Florence*, Doornspijk, 1981.
32. *Ibid.*, p. 154.
33. *Ibid.*, pp. 147f., note 2.
34. *Ibid.*, pp. 110f.
35. Warburg, 'Italienische Kunst und internationale Astrologie im Palazzo Schifanoia zu Ferrara' (1912), *Gesammelte Schriften*, pp. 459ff.
36. *Ibid.*, p. 459.
37. *Ibid.*, p. 472.
38. 'Inwieweit ist der Eintritt des stilistischen Umschwunges in der Darstellung menschlicher Erscheinung in der italienischen Kunst als international bedingter Auseinandersetzungs-Prozess mit den nachlebenden bildlichen Vorstellungen der heidnischen Kultur der östlichen Mittelmeervölker anzusehen? ... Das enthusiastische Staunen vor dem unbegreiflichen Ereignis künstlerischer Genialität kann nur an Gefühlsstärke zunehmen, wenn wir erkennen, dass das Genie Gnade ist und zugleich bewusste Auseinandersetzungsenergie. Der neue grosse Stil, den uns das künstlerische Genie Italiens beschert hat, wurzelte in dem sozialen Willen zur Entschälung griechischer Humanität aus mittelalterlicher, orientalisch-lateinischer "Praktik". Mit diesem Willen zur Restitution der Antike begann "der gute Europäer" seinen Kampf um Aufklärung in jenem Zeitalter internationaler Bilderwanderung, das wir—etwas allzu mystische-die Epoche der Renaissance nennen.' *Ibid.*, p. 461.
39. 'Der recht eigentlich schöpferische Akt, der Dürers *Melancholia I*

zum humanistischen Trostblatt wider Saturnfürchtigkeit macht, kann erst begriffen werden, wenn man diese magische *Mythologik* als eigentliches Objekt der künstlerisch-vergeistigenden Umformung erkennt. Aus dem kinderfressenden, finsteren Planetendämon, von dessen Kampf im Kosmos mit einem anderen Planetenregenten das Schicksal der beschienenen Kreatur abhängt, wird bei Dürer durch humanisierende Metamorphose die plastische Verkörperung des denkenden Arbeitsmenschen.'
Ibid., p. 528.

40. Gombrich, *Warburg*, p. 263.
41. *Ibid.*, p. 253.
42. 'Um diesen Sublimierungsprozess in seiner folgehaften Bedeutung für die europäische Stilentwicklung von Grund auf zu würdigen, müssen wir uns freilich entschliessen, die nachlebende antike Götterwelt einerseits als religiöse Macht—in Gestalt von Schicksals-dämonen, die in der Astrologie ihre systematischen Kultvorschrif-ten fanden—anzuerkennen, und aus dieser Einsicht heraus als Akt der Humanisierung zu begreifen, wenn Raphael eben diese fatalen Dämonen zu olympisch heiteren Göttern wandelt, in deren höherer Region kein Raum mehr ist für abergläubische Praktiken.'
Ibid., p. 269f.
43. 'Man darf der Antike die Frage "klassisch ruhig" oder "dämonisch erregt" nicht mit der Räuberpistole des Entweder-Oder auf die Brust setzen. Es hängt eben vom subjektiven Charakter der Nachlebenden, nicht vom objektiven Bestand der antiken Erbmasse ab, ob wir zu leidenschaftlicher Tat angeregt, oder zu abgeklärter Weisheit beruhigt werden. Jede Zeit hat die Renaissance der Antike, die sie verdient.'
Ibid., p. 238.
c.f. note 18 above. In the margin of Springers passage Warburg wrote "Bravo".
44. 'In der Region der orgiastischen Massenergriffenheit ist das Prägewerk zu suchen, das dem Gedächtnis die Ausdrucksformen des maximalen inneren Ergriffenseins, soweit es sich gebärdensprachlich ausdrücken lässt, in solcher Intensität einhämmert, dass diese Engramme leidenschaftlicher Erfahrung als gedächtnisbewahrtes Erbgut überleben und vorbildlich den Umriss bestimmen, den die Künstlerhand schafft, sobald Höchstwerte der Gebärdensprache durch Künstlerhand im Tageslicht der Gestaltung hervortreten wollen.'
Ibid., p. 245.
45. *Ibid.*, pp. 231f.
46. 'Wir fühlen jetzt, warum bei Francesco Sassetti in der Krisis von

1488 die Windgöttin Fortuna symptomatisch als Gradmesser seiner höchsten energetischen Anspannung über die Schwelle seines Bewusstseins tritt . . .'
Warburg, *Gesammelte Schriften*, p. 151.

47. *Ibid.*, p. 146.
48. *Ibid.*, p. 98.
49. See above, note 20.

NOTES TO CHAPTER IX

1. Panofsky, *Dürers Kunsttheorie, vornehmlich in ihrem Verhältnis zur Kunsttheorie der Italiener*, Berlin, 1915. p. 199.
2. Max Weber, 'Der Sinn der "Wertfreiheit" der soziologischen und ökonomischen Wissenchaften' (1971), *Gesammelte Aufsätze zur Wissenschaftslehre*, 2nd ed., Tübingen, 1951, pp. 506–9; 'The Meaning of "Ethical Neutrality"', *The Methodology of the Social Sciences*, tr. and ed. E. A. Shils and H. A. Finch, New York, 1949, p. 32. For a valuable analysis of this see W. G. Runciman, *A Critique of Max Weber's Philosophy of Social Science*, Cambridge, 1972. The distinction between causal analysis and the understanding appropriate to mental life had been expressed in comparable terms by Dilthey, e.g. 'Ideen über eine beschreibende und zergliedernde Psychologie', *Gesammelte Schriften*, Leipzig and Berlin, 1924, Vol. V, p. 144. English ed., *Descriptive Psychology and Historical Understanding*, tr. R. M. Zaner and K. L. Heiges, The Hague, 1977, pp. 27f.
3. Panofsky's first attack on Wölfflin was in 'Das Problem des Stils in der bildenden Kunst' (1915), but developed in a more sophisticated form in 'Der Begriff des Kunstwollens' (1920), both reprinted in Panofsky, *Aufsätze zu Grundfragen der Kunstwissenschaft*, Berlin, 1964. This volume also contains a bibliography of Panofsky's writing to that date.
4. 'Es ist der Fluch und der Segen der Kunstwissenschaft, dass ihre Objekte mit Notwendigkeit den Anspruch erheben, anders als nur historisch von uns erfasst zu werden. Eine rein historische Betrachtung, gehe sie nun inhalts oder formgeschichtlich vor, erklärt das Phänomen Kunstwerk stets nur aus irgendwelchen anderen Phänomenen, nicht aus einer Erkenntnisquelle höherer Ordnung: eine bestimmte Darstellung ikonographisch zurückverfolgen, einen bestimmten Formkomplex typengeschichtlich oder aus irgendwelchen besonderen Einflüssen ableiten, die künstlerische Leistung eines bestimmten Meisters im Rahmen seiner Epoche oder sub specie seines individuellen Kunstcharakters erklären,

heisst innerhalb des grossen Gesamtkomplexes der zu erforschenden realen Erscheinungen die eine auf die andere zurückbeziehen, nicht von einem ausserhalb des Seins-Kreises fixierten archimedischen Punkte aus ihre absolute Lage und Bedeutsamkeit bestimmen: auch die längsten 'Entwicklungsreihen' stellen immer nur Linien dar, die ihre Anfangs- und Endpunkte innerhalb jenes rein historischen Komplexes haben müssen.'
Panofsky, 'Der Begriff des Kunstwollens', *Aufsätze*, p. 33.

5. E. Cassirer, *Kants Leben und Lehre*, Berlin, 1918, pp. 329–31.

6. *Ibid.*, pp. 312 and 327f.

7. *Ibid.*, pp. 357f.

8. 'So wurde im ästhetischen Gefühl eine Totalität des Bewusstseins und seiner Kräfte entdeckt, die aller Zerlegung des Bewusstseins in vereinzelte, zueinander gegensätzliche "Vermögen" voraus—und zugrunde liegt. In jeder dieser beiden Betrachtungsarten wird also das Ganze, um das es sich handelt, so angesehen, als ob es selbst Ursprung der Teile und der Grund ihrer konkreten Bestimmtheit sei.'
Ibid., p. 358; cf. Dilthey, *loc. cit.*

9. *Ibid.*, p. 333.

10. '. . . die Kunstwissenschaft (stellt) fest . . . dass innerhalb einer bestimmten künstlerischen Erscheinung alle künstlerischen Probleme "in einem und demselben Sinne" gelöst sind. . .' Panofsky, 'Ueber das Verhältnis der Kunstgeschichte zur Kunsttheorie', *Aufsätze*, p. 66. This elaboration of the system was developed with Edgar Wind, whose closely related paper 'Zur Systematik der künstlerischen Probleme' was published in the *Zeitschrift für Aesthetik und allgemeine Kunstwissenschaft*, Vol. XVIII, 1925, in which Panofsky's paper originally appeared.

11. 'Die streng "polychrome" Farbgestaltung ist also, insofern sie die Grundprobleme in einem entsprechenden Sinne löst, das notwendige Korrelat zu einer isolierenden, flächenhaften und kristallinischen Raum—und Körperkomposition, während die "koloristische", insonderheit "tönige", sich ebenso notwendig mit einer vereinheitlichenden, tiefenhaften und malerischen Raum—und Körperkomposition verbunden finden wird.'
Panofsky, *Aufsätze*, p. 55.

12. *Ibid.*, p. 42.

13. For 'Albrecht Dürer and Classical Antiquity', and 'The First Page of Vasari's "Libro"', see Panofsky, *Meaning in the Visual Arts*, Harmondsworth, 1970.

14. Panofsky, 'Die Perspektive als "symbolische Form"' (1927), *Aufsätze*, pp. 99–167.

15. Guido Hauck, *Die subjektive Perspektive*, Stuttgart, 1879.
16. M. H. Pirenne, *Optics, Paintings and Photography*, Cambridge, 1970, pp. 148f.
17. '. . . der subjektive Seheindruck war so weit rationalisiert, dass gerade er die Grundlage für den Aufbau einer fest gegründeten und doch in einem ganz modernen Sinne "unendlichen" Erfahrungs-welt bilden konnte (man könnte die Funktion der Re-naissanceperspektive geradezu mit der des Kritizismus, die der hellenistisch-römischen Perspektive mit der des Skeptizismus vergleichen)—es war eine Überführung des psychophysiologischen Raumes in den mathematischen erreicht, mit anderen Worten: eine Objektivierung des Subjektiven.'
 Panofsky, *Aufsätze*, p. 123.
18. Both the title of Panofsky's paper, and also an early reference in it to Cassirer's description of geometrical construction as lacking phenomenological quality of spatial perception suggests that Panofsky's notion of 'symbolic form' corresponds to that of Cassirer, but Cassirer (*Philosophy of Symbolic Forms*, Vol. I, p. 97) would seem to insist that art and scientific cognition have their own distinct modes. For a discussion of the link between them see contributions of Cassirer and Panofsky at the 4th Congress of Aesthetics, *Zeitschrift für Aesthetik und allgemeine Kunstwissenschaft. Beilagheft*, Vol. XXV, 1931, pp. 52–4.
19. Panofsky, 'History of the Theory of Human Proportion' (1921), *Meaning in the Visual Arts*, pp. 82–138.
20. Panofsky, *Idea*, Leipzig and Berlin, 1924, pp. 71f. (tr. p. 126).
21. Panofsky, *Hercules am Scheidewege und andere antike Bildstoffe in der neueren Kunst*, Leipzig and Berlin, 1930, p. 76.
22. *Ibid.*, pp. 82f.
23. The original study by Panofsky and Saxl, *Dürer's 'Melancholia I'*, Leipzig, 1923, the material of which was developed in the much more extensive book by Klibansky, Saxl and Panofsky, *Saturn and Melancholy*, Edinburgh, 1964.
24. Klibansky, Saxl and Panofsky, *Saturn and Melancholy*, p. 365.
25. Panofsky, 'Albrecht Dürer and Classical Antiquity', *Meaning in the Visual Arts*, p. 306.
26. Renata Heidt, *Erwin Panofsky, Kunsttheorie und Einzelwerke*, Cologne and Vienna, 1977, p. 214.
27. Lorenz Dittmann, *Stil, Symbol, Struktur*, Munich, 1967, pp. 130f.
28. Panofsky, 'Zum Problem der Beschreibung und Inhaltsdeutung von Werken der bildenden Kunst', *Aufsätze*, pp. 92ff.
29. Panofsky, *Early Netherlandish Painting*, 2 vols., Cambridge, Mass., 1953.

30. O. Pächt, 'Panofsky's *Early Netherlandish Painting*', *Burlington Magazine*, Vol. XCVIII, 1956, pp. 257f.
31. Panofsky, *Early Netherlandish Painting*, Vol. I, pp. 141f.
32. *Loc. cit.*
33. Hegel, *Phänomenologie des Geistes, Werke*, Vol. III, p. 503; English ed. *Phenomenology of Spirit*, tr. A. V. Miller, Oxford, 1977, p. 146.
34. Panofsky, *Gothic Architecture and Scholasticism* (1951), Cleveland, Ohio, 1957.
35. *Ibid.*, pp. 6f.; *Aufsätze*, p. 114, and *Die Deutsche Plastik*, Munich, 1924, 2 vols., Vol. I, pp. 65–7.
36. Panofsky, *Aufsätze*, p. 94.
37. Panofsky, 'Der Begriff des Kunstwollens', *Aufsätze*, p. 46, note 11. An interesting response to this was made by A. Dorner, 'Die Erkenntnis des Kunstwollens durch die Kunstgeschichte', *Zeitschrift für Aesthetik und allgemeine Kunstwissenschaft*', Vol. XVI, 1922, pp. 216ff. Panofsky replied in Vol. XVIII, 1925, pp. 158–61.
38. Panofsky. *Life and Work of Albrecht Dürer*, p. 171.

NOTES TO CHAPTER X

1. Ernst Heidrich, *Beiträge zur Geschichte und Methode der Kunstgeschichte*, Basel, 1917.
2. On this distinction see Julius Kovesi, *Moral Notions*, London, 1967.
3. J. von Schlosser, 'Stilgeschichte und Sprachgeschichte der bildenden Kunst', *Sitzungsberichte der Bayerischen Akademie der Wissenschaften*, Munich 1935.
4. See Richard Wollheim, *Art and its Objects*, 2nd ed., Cambridge, 1980, particularly 'Criticism as Retrieval', pp. 185ff. For the incompatible—incommensurable distinction see p. 202.
5. E. D. Hirsch, Jr, *The Aims of Interpretation*, Chicago and London, 1976, Chap. III.
6. E. H. Gombrich, *Art and Illusion*, London, 1962, and subsequent papers, particularly 'The Mask and the Face', in E. H. Gombrich, Julian Hochberg and Max Black, *Art, Perception and Reality*, Baltimore and London, 1972; 'Illusion and Art' in R. L. Gregory and E. H. Gombrich, eds., *Illusion in Nature and Art*, London, 1973; and *The Heritage of Apelles*, London, 1976.
7. See E. H. Gombrich, *Norm and Form*, London, 1966, pp. 64ff. and 81ff., and *The Sense of Order*, Oxford, 1979.
8. See particularly Wollheim, *Art and its Objects* for the relevant application of Wittgenstein's conception of language as a 'form of life' to art.

A SELECT BIBLIOGRAPHY

THE FIRST section lists the main primary works discussed in the book and the second section the main general writing about them. References to further literature and bibliographies on particular authors are given in the notes.

I

Burckhardt, J., *Jacob Burckhardt-Gesamtausgabe*, 14 vols., Berlin and Leipzig, 1929–34.
—— Vol. II, *Die Zeit Constantins des Grossen* (1853); *The Age of Constantine the Great*, tr. M. Hadas, London, 1949.
—— Vol. III, *Cicerone* (1855).
—— Vol. VI, *Die Kunst der Renaissance in Italien* (1867).
—— Vol. VII, *Weltgeschichtliche Betrachtungen* (1905); *Reflections on World History*, tr. M. D. Hottinger, London, 1943.
—— Vol. XII, *Beiträge zur Kunstgeschichte von Italien* (1898).
—— Vol. XIII, *Erinnerungen aus Rubens* (1898); *Recollections of Rubens*, tr. M. Hottinger, London, 1950.
Frankl, P., *Die Entwicklungsphasen der neueren Baukunst*, Leipzig and Berlin, 1914; *The Principles of Architectural History: The Four Phases of Architectural Style, 1420–1900*, tr. and ed. James F. O'Gorman with a Foreword by James S. Ackerman, Cambridge, Mass., 1968.
Göller, A., *Zur Aesthetik der Architektur*, Stuttgart, 1887.
—— *Die Entstehung der architektonischen Stilformen*, Stuttgart, 1888.
Hegel, G. W. F., *Werke* (20 vols.). Theorie Werkausgabe, ed. Eva Moldenhauer and Karl Markus Michel, Frankfurt-am-Main, 1970.
—— Vols. XIII, XIV, XV. *Vorlesungen über die Aesthetik*; *Aesthetics, Lectures on Fine Art*, tr. T. M. Knox, 2 vols., Oxford, 1975.
—— *The Introduction to Hegel's Philosophy of Fine Art*, tr. with Prefatory Essay by B. Bosanquet, London, 1905.
Hildebrand, A., *Das Problem der Form in der bildenden Kunst* (1893), 3rd ed., Strassburg, 1901.
—— *The Problem of Form in Painting and Sculpture*, tr. M. Meyer and R. O. Ogden, 2nd ed. New York, 1932 (Garland Reprint, New York and London, 1978).
Panofsky, E., *Dürers Kunsttheorie, vornehmlich in ihrem Verhältnis zur Kunsttheorie der Italiener*, Berlin, 1915.

———— *'Idea': ein Beitrag zur Begriffsgeschichte der älteren Kunsttheorie*, Leipzig and Berlin, 1924; *Idea. A Concept in Art Theory*, tr. J. J. S. Peake, Columbia, 1968.

———— *Hercules am Scheidewege und andere antike Bildstoffe in der neueren Kunst*, Leipzig and Berlin, 1930.

———— *Studies in Iconology* (1939), New York, 1962.

———— *The Life and Art of Albrecht Dürer* (1943), 4th ed., Princeton, 1955.

———— *Gothic Architecture and Scholasticism* (1951), Cleveland, Ohio, 1957.

———— *Early Netherlandish Painting*, 2 vols., Cambridge, Mass., 1953.

———— *Aufsätze zu Grundfragen der Kunstwissenschaft*, Berlin, 1964. Included among the papers republished here are:
'Das Problem des Stils in der bildenden Kunst' (1915).
'Der Begriff des Kunstwollens' (1920).
'Über das Verhältnis der Kunstgeschichte zur Kunsttheorie' (1925).
'Zum Problem der historischen Zeit' (1927).
'Die Perspektive als "symbolische Form"' (1927).
'Zum Problem der Beschreibung und Inhaltsdeutung von Werken der bildenden Kunst' (1932).

———— *Meaning in the Visual Arts*, Harmondsworth, 1970. Included among the papers translated and republished here are:
'Die Entwicklung der Proportionslehre als Abbild der Stilentwicklung' (1921); 'The History of the Theory of Human Proportions as a Reflection of the History of Styles'.
'Dürers Stellung zur Antike' (1921); 'Albrecht Dürer and Classical Antiquity'.
'Das erste Blatt aus dem "Libro" Giorgio Vasaris. . .' (1930); 'The First Page of Vasari's "Libro"'.

———— with R. Kilbansky and F. Saxl. *Saturn and Melancholy*, Edinburgh, 1964.

Riegl, A., *Stilfragen*, Berlin, 1893.

———— *Spätrömische Kunstindustrie* (1901), Vienna, 1927.

———— *Das Holländische Gruppenporträt* (1902), 2 vols., ed. K. M. Swoboda, Vienna, 1931.

———— *Gesammelte Aufsätze* (1929), Augsburg and Vienna, 1929.

———— *Historische Grammatik der bildenden Künste* (1966), ed. K. M. Swoboda and O. Pächt, Graz and Cologne, 1966.

Rumohr, C. F. von, *Über die antike Gruppe Castor und Pollux oder von dem Begriff der Idealität in Kunstwerken*, Hamburg, 1812.

———— *Italienische Forschungen* (1827–32), ed. J. von Schlosser, Frankfurt-am-Main, 1920.

———— *Drei Reisen nach Italien*, Leipzig, 1832.

Schmarsow, A. *Beiträge zur Aesthetik der bildenden Künste*. Vol. I, *Zur Frage nach dem Malerischen*, Leipzig, 1896. Vol. II, *Barock und*

Rokoko, Leipzig, 1897. Vol. III, *Plastik, Malerei und Reliefkunst*, Leipzig, 1899.

Schnaase, Karl, *Niederländische Briefe*, Stuttgart and Tübingen, 1934.
—— *Geschichte der bildenden Künste*, 8 vols., 2nd ed., Düsseldorf, Stuttgart, etc., 1869–79; Vols. III to VII, *Geschichte der bildenden Künst im Mittelalter*; Vol. VIII *Geschichte der bildenden Künste im 15. Jahrhundert*.

Semper, G., *Vorläufige Bemerkungen über gemalte Architektur und Plastik*, Ancona, 1834.
—— *Wissenschaft, Industrie und Kunst* (1851), ed. H. M. Wingler, Mainz, 1966.
—— *Die vier Elemente der Baukunst. Ein Beitrag zur vergleichenden Baukunde*, Brunswick, 1851.
—— *Über die formelle Gesetzmässigkeit des Schmuckes und dessen Bedeutung als Kunstsymbol*, Zürich, 1856.
—— *Der Stil in den technischen und tektonischen Künsten oder praktische Aesthetik*, 2 vols., 2nd ed., Munich 1878–9.

Springer, A., *Die Hegel' sche Geschichtsanschauung*, Tübingen, 1848.
—— *Paris im dreizehnten Jahrhundert*, Leipzig, 1858.
—— *Bilder aus der neueren Kunstgeschichte*, 2 vols., 2nd ed., Bonn, 1886.
—— *Aus meinem Leben*, Berlin, 1892.

Warburg, A., *Gesammelte Schriften*, ed. G. Bing and F. Rougemont, Leipzig and Berlin, 1932.

Wölfflin, H., *Renaissance und Barock*, Munich, 1888; *Renaissance and Baroque*, tr. K. Simon, London, 1964.
—— *Klassische Kunst* (1899), 4th ed., Munich, 1908; *Classic Art*, tr. P. and L. Murray, London, 1953.
—— *Die Kunst Albrecht Dürers* (1909), 5th ed., Munich, 1926; *The Art of Albrecht Dürer*, tr. Alastair and Heide Grieve, London, 1971.
—— *Kunstgeschichtliche Grundbegriffe* (1915), 5th ed., Munich, 1943; *Principles of Art History*, tr. M. Hottinger, London, 1932.
—— *Kleine Schriften*, ed. J. Gantner, Basel, 1946. Included among the papers of this volume are:
'Prolegomena zu einer Psychologie der Architektur' (1886).
'Die antiken Triumphbogen in Italien' (1893).
'Adolf Hildebrands "Problem der Form"' (1893).
'Das Erklären von Kunstwerken' (1921).
—— *Gedanken zur Kunstgeschichte*, ed. J. Gantner, 4th ed., Basel, 1947.

II

Dilly, H., *Kunstgeschichte als Institution. Studien zur Geschichte einer Disziplin*, Frankfurt-am-Main, 1979.

Dittmann, L., *Stil, Symbol, Struktur*, Munich, 1967.

Gombrich, E. H., 'Kunstwissenschaft', *Atlantis Buch der Kunst. Eine Enzyklopädie der bildenden Kunst*, Zürich, 1952.

Hauser, A., *The Philosophy of Art History*, London, 1959.

Heidrich, E., *Beiträge zur Geschichte und Methode der Kunstgeschichte*, Basel, 1917.

Kleinbauer, W. E., *Modern Perspectives in Western Art History*, New York, 1971.

Passarge, W., *Die Philosophie der Kunstgeschichte in der Gegenwart*, Berlin, 1930.

Schlosser, J. von, *Die Wiener Schule der Kunstgeschichte*, Innsbruck, 1934.
———— 'Stilgeschichte und Sprachgeschichte der bildenden Kunst', *Sitzungsberichte der philosophisch-historischen Abteilung der Bayerischen Akademie der Wissenschaften*, 1935.

Tietze, H., *Die Methode der Kunstgeschichte*, Leipzig, 1913.

Waetzoldt, W., *Deutsche Kunsthistoriker*, 2 vols., Leipzig, 1921–4.

INDEX